CONNECTING ART HISTORIES IN THE MUSEUM

From Granada to Berlin:
the Alhambra Cupola

Connecting Art Histories in the Museum is a collaboration between Staatliche Museen zu Berlin, Stiftung Preußischer Kulturbesitz and Kunsthistorisches Institut in Florenz, Max-Planck-Institut. The book series is edited by Michael Eissenhauer, Jörg Völlnagel, Hannah Baader, Gerhard Wolf.

ANNA MCSWEENEY

From Granada to Berlin: the Alhambra Cupola

CONNECTING
ART HISTORIES
IN THE MUSEUM

Vol. 5

Staatliche Museen zu Berlin
Preußischer Kulturbesitz

Kunsthistorisches
Institut
in
Florenz
Max-Planck-Institut

VERLAG KETTLER

Table of Contents

Acknowledgements

This book has been a long time in the making, so a great many thanks are due. Foremost thanks to the Museum für Islamische Kunst (Museum of Islamic Art) in Berlin, in particular to the director Stefan Weber, for hosting me in the Museum from 2013-14 and again in 2015. I am very grateful to Julia Gonnella, whose sustained interest, support, and insights both in the Museum and outside of it, from Krumke to Granada, were hugely valuable. Jens Kröger generously shared his extensive research on the cupola and on Gwinner with me. I spent many hours up a scaffold with Jutta Maria Schwed examining the cupola in detail and her conservation expertise was enormously informative.

In Berlin, I was an *Art Histories and Aesthetic Practices* fellow with the *Forum Transregionale Studien* from 2013-14 when my research into the cupola began. I am grateful to the directors of the programme Hannah Baader and Gerhard Wolf, in particular to Hannah for her intellectual support, and to Luise Neubauer and Lucy Jarman for their practical help and administrative support. In 2015 my research time in Berlin was funded by an International Scholarship awarded by the Staatliche Museen zu Berlin, Preussischer Kulturbesitz, and by the Oleg Grabar Postdoctoral Fellowship, awarded by the Historians of Islamic Art Association. Thanks also to Kay Kohlmeyer and Arie Browne of the Hochschule für Technik und Wirtschaft Berlin.

In Granada, I am grateful to Jesús Bermúdez López and Reynaldo Fernández Manzano of the Alhambra, for allowing me such excellent access to the monument and its archives; to Maria Carmen López Pertíñez in the Fundación Rodríguez Acosta for sharing her expertise in Nasrid carpentry; to Carlos Sánchez, and to Antonio Almagro Gorbea and Antonio Orihuela Uzal at the Escuela de Estudios Árabes, CSIC.

In London, I was grateful that my work was funded while I was a fellow with the research group *Bilderfahrzeuge: Warburg's Legacy and the Future of Iconology*, a project financed by the German Ministry for Culture, at the Warburg Institute, London (2015-18). Image costs for the book were generously supported by the Department of Art History at the University of Sussex.

I am very grateful to my copy editor Melinda Johnston for going above and beyond, to Matilde Grimaldi for her beautiful maps and to the anonymous peer reviewers whose thoughtful comments and suggestions for changes I hope improved the text. Finally, I owe so much to my family, to Paul, Alex and Eloisa, who have lived with my cupola obsession for many years.

Anna McSweeney, London, 2020

Preface: Some Thoughts on Museums, the Agency of Objects and the Making of Meaning

This is a biography of a 700-year-old wooden cupola from the Alhambra Palace in Granada, Spain. Its long history in Granada was cut short in the late 19th century when it was dismantled and left its home for Berlin. The cupola barely survived World War II when it almost turned to ashes during the winter of 1945 in the countryside east of Berlin. It then took shelter from the Cold War in an old garage close to Empress Sisi's palace in Possenhofen / Bavaria. In 1992 it was a star piece in an exhibition at the Metropolitain Museum in New York before it found a new home, after Germany's unification, in the Museum for Islamic Art at the Pergamon Museum in Berlin. Today it is marvelled at by almost a million visitors a year.

Much of its biography – especially of its early life - was lost until Anna McSweeney became a research fellow of the Forum *Transregionale Studien* and the Kunsthistorisches Institut in Florence. She joined our museum and engaged in a profound research project on the cupola. Its biography does not reflect so much its own life-story, but the changing environments surrounding it, from the days of its creation until now. Throughout the book the cupola serves as a mirror reflecting the different situations in which it finds itself, "... in which the object may not only assume a number of different identities as imported wealth, ancestral valuable or commodity but may also 'interact' with people who gaze upon it, use it and try to possess it." The carpenters in 14th-century Granada may not have considered the different meanings the cupola would eventually acquire, but they certainly thought about the agency of their creation. As José Miguel Puerta Vílchez had shown through his study of the poetry written on the walls of the Alhambra, it was the intention of

its creators that the objects talk to or create an impact on us. And it still does today. Anna McSweeney follows throughout the book these "charged meanings" of the object, as Alfred Gell calls it in his seminal book 'Art and Agency' (1998).

What does that mean for the museum and how can these meanings be communicated? Yes, the object itself has an agency but 'meaning' is at least co-produced by the exhibiter and ultimately made by the visitor. Often the keys provided by a museum to understand the various dimensions of art and architecture from Islamicate societies are limited and meaning is produced based on basic information and in the worst case on culturalistic, schematic world views. Yes, the cupola is full of star imagery. But must it be seen as heaven's tent when all the walls and doors are full of stars as well? For the presentation of the cupola in the new galleries (scheduled for 2026) we will focus primarily on the experience of the object and secondarily on 'meaning making'. We will recreate the spatial setting of the cupola, creating a sensory experience of in-and-outside and provide a sound and light experience to open up the space. For those who are searching for more we will provide additional information. While sitting in the room, one will then be able to listen to many of the stories illuminated in this book.

The Museum for Islamic Art is full of objects that moved. Most of the many fine ceramic bowls and plates or fine fabrics and carpets were meant to travel. They were produced for the market, often for export. Some carpets have been in Europe for 500 or 600 years, while some rock crystal or ivory objects from Fatimid Egypt and Sicily have been in Germany for almost a thousand years. Ceramics from Islamic Spain made their way to England and Egypt, where they are excavated in large quantities. But these are movable objects made to travel. Most architectural objects were not meant to travel at all. From a legal standpoint the present situation of the Alhambra cupola is unproblematic, but ethical questions do, of course, remain. One consequence of this complexity is to 'make meaning' out of its existence in Germany. The museum runs several programs addressing the historical entanglement between Europe and the Middle East. The cupola is an 'agent' of Islamic history in Europe and we will do our best to make this 'meaning' understood. This process starts

with research. Therefore I am extremely thankful for the program 'Art Histories and Aesthetic Practices' run by Hannah Baader, Gerhard Wolf, Georges Khalil and the State Museums for making this fellowship possible and Anna McSweeney for creating so much meaning!

Prof. Dr. Stefan Weber
Director, Museum für Islamische Kunst (Pergamonmuseum)
Staatliche Museen zu Berlin - Preußischer Kulturbesitz
February 2020

Introduction

Without things, we would stop talking.
—Lorraine Daston, *Things that Talk*

He sends the steed of his gaze into space where the zephyr plays
and returns content with what he has seen:
mansions in which the eyes find enjoyment
and where the gaze is captivated and reason enthralled.
—Extract from a poem composed by Ibn Zamrak, inscribed on the walls
of the Mirador de la Lindaraja in the Alhambra

The palaces of the Alhambra are crowned with ceilings that hang from
its vaults like suspended sculptures. From the majestic wooden ceiling
of the Throne Room in the Comares Palace, to the dazzling carved plas-
terwork of the halls of the Court of the Lions, these ceilings represent
some of the most extraordinary surviving works of art from medieval
palace architecture. They were made by craftsmen working for the Nasrid
dynasty, which ruled Granada from 1238 to 1492, for the series of palace
residences, towers, pavilions, and reception rooms that made up the Al-
hambra palaces.

This is the story of one of those ceilings, a cupola (from the Latin *cupula*,
meaning cup, referring to its shape) that is now in the Museum für Is-
lamische Kunst (Museum of Islamic Art) at the Pergamon Museum in
Berlin (Figure 0.1). It was made in the first decades of the fourteenth cen-
tury as the carved and painted wooden ceiling of a jewel-like room in the
mirador, or look-out tower, of one of the earliest palaces of the Alhambra,
a building known as the Partal (Figure 0.2).

The cupola remained in the Partal for over five hundred years. It was wit-
ness to some of the most dramatic political events in European history as
the palaces of the Alhambra were taken over by the new dynasty of Cas-

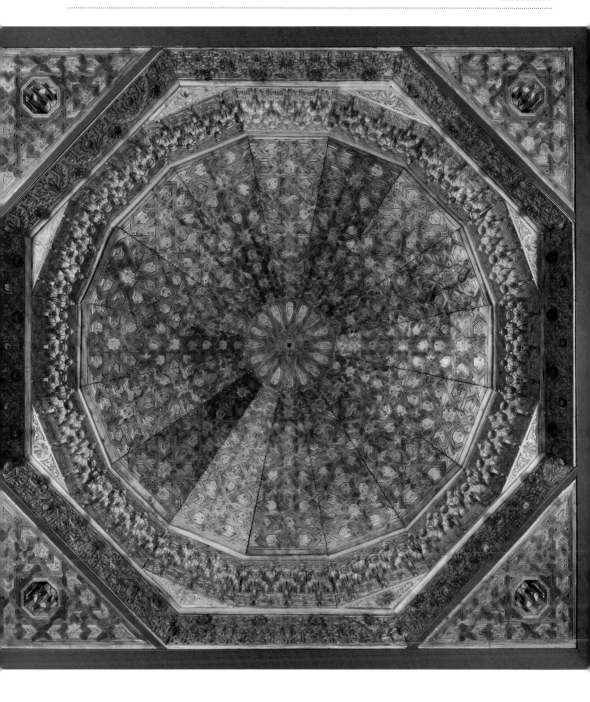

Fig. 0.1

The Alhambra Cupola in the Museum für Islamische Kunst, Berlin.
Inv.Nr: 1.5/78. Photo by Johannes Kramer.

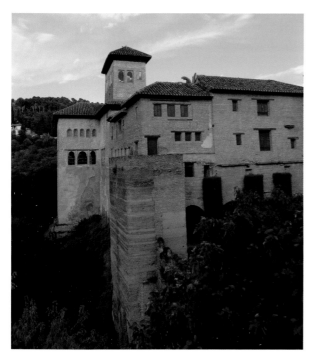

Fig. 0.2

The Partal Palace, Alhambra.
Side view.
Photo by the author

tile and Aragon in 1492, and the Partal went from being a royal pavilion under Muslim rule, to a soldier's residence under the rule of the Catholic monarchs, Ferdinand and Isabella. The cupola survived the royal household's neglect of the Alhambra palaces over subsequent centuries, and the destructive occupation of the site by Napoleon's troops in the first decades of the nineteenth century. It provided shelter to the widows, invalid soldiers, and artisans who struggled to make a living in the palace on the hill following the troops' withdrawal. In the mid-nineteenth century the cupola was witness to the beginnings of modern tourism and the romanticization of the Alhambra, when the picturesque residence was painted by artists and described by the scholars and tourists who fell for the charms of its now-crumbling facades.

It was in the 1890s that the cupola's story took another dramatic turn, when it was dismantled by the then owner of the Partal palace, Arthur von Gwinner. This German banker brought the cupola to his home in Berlin, where he erected it as part of an oriental-style room. Once in Berlin, the cupola was again witness to pivotal events; it was under the cupola that Gwinner held gatherings of his influential circle of friends and colleagues at a key time in German history. Gwinner was involved in the expansion of the German industrial empire across the world, including

building the railway line from Istanbul to Baghdad. The cupola survived World War I; during World War II it narrowly avoided being burnt by Russian soldiers occupying the house in which it had been held in crates for safe keeping, following Gwinner's death in 1933.

Its later twentieth-century history and eventual acquisition by the Museum of Islamic Art in Berlin in 1978 echoes the fluctuating political and economic fortunes of Spain and Germany at the end of a turbulent century. Having brought the cupola out of what became East Germany after World War II, Gwinner's descendants offered it for sale in the 1970s, initially to the Spanish state. The fractured political and economic condi-

Fig. 0.3

The Partal Palace, Alhambra.
Photo by the author

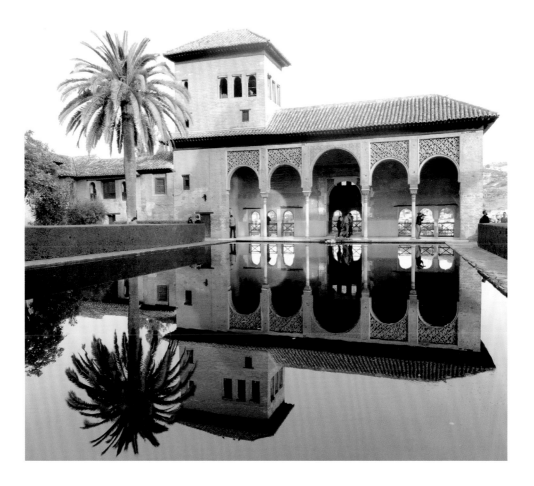

tions in Spain at the end of General Franco's rule meant that it was not in a position to take up the offer. Instead the cupola was bought by the Museum of Islamic Art in Berlin, then situated in Dahlem in West Berlin, a museum that was in the process of acquiring world-class works of art to rival those of the Islamic collection in East Berlin's Pergamon Museum.

The cupola now hangs in the Spanish room at the Museum of Islamic Art, whose works have been part of a reunified collection within the Pergamon Museum in central Berlin since 1992. As the only significant architectural piece of the Alhambra that has survived outside Granada, the cupola is unique. Islamic art historian Richard Ettinghausen recognized its value in his written evaluation of the cupola before its purchase in 1978, noting that, "to find a large authentic architectural unit from the Alhambra and be able to purchase it for a museum, is a unique occasion. There are no better ceilings available anywhere and even in the Alhambra itself there is only one which can match it in quality, so this piece of interior architectural decoration is of supreme importance."[1] It bears extraordinary witness to the sophisticated craftsmanship of artisans working in Nasrid Granada, to the long and precarious history of the Alhambra palace, and to the fascination with and demand for Islamic objects in western European collections from the nineteenth century.

It was under the cupola in the Museum of Islamic Art that I first heard the question, frequently asked by the many Spanish visitors, their necks bent back to wonder open-mouthed at the cupola above: *"Pero que hace esto aqui?"* (But what is this doing here?). This was their response to finding a large part of one of "their" national monuments on display in Germany. The answers were not easy to come by. While never hiding its history, until recently the Museum displayed the cupola without reference to how it arrived in their collection; instead presenting it as an object from another time, as a representative of a historic Islamic culture in Europe that was part of a wider narrative about Islamic art history that the Museum told through its vast collections. Little was made explicit about the cupola's long and complex history, a history of the rise and fall of dynasties, fashions, and the economic fortunes of countries including Germany and Spain, through which the story of much of western Europe could be told. In focusing on the cupola's origins, the Museum's approach

Fig. 0.4

Plan of the Partal ('Torre de las Damas') and its surroundings by Manuel López Reche, 1962. Paper, 85 x 78cm. APAG/ Colección de Planos/ P-002282.

was not unique: objects in museums are often presented through the moment of their creation, while their long use, adaptation, movement, acquisition, or damage is frequently left largely unsaid and the objects instead presented through a moment in their history as if in suspension of subsequent time or politics.

The answer to that question—"What is it doing here?"—can be found through the telling of the long histories of objects: the continuous "lives" or object biographies. It is through these long histories that we can gain new insights into the many meanings, values, and changing relationships that objects such as the Alhambra cupola acquire over time. It is only since it went on display at the Museum that it has even become possible to tell this longer history of the cupola. Like many precious and fascinating objects now in museum collections, the cupola was only visible to an elite few until it entered the museum. For much of its life, the only people who had access to it were the court insiders under the Nasrids, high-ranking soldiers under Catholic monarchs, artists able to travel to Spain, the Spanish private owners of the Partal in the nineteenth century, and then a wealthy banker with resources enough to bring it to his private home. Therefore, the story of the cupola and its movements was largely hidden; one of elite aesthetic and technical achievement in its production and luxury in its display, it was invisible and unknown to the

wider world. Today, the paying public can walk the once-private rooms of the Alhambra and experience some of its captivating beauty and arresting design, while in the halls of the Museum in Berlin, the paying public can stand beneath the cupola in the Spanish room and wonder at its presence juxtaposed with similarly displaced, extraordinary objects from across the wider Islamic world.

With this new visibility comes a responsibility to tell the long histories that do not always fit into the space allotted to an object displayed in a museum context. At a time when the colonial histories of western museums have increasingly led us to question the circumstances of their acquisitions and to require them to justify the items' retention, it is more important than ever to reveal how objects changed, moved, travelled, and were sold over time. It is in the very context of the museum where these long and complex stories must be told, stories that reach beyond the classifications of origins and beginnings and allow for mutations in form, style, taste, and in market and demand, and that can often explain why museums hold these objects at all.

Recent years have seen a proliferation of histories of the "lives" of objects, from the British Museum's exhibition and book *History of the World in 100 Objects* (2010), to the biographical account of a netsuke collection in Edmund de Waal's *The Hare with the Amber Eyes* (2010). This reflects a new concern for the materiality of things and their potential agency that has proved particularly fruitful in art historical practice. Familiar to the field of anthropology, it draws from the work of cultural theorists and anthropologists such as Arjun Appadurai and Igor Kopytoff, whose essay "The Cultural Biography of Things" offered new ways to think about objects in society by exploring the possibilities of adopting a biographical model in relation to these objects, encouraging us to ask the questions of an object that you might ask of a person about their life.[2]

The capacity for objects to act upon societies and individuals, to exercise agency, was explored by Alfred Gell in his more active model of object biography, in which things are not only representative *of* ideas, histories, and cultures (metaphors in the museum), but are themselves actors in the world.[3] The visitors' question "What is it doing here?" is not only one

of legal ownership— possibly answered through the documentation of receipts for the cupola's sale and exchange—but also one of agency: what is the object *doing* here. This questions how the cupola acts as well as how it was acted upon, thereby positioning the object as an active agent in society rather than simply a reflection of meaning.[4]

The biographical approach allows the historian to draw attention to these different social contexts, value systems, and modes of interpretation that determine how an object acts on us. It seeks to illuminate these questions of agency through the actions of the object on the many societies with which it has had contact.[5] But where does that agency come from? It is metaphorical to apply the literary practice of biography to an object, embedding ideas associated with life in lifeless things. Objects are not animate, they do not have their own independent agency; rather, they are imbued with agency by people, through the social realms within which they are active. As anthropologists have argued, objects make people as much as people make objects—we exist in a realm in which the things we make can impel us to act or perform in particular ways.[6]

This is especially true when an object is as charged as the Partal cupola. In its presence, people have been compelled to perform a kind of nostalgia since it was first erected. One of the recurring actions in the story of the cupola is that of remembering, of a kind of active nostalgia in its presence. The cupola allowed its viewers, those who sat under it or looked up at it, to remember particular and different histories. For the Nasrids, it crowned a pivotal viewing point in a dynastic palace, its presence in the Partal recalling the great water palaces of caliphal Córdoba and Berber North Africa. For artists of the nineteenth century like John Frederick Lewis, it epitomized the crumbling remains of a glorious artistic tradition from what they perceived as a lost Islamic dynasty. For Gwinner, the cupola installed in his house in Berlin acted as a literal place of memory, a *lieu de mémoire*, under which he remembered a place, Granada, that he had come to love in his own youth.[7]

Gell described this ability of an extraordinary object to activate the viewer without us knowing why as a kind of captivation, "the demoralisation produced by the spectacle of unimaginable virtuosity."[8] The cupola held a

certain power and agency over its viewers because of the skill with which it was made, the beauty of its design and articulation, and the particular cultural fascination that developed with the Alhambra from the late eighteenth century. Gell's notion of captivation is particularly apt in the Alhambra, in which the act of captivation was written into the very walls of its structures, suggesting that the cupola activated Nasrid viewers in the fourteenth century as much as it does visitors in Berlin today. In the mirador of Lindaraja, a small and exquisitely formed throne chamber in the Alhambra from a slightly later date than the Partal, the words of the court poet Ibn Zamrak were inscribed in plaster around the windows. The verses, written in the first person, describe the building as a place where the viewer's gaze is captivated, time is suspended, and the intellect is engaged. The building speaks through its poetry, describing its palaces as "mansions in which the eyes find enjoyment and where the gaze is captivated and reason enthralled."[9] Verses inscribed on walls throughout the Alhambra similarly demand viewers' visual attention, commanding them to look and pay heed to the experience of being inside its walls. In the Qalahurra, a small palatial Nasrid tower in the Alhambra, the verses tell readers: "Look where you will and you will see many designs, all of them coloured, gilded and decorated."[10] In an article on how we experience objects in museums, Svetlana Alpers argued that this kind of "attentive looking" was a practice peculiar to objects in western museums; however, it is clear that it was just this kind of close viewing, the experience of looking closely and engaging with the aesthetic experience of an object's materiality, that was present in the very conception of the cupola.[11]

In a recent book on the purpose of the museum in contemporary society, Nicholas Thomas argues that this notion of captivation encapsulates the sensory and sensual power of the material presence of objects in museums today—objects that are "captivating in their presence and intricacy."[12] The agency of the object lies in its ability to captivate, and for the cupola this was as true in the fourteenth century as when it is singled out for "attentive looking" in the museum today. The question "What is it doing here?" can then be answered as a kind of captivation—the cupola captivates the viewer, it has always captivated the viewer, whether that viewer was in Granada or Berlin, a Nasrid ruler or a museum visitor. It is that long history of our captivation by a single object that is the subject of this book.

The telling of the long history of an object and its relationships over time can prove structurally difficult; academics tend to define themselves by their specialisms, as historians of a particular time or place (of the medieval Mediterranean, or of the nineteenth century, for example). Following an object from the fourteenth to the twenty-first century and from al-Andalus to Berlin involves attempting to understand many different cultures and archives, even within one institution, such as the Alhambra. When an object breaches cultural or religious boundaries, the story becomes more difficult to relate. When the subject of this book, the Alhambra cupola, switched from Nasrid to Christian hands, alongside the rest of the Alhambra, or when it was moved from a Spanish boarding house to a private banker's home in Berlin, it inadvertently crossed those subject boundaries that contain us as historians, writers, and academics—boundaries of European and Islamic art history in particular.

These subject boundaries—abstract classifications created within academia and museum scholarship—can constrain objects that enter into museum collections in particular, testing the value of their metadata to the limit. Was the cupola still Islamic when it hung in a soldier's residence in a royal palace of the Castilian monarchs (as the Partal in the Alhambra was) in the sixteenth century? What about when it was suspended above Gwinner's front room in his house in Berlin? These traditional classifications of Islamic or western European art history, of "medieval" or "early modern" material culture, don't change the nature of the cupola of course, but they can determine the kinds of histories that are told about objects. Writing the long history of an object then demands a certain flexibility and a willingness to disregard the academic and cultural borders that tend to enclose us and to move between Islamic and western European, medieval and modern cultures. I have attempted to cross these boundaries in telling the story of the cupola; however, I am certain that I am nevertheless blinkered to other borders, invisible to me, which remain to be crossed by other historians of this remarkable object.

The telling of an object biography also requires a certain stamina and discipline to stick with the object as far as possible, claiming it as the centre of the story despite the political changes, movements, and seismic cultural shifts that went on around it. In the case of the cupola, the dramatic

change from Islamic to Christian rule in 1492 had little material effect; it was the change from being *the* royal palace to being one of many in a peripatetic kingdom over subsequent decades that endangered its existence. Staying with the cupola was particularly difficult during periods of stasis and apparent lack of activity. Biographies are illuminated by interactions and relationships; the cupola was enlivened by those changes, movements, and adaptations made by people under it and to it. But when the cupola stayed still, in the seventeenth and eighteenth centuries for example, and the Partal that contained it remained a soldier's residence with little change to the social or cultural conditions on the site, it was difficult to find direct evidence for its existence, let alone importance—indeed the cupola was not yet even clearly an object in its own right.

This highlights a key problem with the idea of the object in the object biography: the methodology presupposes the continued integrity of the object as a definable, unchanging given. But many objects in museums today were not "born" as portable, self-contained objects; rather, they are fragments or parts of something else, their histories forever linked with other disparate objects or sites. By the time the cupola had been identified as a desirable object, when its purchaser Gwinner described it specifically in a sale document in 1885 for example, its movements and therefore its biography were more easily traced. This paradox, the fact that it took an act of destruction, the tearing down of the cupola, for it to become an object, an exchangeable commodity, is the paradox at the heart of this object biography. For much of its life, the cupola was an architectural element of a larger whole, the Partal pavilion, within which it formed an important but interdependent part. The cupola was not made as an object in its own right; rather, it was constructed as the ceiling to crown a room, as one part of an integrated whole. It was not equipped with handles, hooks, or stands to allow it to be detached, to sit or stand as an independent thing, but had to be cut down from its frame. Despite becoming a fragment of what was once a whole, its history remained entangled in that of the building for which it was made, the Partal. This entanglement and the cupola's status as architectural fragment, complicates the methodology of object biography, in which the portability and boundaries of the object are often taken for granted. In writing the object biography of a cupola, the ambiguity in the nature of objects is revealed: When did the cupola begin? How can I

tell the biography of the cupola as an object when it was not identifiable as such until Gwinner, with his tastes formed by the western fashion for "exotic" rooms in private houses, cut it down?

One approach explored recently by anthropologists and material culture specialists might offer a way to navigate these questions about the nature of objects and their boundaries. In his study of material culture and movement, Paul Basu argues that objects are by their nature diasporic, with movement and dislocation essential to their understanding.[13] He explores a way of thinking about objects through what he calls their "inbetweenness," a way to escape the essentialism of definitive classifications that search for one true nature of things, favouring instead the complexities and entanglements of objects. He defines inbetweenness as a relational space, a middle ground, or contact zone, in which the object is neither one definite thing nor another, but many things at once. Thomas describes this state as a "doubleness," a "lack of fixity" that characterizes the material world of objects.[14] In the case of the cupola, it can be understood in the museum as both an object and a fragment throughout its history. When it was separated from the Partal, it remained entangled in its network of relationships despite its physical separation. Hanging in the Museum today, it is intimately connected with the Alhambra, with Spain, as well as with the city of Berlin, caught in the web of these multiple histories that make up its biography. Thinking about objects through the framework of inbetweenness allows us to acknowledge that they are neither this nor that, here nor there, but rather carry movement and dislocation in their core, in a world of objects defined by their web of social, temporal, and spatial relations.

This idea of objects carrying dislocation and movement at their core is particularly pertinent to the architectural fragments in museum collections that carry the material traces of the moment of their dislocation. The cupola only became an object in its own right through an act of violence, when it was cut down from the mirador and dismantled into packing cases in 1891. The cupola was not structural, rather it was suspended from the vaults, so it could be cut down, but not without damage to its frame and the loss of millimetres from the panels' sides. The violence of this kind of moment of dislocation is visible in many architectural

fragments in museums today. For instance, Lindsay Allen has charted the routes taken by fragments chipped and hauled from the site of Persepolis, in present-day Iran, to museums and collections across the world. They bear marks of their movement, their birth into objecthood, in the scratches and scrapes on their surfaces, their fragmentary nature, and the voids left behind in Iran.[15] Similarly, Eva-Maria Troelenberg has documented how the Umayyad walls of Mshatta palace were dismantled from their site in Jordan with hammers and saws used to fracture the surface of the thousand-year-old stone facades, marks that are still clearly visible today on the displaced Mshatta facade now in the Museum in Berlin.[16]

The Alhambra cupola therefore bears the marks of its violent birth as an object in the missing millimetres of wood from the dismantling process. This moment of partial destruction, which involved the loss of material from each of the panels, was also a moment of birth, when the cupola became an object whose biography could be told. In its materiality it bears witness to the violence of its creation through the loss of material; an act of violence that continues to hover under its canopy as it sits in the museum today, echoing with the questions of visitors beneath it.

This is then an object biography of the cupola and its life within the extraordinary times and spaces in which it was present and on which it acted. While it is not a history of the many complex buildings of the Alhambra, it offers a new and longer prism through which the site can be interpreted. In the sense in which I have argued that the cupola and the Partal were one entwined object, it also acts as a partial biography of the Partal palace, a pivotal construction in the Alhambra that has been largely ignored in many histories of the site. As a witness to pivotal moments in European history, the cupola can also tell a larger story of the seismic political changes at the end of Muslim rule in western Europe: changes that continue to reverberate in cultural and political spheres today. By following this one key object, I hope to tell the story of an extraordinary piece of craftsmanship and its legacy in one of the world's most visited, yet most misunderstood, monuments, the history of its fragmentation and movement to Berlin, as well as the story of the people who lived and worked beneath the cupola: the soldiers and sultans, the opera singer, the peasant, the textile workers, the artists, and the tourists.

Chapter One:
Early Nasrid Granada

When the Partal was built in the early years of the fourteenth century, Granada was a city that was only just catching its breath. The previous century had been a tumultuous one during which most of Muslim al-Andalus was conquered by the Christian forces of Castile and Aragon: Córdoba in 1236, Jaén in 1244, Seville in 1248, and Cádiz in 1264. As they were conquered, many resident Muslim populations were faced with a stark choice: convert or face enslavement.[17] Many chose to flee. Those Muslims who had portable wealth were often the most able to negotiate their freedom and establish themselves elsewhere. While some went to North Africa, many settled in Granada, capital city of the new Nasrid dynasty, where they built their homes and established their businesses.[18]

Granada: Early History

Granada had been a small town until the arrival of the Zirids, a Berber dynasty (1013–91) who established the city they called Madinat Garnata as their capital under Zawi b. Ziri in 1013.[19] It was the Zirids who walled off a large area of the city, which incorporated a fortress (alcázar or castle) in the higher region of the city known as Alcazaba (opposite the Alhambra) as well as a smaller fortress (a *hisn* in Arabic) on the Sabika Hill, the site on which the Alhambra would be built. They restored and built new irrigation canals from the Darro and Genil rivers to supply the city's orchards, agriculture, and urban water demands. They built bathhouses and established Granada's congregational mosque in the lower part of the city. The Berber rulers known as the Almoravids and Almohads, who ruled from 1090–1232, continued to expand the city of Madinat Garnata, although from 1157 their capital city in al-Andalus was Seville. An Almohad royal residence on the outskirts of Granada, the Alcázar Genil, partially survives today.[20]

In 1238 Granada became the capital of a new Muslim dynasty, the Nasrids. Their first leader, Muhammad b. Yusuf b. Nasr I (b. 1195) came from the town of Arjona in the province of Jaén, some 120 kilometres north of Granada. He had been proclaimed ruler in 1232 by a group of soldiers and leading Muslim families who had been driven from their lands by the Castilian invasions. Through a series of compromises with Christian and rival Muslim forces, including the surrender of Jaén to Castile in exchange for a twenty-year truce, Muhammad I, as he would be known, managed to forge a new Muslim kingdom out of the remains of al-Andalus, encompassing Almería and Málaga, with its capital in Granada and its new palace city and fortress in the Alhambra (Figure 1.1). By the late

Fig. 1.1

Map of the western Mediterranean showing the Nasrid Kingdom in the 14th century.
Map by Matilde Grimaldi.

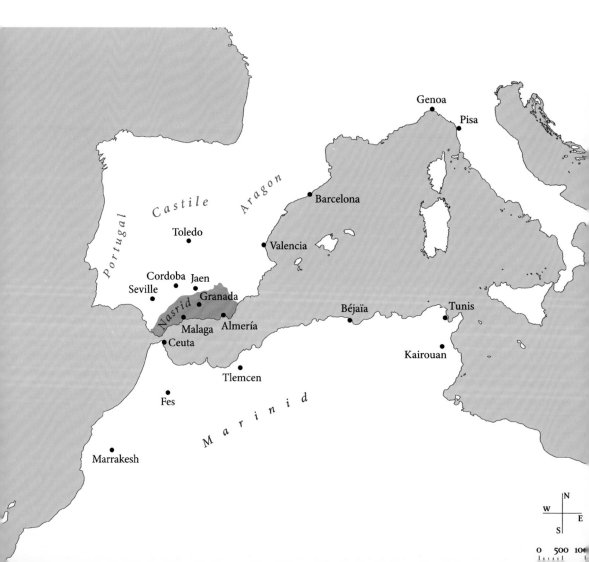

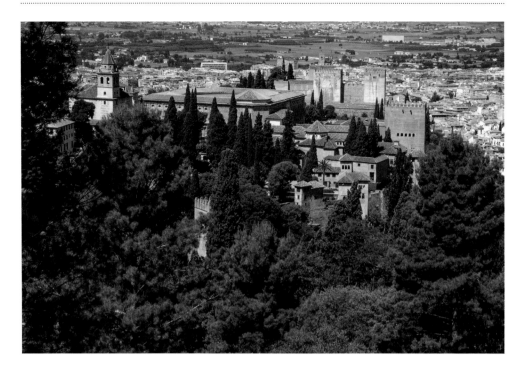

Fig. 1.2

**View of the
Alhambra, Granada.**
Photo by
Simon Lane.

thirteenth century, Granada was a cosmopolitan city that was rapidly increasing in size with the large number of refugees who arrived there from the surrounding towns. Over the next two centuries the Nasrids would transform the palace city in Granada into a series of royal residences with pavilions, known as the Madinat al-Hamra, city of the red: the Alhambra (Figure 1.2).

Population

It was probably the presence of this dense, relatively wealthy, and cosmopolitan population of residents and refugees that allowed the Nasrid dynasty to thrive and that led to the intense and fertile programme of building in Granada under their regime. The city was further swollen in numbers by the arrival of Berber soldiers, known as Zanatas, who were recruited by the Nasrids to help maintain power. Political exiles from the Marinids, a Muslim dynasty in Morocco with its capital in Fez,[21] the Zanatas were army mercenaries who formed a wealthy and often powerful sector of Granadan society. Estimates of up to ten thousand soldiers in the city at the turn of the century would have put their population at one fifth of the total Granadan population of around fifty thousand in the early fourteenth century.[22]

This combination of displaced Muslims—who brought with them their portable wealth—with the long-term residents of Granada and the influx of Berber soldiers, made for a diverse and rich population, in a growing urban centre with increasing infrastructure needs. While the new territories of Castile and Aragon were struggling to maintain their populations with little of the hoped-for influx of Christians from the north, the Nasrids enjoyed a period of relative political stability and productivity. This stability was only maintained through a delicate and complex series of compromises, in which the Nasrid rulers carefully balanced the powers and demands of Christian Castile in the north against those of the Marinids in the south, while maintaining open trade routes with northern Europe, North Africa, and the Mediterranean. Sometimes at war with both sides, while at other times forging alliances, the early Nasrids showed little interest in *jihad* or religious warfare.[23] Instead, the Nasrids paid more attention to maintaining their borders on all sides, by preventing the Marinids from crossing the Straits of Gibraltar and keeping the Castilians at bay, than they did to religious warfare with Christians or the spread of Islam into Christian lands for its own sake. This pattern of relationships complicates the traditional historical narrative of thirteenth-century Spain, which describes it as a time and place of outright religious conflict between Christians and Muslims. While the period had its fair share of wars and conflict, the Nasrids thrived by building and maintaining a web of alliances that reached far beyond supposed religious boundaries.

Economy

The Kingdom of Granada had several natural advantages that enabled it to thrive; namely, its mountainous defences, its long coastline, fertile plains, and the port cities of Almería and Málaga. The rich agricultural lands and favourable climate enabled the Nasrids to produce a surplus of silk, sugar, and dried fruits for export. The Nasrid court minister and writer Ibn al-Khatib (d. 1374) described Málaga as a "pilgrimage spot for merchants" who bought figs and sugar and sold a variety of goods.[24] Granadan figs, pomegranates, raisins, silks, sugar, and luxury glazed ceramics reached the tables of Europe via the trade ports of Flanders and Bruges. We know from tax documents that in 1350, forty Spanish ships arrived in Bruges with cargoes of raisins and figs.[25] Kermes (*qirmiz* in Arabic) was

another valuable product exported from Granada—in 1228 one hundred pounds of kermes was found on board a Spanish ship attacked by pirates off the coast of Sandwich in the south of England.[26] Made from the bodies of the *Kermes vermilio* insect that lives on Mediterranean oak trees, this red dye was valued for its fastness on silk and wool by the northern European textile industry, where it was used to dye luxury textiles such as the prized English wool known as *scarlatti*.

Much of the maritime trade with northern Europe was conducted by Genoese and Catalan-Aragonese merchants, who increasingly dominated the Mediterranean seas in the thirteenth century. Documentary records from Genoa show that ships would stop in Málaga on their way through the Straits of Gibraltar to Ceuta, Tunis, or Bugie in North Africa.[27] Genoese merchants had negotiated trade agreements with the Nasrids that allowed them to use Almería and Málaga for the export of dried fruits. Berber geographer Ibn Battuta (d. 1369) proclaimed, "Oh fig, you have sustained the life of Málaga, and because of you boats arrive to [this city]." Catalan-Aragonese merchants also acted in the region: in 1327, when a group of Tunisian traders wanted to trade with Granada, they travelled on a Catalan ship via Sardinia and Mallorca to Almería and Málaga.[28]

While Nasrid merchants did not direct the northern European trade routes, they were actively trading with North Africa, with the Marinids and Hafsids, as well as the Mamluks in Egypt. Grain and luxury ceramics were regularly traded by Nasrid merchants across the Straits of Gibraltar. The Nasrids produced luxury ceramics for export from Málaga and traded them with the merchants of Mamluk Egypt. The discovery of hundreds of sherds of Spanish lustreware ceramics in the rubbish pits at Fustat, near Cairo, point to the large scale of the luxury ceramic trade. Particularly interesting are the lustre sherds with the word "Málaga" written on their base in Arabic that were found on the pits at Fustat: evidence for the large-scale export of luxury ceramics from pottery workshops in this Nasrid port city.[29]

It was the dynamic and open nature of the Nasrid economy that allowed the Nasrid dynasty, and the city of Granada, to flourish in the fourteenth and fifteenth centuries. Their economy was one in which trade with

northern Europe and the Mediterranean was cultivated by both international and indigenous merchants.[30] Muslim and Christian traders moved across the frontiers of their lands, establishing trading consulates in ports across the Mediterranean. Even in times of war they continued to trade their goods through the Nasrid ports, thus enriching and maintaining the Nasrid coffers and thereby allowing the rulers to embark on building palaces with the scale and towering ambition of the Alhambra.[31]

Chapter Two:
The Partal and its Cupola:
A Captivating Space

The overwhelming objective of the Alhambra's elevation lies in its seeking to provide what may be called illusions, that is, impressions and effects which are different from the architectural or decorative means used to create them.
—Oleg Grabar, *The Alhambra*

The cupola was made for a building known today as the Partal, although one of the complications in the history of the Alhambra is that its individual buildings have been known by many different names over the centuries. The Partal has been called the Palacio del Partal, Torre de las Damas, Torre del Príncipe, Palacio del Pórtico, Torre de Ismael, Torre de las Odaliscas, Torre del Belvedere, Mirador de Buenavista, and the Casa Sánchez; none of these was likely to have been the original name by which it was known when it was built, but Partal has the longest history, as it occurs in documents from the sixteenth century referring to the gardens and pool area adjacent to the building.[32] It was built by Muhammad III (1257–1314) high above the city of Granada, on the Sabika Hill, where there had been a fortress since the eleventh century. If you stand below the Alhambra and look up at the palace from the city of Granada, it is immediately clear why the Nasrids chose this site (Figure 2.1). It is surrounded on three sides by an escarpment that was reinforced with a strong boundary wall dotted with towers. The Sierra Nevada mountain range to the southeast and the Sierra de Huétor and Sierra de la Alfaguara mountains to the northeast provide natural defences as well as crucial sources of fresh water in the Genil and Darro rivers (Figure 2.2). One of the first things the Nasrids did at the Alhambra was to provide it with its own fresh water that was independent from that which supplied the rest of Granada. The Royal Canal (*Acequia Real*) brought water to the

Alhambra from the river Darro, creating the distinct urban areas of Madinat Garnata (Granada) and Madinat al-Hamra (Alhambra). These natural defences not only protected the Nasrids from external threats, but also from the many powerful internal forces and rival Berber families within the Kingdom of Granada. Building a palace on the hill meant that you could keep your enemies close to hand, within sight in the city below, while remaining protected from them in your walled-off palace city with its towers and fortresses.

Fig. 2.1

View of the Alhambra, Granada.
Photo by Simon Lane.

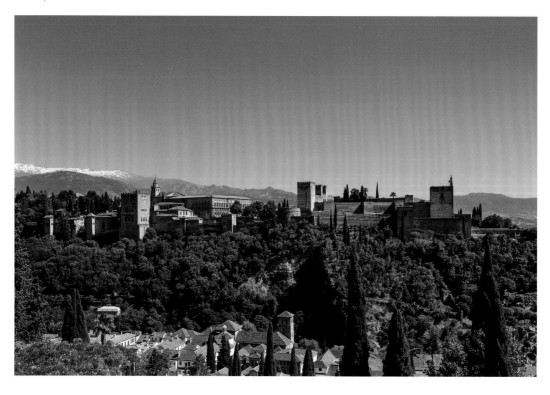

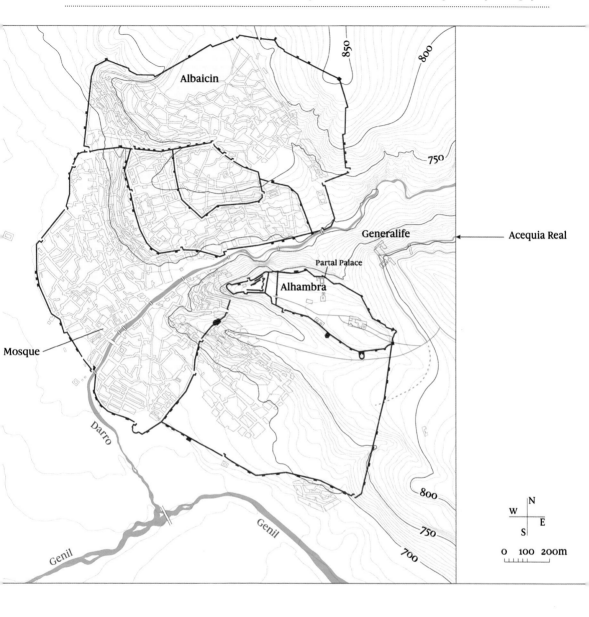

Fig. 2.2

Map of Granada showing the waterways and the Partal in the Alhambra in the 14th century.
Map by Matilde Grimaldi.

As we shall discover, the Partal was probably not built as a royal residence for the ruler. By the time Muhammad III came to the throne (r. 1302–9), he already had plenty of large residences to choose from. Under Muhammad I (1232–73) and Muhammad II (1273–1302), at least three royal residences had been built outside of the Alhambra walls: the Alcázar del Genil (built under the previous Almohad dynasty), the Cuarto Real de Santo Domingo (built in the second half of the thirteenth century),[33] and the Generalife palace. Meanwhile three royal palaces had been completed inside the Alhambra: the Abencerrajes, the Convent of San Francisco, and the Tendilla palace.[34] We know little about the layout of the Abencerrajes palace (which is no longer standing), or the Generalife, a pavilion that was altered substantially in the fourteenth century, but the Convent of San Francisco (now a hotel) and the Tendilla palace (no longer standing), situated high in the middle of the Alhambra plateau, were substantial buildings with internal courts and plenty of suitable spaces that would have been large, private, and secure enough for a ruler's residence (Figure 2.3).

Fig. 2.3

Plan of the Alhambra and the Generalife by Modesto Cendoya, 1908. Cyanotype, 49 x 62cm. APAG/ Colección de Planos/P-000225.

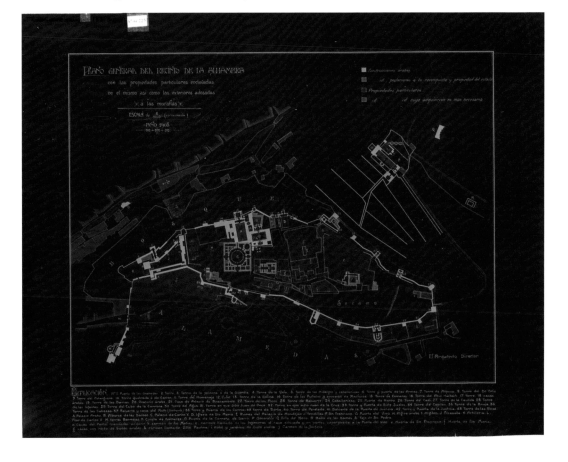

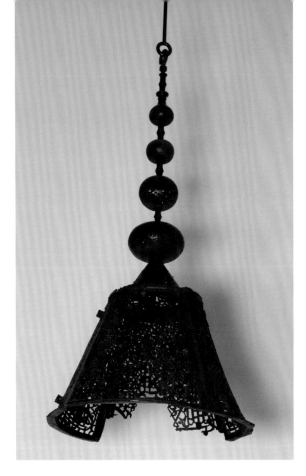

Fig. 2.4

**Mosque lamp from
the Alhambra
1305CE.** Bronze,
79cm (max. diam.)
x 176cm (h.).
Museo Arqueológico
Nacional, Madrid,
Inv. Nr.:50519.
Photo by Ángel
Martínez Levas.

When Muhammad III came to power in 1302, he embarked on an ambi-
tious building programme that expanded the reach of the palace of the
Alhambra towards the west escarpment.[35] An important part of this new
expansion was founding a new mosque, the Royal Mosque of the Alham-
bra, to the south of the Partal on the site where the church of Santa María
de la Alhambra is today. The mosque was a brick building with a foot-
print some 13.3 by 16 metres, with three naves separated by arches that
were supported by white marble and jasper columns, and a ceiling made
from carved and decorated wood. A bronze lamp is one of the only sur-
viving objects from the mosque (Figure 2.4). It has an inscription in Ara-
bic that dates the completion of the mosque to 1305; that is, in the middle
of Muhammad III's reign (1302–9).[36] Adjacent to the mosque, Muham-
mad III also built a public bath, the proceeds of which went towards the
upkeep of the mosque. He was probably also responsible for the insertion
of a new mirador (viewing place) in the Generalife court.[37]

The Partal was an important part of this expansion, built not as a resi-
dence but as a pavilion in the royal gardens that may have extended as

far as four hundred metres along the northern wall of the Alhambra, spreading down from the residential palaces of the Tendilla and the Convent of San Francisco. It was built directly on the northern walls of the Alhambra complex, between the steep hill that drops down to the river Darro and Granada city, and a large man-made pool that abuts the building directly to the south.

The Partal and its Mirador

The Partal is a long, double-height portico (16.8 m long x 3.3 m wide) and tower of rammed earth and baked-brick construction (Figure 2.5). The south facade of the portico comprises five arches supported by brick pillars—replaced by marble columns in the twentieth century— that open towards the south to a large pool of water immediately adjacent. The portico has a long carved wooden ceiling with its own cupola in the centre, which is smaller than the mirador cupola (Figure 2.6). A room projects to the north from the middle of this hall, forming a T-shaped ground plan (Figure 2.7). This room (5.9 m x 7.8 m) has nine windows set low in the walls on its three sides, from which you can see the city and the Generalife palace. At the western end of the portico, the entrance to a staircase that led up two flights to the tower has been sealed. This staircase is now reached through a new door from the south facade that was opened in the 1920s. The roof of the staircase

Figs. 2.5 and 2.6

The Partal Palace, Alhambra and the wooden ceiling and cupola in the lower portico. Photos by the author.

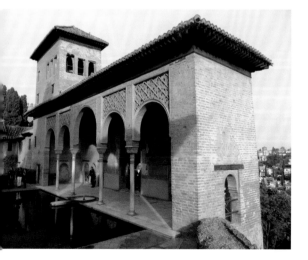
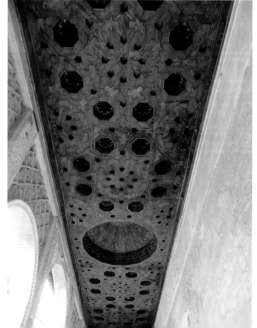

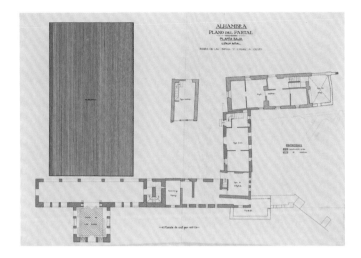

Fig. 2.7

Ground floor plan of the Partal drawn by Leopoldo Torres Balbás in June 1923. Pen on paper, 81 x 106cm. APAG/Colección de Planos/P-000629.

features arches decorated with some painted plasterwork that may date from the Nasrid period.

Inside the mirador tower are two square rooms and a niche. The first room, where the cupola was situated, is the larger of the two, at just under 12 square metres (Figure 2.8). This room has three windows on each of its three walls, towards the north, south, and east. It is separated from

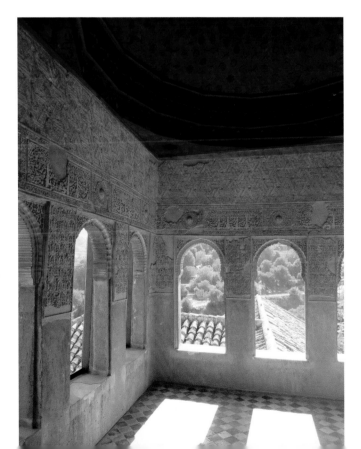

Fig. 2.8

Mirador in the Partal, with the replica cupola in place.
Photo by the author.

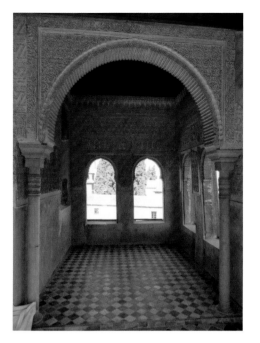

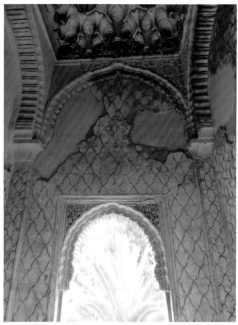

Fig. 2.9

View towards the smaller room in the mirador, showing
the modern columns that replaced the originals
in the 20th century. Photo by the author.

Fig. 2.10

Raised niche in the Partal mirador off the smaller room,
showing plasterwork and *muqarnas* ceiling.
Photo by the author.

the second smaller room to the west by a wide arch that was originally
supported by columns. This smaller room, measuring 5.9 square metres,
has two windows towards the north and two towards the west (Figure
2.9). The south side of this room is partly occupied by the encasement of
the staircase. To the southwest above the staircase there is a niche meas-
uring less than one square metre that fits between the rise of the stair-
case and the ceiling of this second room. The niche, large enough to fit
only one seated person and situated with its floor at waist height, has two
windows that look towards the south and the west (Figure 2.10).

These mirador spaces are some of the earliest and most exquisite inte-
riors of the Alhambra. Growing consecutively smaller, they play with
the viewer's experience of space, opening from a narrow and winding
staircase into a series of small but perfectly formed rooms, which are
as pierced with windows as they could possibly be, leading the viewer's
gaze from the jewel-like details of the interior to the hills of the nearby
Albaicín district, the distant plains, and hills around Granada, back to the
reflective water of the Partal pool, the gardens of the Alhambra, and up to
one of the earliest palaces of the Generalife. The viewer experiences this

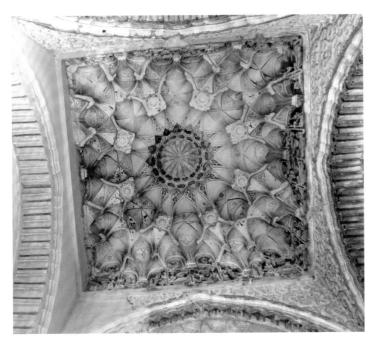

Fig. 2.11

Muqarnas ceiling of the niche in the Partal mirador.
Photo by the author.

mirador as both an enclosure in a private tower and as an opening to a world beyond, as a place from which the landscape could be experienced through smell and sound as well as framed and observed by sight.

Despite the small size of the mirador space, it manages to include many different decorative techniques and materials on its walls and ceilings. There would probably have been a carved and painted wooden ceiling in the second smaller room, although this ceiling has not survived. The smallest space in the mirador tower is the niche above the staircase, whose *muqarnas* (a series of carved arches) ceiling in carved and painted plaster is the oldest in the Alhambra (Figure 2.11). Echoing the cupola in the main space, this smaller plaster cupola radiates from a central sixteen-pointed star, through a ring of eight eight-pointed stars culminating in an epigraphic panel around the four sides of the niche wall, which bears an Arabic inscription in knotted Kufic calligraphy, all in carved and painted plaster.

The walls of all three spaces were covered with carved and moulded plasterwork that was brightly painted and possibly also gilded in places.

Fig. 2.12

Mirador in the Partal,
showing the plasterwork
on the walls of the
smaller room
Photo by the author.

Similar plaster panels to those in the Partal were found in the mirador
of the Generalife palace and demonstrate the colour scheme of red, blue,
green, and black that may have been originally used in the Partal. These
Generalife panels are important, because the attribution of the Partal to
the reign of Muhammad III is partly based on a comparison of its plaster
panels with the style and technique of contemporary plaster panels in
the Generalife.[38]

The plasterwork on the walls of the larger rooms in the mirador is sep-
arated into three horizontal registers, of which the two lower levels are
consistent across both larger and smaller mirador rooms (Figure 2.12).
The lowest level surrounds the windows, and would probably have sat
above a level of glazed and coloured ceramic tiles, of which none remain.
This plasterwork comprises a series of interlocking arches, within which
are knotted Kufic motifs. The arched windows are framed with panels
of decorative scrollwork. The second level of plasterwork is a horizontal
band of knotted Kufic inscriptions against a scrollwork background, in-
terspersed with round medallions. These are each framed with bands of
cursive inscriptions that surround the entire horizontal band. The knot-
ted Kufic inscriptions are contained within separate long rectangles with
rounded ends. The medallions are formed of a concave circle that pro-
trudes in the centre, framed by a circle with a scalloped edge, set within a
square frame.

The larger room in which the cupola was housed has a wide band with a motif that is rarely found in the Alhambra and is based on a six-pointed star whose arms extend beyond the limits of the central star to form geometric shapes in horizontals and diagonals (Figure 2.13). These three levels of different carved plasterwork are visible in the earliest visual record of the interior of the mirador, a sketch from 1833, in which the cupola can be seen alongside the three levels of plasterwork (see Figure 5.1). This provides crucial evidence that the remaining plasterwork predates changes made to the Partal in the later nineteenth century, suggesting that this plasterwork is largely original to the Nasrid period and not a later repair.

Fig. 2.13

Mirador in the Partal, with the replica cupola.
Photo by the author.

The inscriptions in stucco in the Partal, which have been published by José Miguel Puerta Vílchez, include poems composed by the court poet to Muhammad III, Ibn al-Jayyab (1274–1349). One of the earliest poetic verses, which is found on the ground floor in the portico above the windows, praises god for his generosity and mercy. A second salutes the building for its achievements and asks for protection of the Nasrid kingdom. Among the blessings on the walls of the mirador are the verses of an anonymous, devout popular poem, inscribed in the arch connecting the two rooms:

> Oh my certainty and my hope!
> In thee I trust, thou art my protection.
> For the sent Prophet's sake, bring my deeds to a happy conclusion.

The words "continuous happiness" and "good fortune" are repeatedly inscribed in Kufic script throughout.[39]

The lower walls would have been covered with glazed and coloured tilework, similar to other parts of the Alhambra, although only the undecorated plaster remains. The floor was probably tiled, although is now made of brick. The overall impression within the room today is of a vivid light that dances off the ceiling from reflections in the adjacent pool. In Nasrid times the impression must have also been of intense colour, before the bright hues that once covered the plasterwork, wooden ceiling, and glazed ceramic tiles faded or disappeared.

The Ceilings of the Alhambra

The art of creating awe-inspiring ceilings to impel the viewer to look up and think of God and the patron was one that was practiced to perfection in the medieval period. Across the world, religious and palatial buildings from the thirteenth and fourteenth centuries were capped with feats of engineering and craftsmanship that were made to amaze and enthral the viewer. The richly coloured, vaulted ceiling of the thirteenth-century Saint Chapelle royal chapel in Paris, and the brick structure of the domed ceiling of the early fourteenth-century mausoleum of Sultan Öljeitü at Sultaniya in present-day Iran, were two such celebrated ceilings created for the same purpose and effect as those of the Alhambra palace.

But there is a fundamental difference between the ceilings of the Alhambra and those of the Gothic chapel or Seljuk mausoleum. At Saint Chapelle, the viewer's eye follows the ribbed vaults that rise dramatically to the apex of the chapel, past the stained glass to the full height of the structure itself. The vaults are part of the visual language of the chapel that defines its dramatic structure, and it is this tension between glass and stone that is emphasized visually in the chapel's interior. At the Öljeitü mausoleum, the octagonal building is crowned with a double-shelled dome that is fifty-three metres high. It is the structure and sheer size of this enormous brick dome that is the focus of the surface decoration, a surface that was originally articulated in decorative brick and glazed ceramic tiles, both inside and out. The internal space is defined by the vast size of the dome and emphasized by the lack of buttresses, corner piers, or other obvious supporting devices below. The space created beneath the dome and the improbability of the dome's size and apparent lack of support are celebrated in this mausoleum. In both Paris and Sultaniya, the forces and structures of the buildings and the spaces created by them are celebrated through the visual language of their ceilings.

In contrast, the architects of the ceilings of the Alhambra palace were not interested in revealing the structure of the building or in spanning seemingly impossible heights or breadths. The carved ceilings of the Alhambra are not load bearing and their designs do not demonstrate where the stresses and weights of the building may lie. The Nasrids knew how to make such load-bearing ornamental ceilings, but this was not the point.[40] The palace's decorative ceilings were not made for practical purposes, such as holding back the rain or wind or providing shelter from the sun, nor were they made to demonstrate the ability of the architect to build bigger or higher than others before. Instead, these Nasrid ceilings are suspended sculptures, extraordinary feats of craftsmanship in wood or plaster, hung beneath a hidden, functional roof. Their role was not to draw attention to the material world of loads and supports, but rather to dissolve that form, to distract from material concerns and structure and to draw the viewer into contemplation of another world (Figure 2.14).

The idea that the viewing of the palace was an aesthetic experience that should bewilder, enthral, and captivate the viewer is written into the

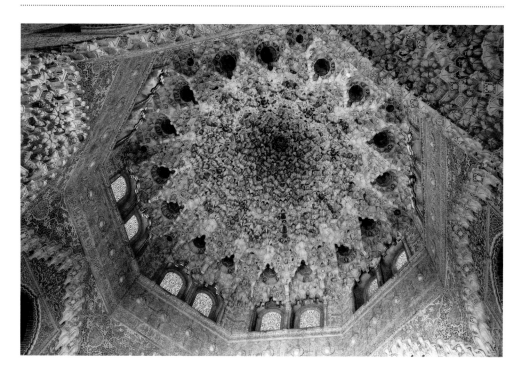

Fig. 2.14

Muqarnas
plasterwork ceiling
in the Hall of
the Two Sisters,
Alhambra, late
14th century.
Photo by Simon
Lane.

plaster of the very walls of the Alhambra. Poetic verses written by court poets who worked in the close circle of the Nasrid rulers are inscribed in carved plasterwork on the walls of the palace buildings. Much of this poetry describes the experience of being in the rooms of the Alhambra. The inscription in the walls of the Partal, from a poem by the court poet Ibn al-Jayyab, describes the pleasure and harmony of spending days and nights in this space:

> Salutations, noble dwelling, for the fortune and joy experienced, for the glory and hope extended.
> Your builder achieved his desire in you and good news joined in harmony with his deepest desires.
> His night in you is pleasing, all dawn, and his day, coming after happiness, is jubilant.[41]

The Alhambra's decorative ceilings achieved this very particular aesthetic experience through the use of coherent and unified decorative schemes. The geometry of these ceilings was minutely planned and their carved motifs and painted colours were designed to act together with those of the wall decorations in carved and moulded plaster and glazed and cut

tiles. From a single unit—based on a sixteen-sided star in the case of the Partal cupola—the complex geometrical forms were expanded across the surface by the multiplication of these units and their polylobed forms. The viewer, looking up at the cupola and surrounded by carved plasterwork and glazed tiles, has no single primary image on which to focus. Instead, the act of viewing these ceilings was part of an all-encompassing experience of colour, line, and depth that was enhanced by the manipulated play of light on the walls from the sun's reflection off the water pools, the sound of running water from the fountains nearby, the scents from the surrounding gardens, and the far-reaching views of the city and mountains beyond.

In the tower of the Qalahurra, a small Nasrid tower in the Alhambra that is slightly later than the Partal palace, four poems (*qasidas*) composed by Ibn al-Jayyab fill the corners of the room. The poems describe this all-encompassing sensory experience of being in a Nasrid palace room crowned with a carved ceiling. In the verses, which frame Koranic inscriptions on the walls, the poet describes the craftsmanship of the floors, walls, and ceilings, emphasizing the harmony of their individual elements.

> It is a palace whose splendour is shared by a ceiling, floor and four rooms.
> Marvellous its stucco and tiles, but even more prodigious the carpentry of its ceiling.
> After being assembled it was lifted precisely to its lofty position.[42]

Such aesthetic harmony is difficult to imagine when you stand in the mirador of the Partal with its replica ceiling, empty rooms, and colourless walls, or when you stand beneath the cupola in Berlin today. However, this idea of a coherent space in which poetry and architecture, carved and painted plasterwork and woodwork, and glazed ceramic tiles, as well as smells, sounds, and light were of equal importance, was central to the way the cupola was experienced when it was first made and to its meaning in the Nasrid period.

The Cupola

The cupola measures 3.5 by 3.5 metres, has a height of 1.9 metres from its
base to its top, and weighs 523 kilograms.[43] It is made from hundreds of
separate pieces of intricately carved and painted wood that were fitted to-
gether using carved joints, thin nails, and interlacing strapwork to form a
domed structure. The dome was formed from sixteen trapezoidal panels
onto which the individual wooden polygons and strapwork were affixed.
These panels rest on two horizontal friezes, which are decorated with Ar-
abic inscriptions, *muqarnas*, and vegetal motifs.

This domed structure rested on a four-sided wooden frame that was
positioned on the top of the decorative walls of the mirador room. The
reverse side of the cupola, invisible to the viewer below, is revealed in this
image as undecorated wooden panels (Figure 2.15). The cupola was com-
pletely independent of the four-sided roof of the mirador tower. It func-
tioned as a separate decorative ceiling, a kind of suspended sculpture,
whose purpose was to inspire awe in the viewer and to crown the ceiling
of the royal tower room used by members of the Nasrid royal family.

The overall decorative design of the cupola springs from a central sixteen-sided star shape in the centre of the ceiling. From this central star, the sixteen separate trapezoidal-shaped panels are arranged in a conical format. Each panel is decorated with a succession of three horizontal bands of eight-pointed stars, on each of which is carved the Nasrid motto in a cursive script, set within strapwork that encloses polygonal pieces with abstract floral motifs. The overall effect of this is to create a dome of three concentric rings of sixteen stars, a total of forty-eight stars plus the central star form, that hang low in the room over the head of the viewer (Figure 2.16).

The motif of an eight- or sixteen-pointed star that expands in polygons to form a multi-sided form was a popular motif that was found across the western Islamic lands in the fourteenth century, on media ranging from carved ceilings to textiles, plaster, wood, and ceramic. In a Nasrid Qur'an painted frontispiece dating from 1305, the geometric motif evolves from

Fig. 2.16

The Alhambra cupola, Berlin.
Photo by Johannes Kramer.

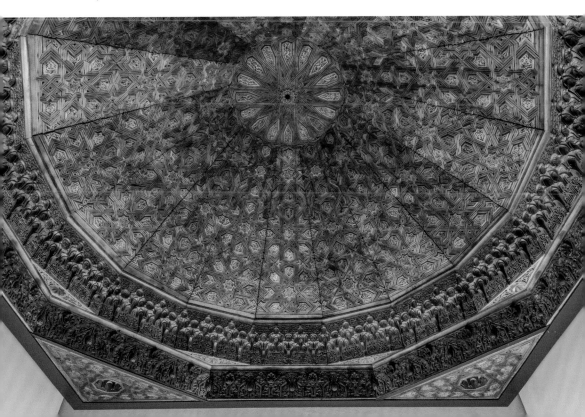

the central eight-pointed star repeated numerous times and is painted in gold, blue, red, and green pigments.[44] Luxury silks and other textiles in similar designs would have been used in the Partal to complement in colour and motif the wall and ceiling decorations.

This evocation of the stars overhead was crucial to how the cupola was meant to be experienced. The cupola was part of an exquisite and carefully planned room in a formal garden, a place with views across the palace, garden, city, and hills that, as the poem by Ibn al-Jayyab suggests, was meant to be enjoyed by day and by night. With its details painted in reds, blues, and golds, the stars of the cupola would have shimmered and glittered in the sunlight that was reflected from the pool of water below, and would have glowed warm in the lamp light of the night.[45]

The upper section of the cupola rests on a frieze of *muqarnas*, made in sixteen sections that correspond to the sixteen trapezoidal sections they support. The *muqarnas* arches spring from miniature columns, each of which frames a carved inscription of the Nasrid motto in a cursive Arabic script that reads "*Wa lā gāliba illā-llāh*" (there is no victor but God). Used for the first time at the battle of Alarcos in 1195, this motto was adopted by Muhammad I and appeared on the earliest Nasrid coins, as well as in the plasterwork of the early Nasrid Generalife palace that predates the Partal. It is a motto that would appear throughout the Alhambra's palace interiors in plasterwork and wood as well as in textiles and ceramics.

The sixteen-sided form transitions to an eight-sided form through the insertion of eight triangular sections set horizontally. This eight-sided form sits on eight vertical panels that support the rest of the cupola. These panels are carved with sculptural motifs, filled with deeply relief-carved palmettes and pine cones that are themselves carved with decorative details (Figure 2.17). Each of the eight panels contains four relief palmettes and four pinecones, a total of thirty-two pinecones and thirty-two palmettes that form the outer edge of the sixteen-pointed central star. Each pine cone, its scales individually carved, sits at the centre of a carved inscription of the Arabic word *yumn*, meaning "good fortune," written in a mirrored Kufic script. These are framed by a polylobed arch and vegetal motifs. The palmettes sit tall on long stems marking the

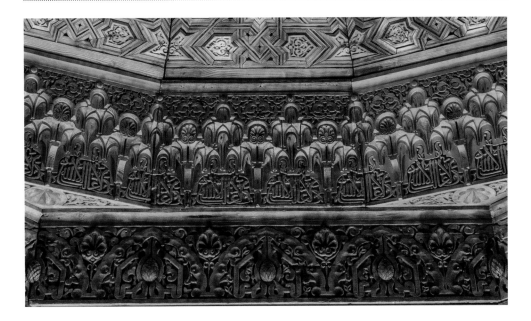

frame of each polylobed arch. The cupola transitions to the four-sided shape of the mirador room in which it sits through four triangular corner panels arranged horizontally. Each corner panel is embellished with carved polygons and a small recessed *muqarnas* cupola.

A Berber Style

While the trapezoidal panels are extraordinary for their shallow-relief evocation of the stars, the lower horizontal panels demonstrate sculptural depth and three-dimensionality. The pine cones and palmettes are carved in relief and their details, such as the individual pine cone scales, are delicately articulated. This sculptural quality of wood and plaster was one that had already been explored in the carved wood and plasterwork ceilings of the Berber Almoravid and Almohad dynasties. In Marrakesh for example, the twelfth-century Almoravid ruler Ali b. Yusuf (1106–43) built a domed kiosk, known as the Qubbat al-Barudiyyin (1117), with complex internal and external domes and *muqarnas* stucco vaulting. The plasterwork ceiling of the Qubbat al-Barudiyyin is carved with a series of eight plasterwork palmettes that protrude and frame polylobed arches in a similarly sculptural fashion to those of the Partal cupola (Figure 2.18).

Very similar motifs can be found on a series of three carved and painted wooden panels that were probably made in Fez at around the same time as the Partal cupola. The Fez panels include polylobed arches with sculp-

Fig. 2.17

Detail of the Alhambra cupola in Berlin.
Photo by Johannes Kramer.

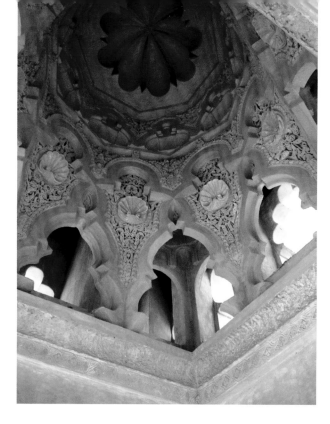

Fig. 2.18

Plasterwork ceiling of the Qubbat al-Barudiyyin, Marrakesh, 12th century.
Photo: Creative Commons.

tural palmettes and pine cones as well as mirrored Kufic inscriptions of the Arabic word *yumn*, a motif which is found in the same mirrored format on the Partal cupola (Figure 2.19). The close similarities with the Partal cupola in both sculptural approach and in specific motifs suggest that the carpenters in both Fez and Granada were working within a tradition of carpentry and building that was common in Nasrid and Marinid spheres of influence, with motifs and decorative schemes that had been popular in the Maghreb and al-Andalus.

Many of the motifs that were carved in the Partal cupola, such as the polylobed arches that frame the palmettes and pine cones, also formed important parts of the artistic repertoire of the Berber dynasties of the

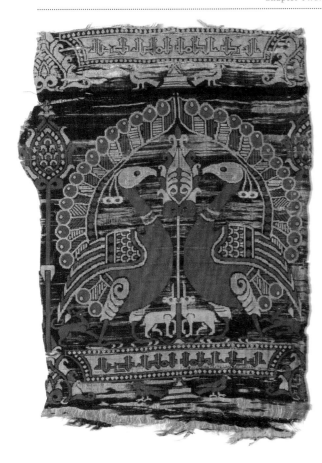

Fig. 2.20

Silk fragment from al-Andalus, early 12th century. The Arabic inscription reads 'perfect blessing'. V&A Museum, London, Inv. Nr.:828-1894. 34 x 24cm. Image © Victoria & Albert Museum.

Almohads and Almoravids that predated Nasrid rule in Granada. They were used, for example, on an Almoravid (early twelfth century) textile that was preserved as a chasuble in the basilica of Saint Sernin in Tou-louse (Figure 2.20). On this textile the "arches" are formed from the fan of a pair of peacocks' tails that are interspersed with pine cone motifs and palmettes; on the Partal cupola, the equivalent arch frames the inscription in the lower carved panels.

Fig. 2.19

Carved and painted wooden panels from Morocco, probably Fez, 14th century. Metropolitan Museum of Art, New York, Inv.Nr.: 1985.241. 48.3cm (h) x 307.3cm (w) x 7cm (d). Photo: public domain. There is a matching panel in the al-Sabah collection in Kuwait (Dar al-Athar al-Islamiyya, al-Sabah Collection, Kuwait City, Kuwait (Inv.Nr.: LNS 62W).)

Muqarnas

The horizontal friezes and corner niches of the cupola use a technique called *muqarnas* that was well established in the Islamicate world by the early thirteenth century when the Partal was built.[46] *Muqarnas*, from the Arabic *qarnasa* or "subdivisions," describes the use of repeated and successive cellular structures arranged in rows or patterns. Its effect can resemble that of honeycomb or stalactites, terms that have often been used to describe *muqarnas* in English.[47] The earliest use of *muqarnas* seems to have been in North Africa and Iraq in the eleventh century, with surviving examples in the ceilings of shrines and mosques. The dome resting on *muqarnas* squinches at the Great Mosque of Tlemcen (1136) in present-day Algeria and the plaster *muqarnas* vault with star motifs at the al-Qarawiyyin Mosque (1132) in Fez attest to the twelfth-century tradition of *muqarnas* ceilings in Berber North Africa.[48] The painted wooden *muqarnas* of the Cappella Palatina ceiling in Palermo from the 1130s demonstrate its use in Islamicate spheres across the Mediterranean.

In the Partal, the wooden cupola includes a mix of *muqarnas* elements with trapezoidal panels, carved polygons, and strapwork.[49] Alongside the Partal cupola, the mirador also includes the plaster *muqarnas* vault made situated in the niche over the staircase (Figure 2.11). This exquisite ceiling is the earliest example of such plaster *muqarnas* in the Alhambra, made at the same time as the wooden Partal cupola under Muhammad III and seemingly drawing from the tradition for such plaster vaults established in the ceilings of Almoravid North Africa noted above. In subsequent decades, such entirely plaster *muqarnas* ceilings would be built to glorious effect in the Alhambra on a much grander scale in the magnificent *muqarnas* ceilings of the Hall of the Two Sisters and the Abencerrajes Hall. But this early use of full plaster *muqarnas* alongside wood *muqarnas* in one coherent space at the Partal demonstrates an early expertise and experimentation with materials and designs among artisans working in the early Nasrid workshops.

The identity of these artisans is not known, but cosmopolitan Granada attracted immigrants from across al-Andalus and the Maghreb, and it is likely that they brought with them skills and techniques familiar from across the western Mediterranean. Granada was the centre of a building

boom in the fourteenth century, with successive palaces in the Alhambra and beyond demanding the skills of many craftsmen who may have worked in centres such as Seville or Córdoba, which had recently been conquered by the forces of Castile. The Muslim artisans in these conquered towns were initially encouraged to stay on by the new rulers, particularly in those centres that surrendered, so often the craftsmen need not leave; however, the attraction of Granada as a wealthy, active Muslim centre would have proved strong. This would have proved equally true for artisans from North Africa, from Fez in particular, with which Granada had developed close political ties.

Materials: Wood

A detailed sampling and analysis of all the wood used in the cupola has not been carried out to date, but selected samples were examined in the 1960s and again in 1978, revealing that at least five different types of wood were used in its construction: cedar, pine, maple, poplar, and fir.[50] Analysis of the wood types revealed that cedar (*Cedrus atlantica*) was used for the carved polygons that fitted on the trapezoidal panels, and for the lower inscription frieze panel. Mediterranean pine (*Pinus nigra*) was used for the *muqarnas* and edging pieces. Maple (*Acer* sp.) was used for the carved pine cones. The undecorated framing elements of the Kufic inscription panel were identified as poplar (*Populus* sp.) and Aleppo or Maritime pine (*Pinus halepensis*, *Pinus pinaster*).[51] Fir (*Abies* spp.) was used for parts of the inscription panels and for the undecorated support sections of the trapezoidal panels. Fir was also used in later additions for repairs carried out in Berlin in the early twentieth century. Apart from the maple and fir, these findings are consistent with the wood used in other Nasrid ceilings.[52]

This use of several different types of wood on the one ceiling is not unusual.[53] Tests on the wood used in the ceiling of the Cuarto Real de Santo Domingo, a thirteenth-century Nasrid palace in Granada, found four different wood types: Scots or Corsican pine (*Pinus sylvestris or Pinus nigra* subsp. *larico*), Maritime Pine (*Pinus pinaster*), Portuguese oak (*Quercus faginea*), and Atlas cedar (*Cedrus atlantica*). The Cuarto Real cupola, like that of the Partal, was composed of prefabricated panels of wood in which each section used a particular type of wood depending on its properties of resistance and hardness.[54]

The carpenters who made the cupola would have looked to a variety of sources for their different woods. Some of those used in the Partal cupola were available in the forested area surrounding Granada. Maritime pine was available in the Sierras Herana and Huétor, near to Granada, while Scots pine was found in the Sierra Nevada. The source of the fir (probably *Abies pinsapo* or *Abies maroccana*) was possibly from the Sierra de las Nieves region near Ronda (*Abies pinsapo*) or from the Rif in North Africa (*Abies maroccana*).[55] Documents in the Alhambra archive tell us that in the sixteenth century, pine wood was brought from the Sierra de Segura (to the northeast of Granada) to carry out repairs to the building, indicating that local sources were known and employed for building work at that time.[56]

The use of maple wood in the pine cone carvings is unusual as it was not found in the samples taken from the rest of the Alhambra.[57] The tree from which it comes, *Acer granatensis*, is native to Iberia, its name indicating its preferred habitat in the region of Granada, although it is also found in the Rif area of northern Morocco. Its wood is pale or reddish in colour, it can be highly polished, and sustains detailed carving.[58]

Other wood types such as the cedar used in the cupola were probably imported into Granada from North Africa. Atlas cedar is a native of the Rif and Atlas mountain regions of Morocco, prized as a lightweight, robust, and durable wood that resists decay and can hold finely carved detail. It was used in the thirteenth-century ceilings of North Africa and al-Andalus, including in the Sidi bel Hasan Mosque in Tlemcen (1296), as well as for the Cuarto Real de Santo Domingo cupola in Granada.[59] In addition to the Partal cupola, cedar was used in the Alhambra in the carved wooden ceiling of the prestigious Throne Hall of the Comares palace (c. 1350).[60] However, cedar seems to have become scarce after the mid-fourteenth century, as it was not found among the eighty-one samples analysed by López Pertíñez, most of which date from the later part of the Nasrid period (after 1360).[61]

Cedar had long been prized as a wood that was particularly valued for detailed carving. Atlas cedar was one of the principal wood types that was used in the twelfth-century carved and inlaid wooden *minbar* (pulpit) for the Kutubiyya Mosque in Marrakesh. This wooden masterpiece was

made in Córdoba for the Almoravid ruler Ali b. Yusuf, who brought it to Marrakesh for his congregational mosque. Its many materials included cedar that was probably imported from North Africa to Córdoba, before the finished object was sent back to Marrakesh, possibly as part of a group of precious objects that were brought from Córdoba to Marrakesh by the Almoravids ruler.[62] The sourcing of raw materials from abroad was a key aspect in the establishment of intrinsic value and prestige in luxury craftsmanship, exemplified by the importation and carving of ivory from Africa for objects within the royal court throughout the Muslim period in al-Andalus. The use of cedar in key parts of the decorative cupolas of the Alhambra may have signalled their high value as well as the wide networks of the Nasrid artisans. Furthermore, the intensity of building activities at the Alhambra in the fourteenth century attracted skilled artisans to the city, who would have taken advantage of established trading networks to source woods such as cedar from North Africa.

Documentary as well as material evidence suggests that wood was a valued and traded resource in al-Andalus and the Maghreb in the Nasrid period. While the relatively small quantities needed for the carved pieces of the cupolas would scarcely warrant notice in the archives, evidence for the movement of large quantities of wood for the shipbuilding industry survives in archival documents, including in the Archive of the Crown of Aragon. In 1344 for example, a Nasrid boat arrived in Almería from the port of Badis (now Vélez de la Gomera) in Morocco with a considerable load of wood (320 *fustes* and 230 *remos*, referring to different lengths of wood), probably destined for the ship-making industry.[63] In his autobiographical work from the sixteenth century, Leo Africanus noted that good wood for shipbuilding was available from the mountains around Badis (on the northeastern coast of Morocco), and that it was transported from there to diverse places.[64]

Materials: Nails

The components of the cupola were held together with butt-joints and fine hand-forged iron nails. The uppermost, central panel, a sixteen-sided star-shaped piece, acted as a kind of keystone in an arch, drawing all the elements together into tight formation, as the chamfered edges of the angled pieces allowed them to form tight joints. The carved polygonal

decorative pieces of the trapezoidal panels were fixed onto supportive back panels with fine nails. The carved friezes and *muqarnas* sections were also supported by a structural substrate. The pinecones and palmettes were attached separately, while the *muqarnas* comprised delicately constructed curved elements that were then nailed together. The panels and the mouldings were then attached onto a backing substructure using nails that were inserted carefully so as to remain almost invisible: hiding in the decorative moulding grooves, for example.

Two types of nails hold the parts of the cupola in place today. The smaller finer nails with a T-shaped head belong to the original Nasrid construction, while larger fatter nails with a circular head, which are visible from ground level, were added at a later stage, possibly even added in the multiple moves of the cupola in the twentieth century. The nails used in the Nasrid period were made of tinned iron; that is, iron dipped in tin to prevent oxidation and staining of the wood. The tin covered the stem and sometimes also the head of the nails.[65]

These T-shaped nails (known as *clavos "de muleta"* or "crutch" nails, as the union of head and stem is gradual rather than sharply angled) have a flattened, widened head that is rectangular in cross-section (Figure 2.21). They were used to secure the decorative pieces into place against the panels of the ceiling. Their flat profile means they could be inserted into the decorative groove of the mouldings along the grain of the wood without splitting it; indeed, they are practically invisible (Figure 2.22). They were also used to fix the projecting top pieces of the *muqarnas* areas to the panels behind, fixing the whole *muqarnas* in place.

Many of the nails are more obvious today than they were intended to be by the Nasrid craftsmen, having grown loose and therefore more visible over time with the repeated dismantling of the cupola since the 1890s. In other cases, the nails would have originally been hidden under paint, which is no longer there, so they now stand out more than they would have. In some instances, the nails are in very central places in the decoration, such as in the middle of an inscription: these would not have been inserted by Nasrid craftsmen but are more likely to be a later addition or restoration.

Fig. 2.21
Nasrid iron nails undergoing repair in the
conservation studio at the Alhambra, Granada.
Photo by the author.

Fig. 2.22
Detail of the Alhambra cupola in Berlin with the
original nails visible in the grooves.
Photo by the author.

Colour

The cupola in Berlin today retains scarcely any of its once-bright paint covering. Successive cleaning and the effects of age have removed most of the pigmentation, although traces remain on some recessed surfaces (Figure 2.23). Close inspection of the surface without magnification reveals some red, blue, black, and white paint; colours similar to those that are still bright in the surviving Nasrid architectural glazed ceramics as well as in some of the plasterwork and contemporary textiles, versions of which would have decorated the Alhambra interiors.[66]

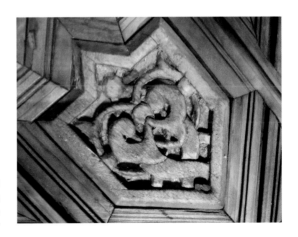

Fig. 2.23
Detail of the Alhambra cupola in Berlin
with the original colour visible in the recess.
Photo by the author.

In 1992 an analysis of a selection of paint pigments that remained on the cupola was carried out. It identified these as azurite (blue), gypsum (white), and minium (red).[67] While a detailed report of this analysis is not available, these findings are consistent with pigments that were used on other painted ceilings of the Alhambra as well as on the plasterwork of the houses adjoining the Partal.[68] Other pigments that may have been used on the cupola include the rarer and more expensive pigments of cinnabar (red), lapis lazuli (blue), and gold, all of which were identified in detailed analyses of later Nasrid woodwork.[69]

These pigments were applied on top of a preparatory layer. In some cases this was an animal-based glue, but a detailed analysis of a selection of early fourteenth-century Nasrid polychrome carpentry from the Alhambra revealed that minium, based on red lead, was used as a dark ground layer for the areas decorated with geometric and vegetal motifs.[70] This minium, which was among the pigments found on the Partal cupola, may have also acted as a protective coat against the insect xylophages, and was known as a primer for carved wood at the time. This was then covered by the decorative pigments, according to the artist's needs, that were separated by thin layers of oil.[71]

Close examination of the cupola without magnification showed that there are traces of a painted white beading motif arranged as a framing element throughout, in particular in the areas that framed the polygonal and *muqarnas* sections. Lead white was used as a white pigment, while the black that is visible in the grooves of the wood strapwork that frames the polygons was not analysed, but is probably carbon black.[72] There are some faint remains of this motif used on the cupola, but a comparison with pieces from the lower cupola in the Partal portico showing similar beaded motifs framing the central motifs suggests that this was used across the ceilings (Figure 2.24). This beading frame motif is interesting as it was common in wooden and plaster painted ceilings of the time; for example, in the twelfth-century wooden painted ceilings of the Cappella Palatina in Palermo.

The red and blue colours remain on the lower relief-carved areas of the cupola. The higher relief zones have very few traces of paint remaining,

Fig. 2.24

Fragments of decorated wood
from the restoration of the lower
cupola in the Partal portico, 14th
century, with traces of white
beading, black and red colours.
Photo by the author.

and the inscriptions in particular show no visible traces. It may be that these areas of the cupola were painted with colours that were more susceptible to rubbing away, or possibly these inscriptions, which contained the Nasrid motto, were highlighted with metallic foil. Analysis of a section of a plaster panel that belonged to the entrance to the Partal, and is now in the Victoria and Albert Museum collection (V&A Museum number 360-1901), has revealed traces of metallic highlighting on the inscriptions. A study by the V&A revealed that the gypsum plaster was covered with a white priming layer, on which traces of pigment were discovered, including red (vermillion, cinnabar) and blue (azurite).[73] Traces of metallic foil were identified on the cursive inscriptions, having been applied to the gypsum with transparent glue. The black lines in the strapwork on the edges of the panel were identified as carbon black.

The metallic foil was a tin leaf that was used as a bright pigment, perhaps to imitate silver, or to imitate gold leaf when covered with yellow paint or varnished, a practice known as *corladura*, which was common in sixteenth-century restorations of the palace.[74] However, this use of metallic foil may also have been part of the original Nasrid decorative scheme. Analysis of samples from wooden ceiling pieces from the Alhambra dating from the mid-fourteenth century revealed that layers of tin foil applied over a base of calcium sulphate (e.g., gypsum) were used to highlight areas decorated with inscriptions.[75] This tin layer may have been varnished to take on the appearance of gold, or left as tin colour. The practice of mixing powdered tin into paint pigments was also identified

in this analysis. This would have been used to add luminosity to the paint pigments, in particular to the dark red minium.

Early descriptions of the palace interiors further support the use of metallic colours on the ceilings and plasterwork. Hieronymus (Jerónimo) Münzer (d. 1508), a scholar from Nuremberg who wrote a first-hand account of his visit to the Alhambra in 1494, described the ceilings of "gold, lapis lazuli, marble, and cypress" that he saw there.[76] Ibn al-Khatib, who wrote about the Alhambra palace at the time of the celebration of *mawlid* in 1362, described how the inscriptions in plaster on the Alhambra walls were covered with layers of fine gold and surrounded by ground lapis lazuli.[77] The Partal cupola has not to date been subjected to detailed analysis that might reveal evidence of this kind of gilding or tin work on its upper relief carving, if it survives, but given the presence of tin on the contemporary plasterwork and on epigraphic motifs in near-contemporary palace woodwork, it is highly likely that the inscriptions on the ceiling shined bright with gold or silver among the painted colours of the rest of the cupola.

Traces of Artisans

Remarkably, we know more about the identities of those who built the tenth-century palace city of Madinat al-Zahra in Córdoba than we do about those architects and artisans who were responsible for building the Alhambra. The identities of the chief architect and chief mason at Madinat al-Zahra were preserved in the historical accounts, while stone masons' names were preserved in their inscriptions on the bases and capitals of columns throughout the site.[78] In contrast, the architects, builders, carpenters, and artisans who built the Alhambra remain anonymous today.

The carpenters who made the cupola may have left few signatures, but traces of their methods remain on pieces of various cupolas in the Alhambra. In order to plan and produce the complex geometrical forms of cupolas such as that in the Partal, they worked with a system of marks that correlated a particular piece (such as a polylobed element) with where it should fit in the final whole. On the reverse of the polylobed elements they scratched a simple symbol of spirals, lines, or crosses, which

identified its final position in the trapezoidal panel (Figure 2.25). These would correspond to similar marks on a plan that would have accompanied the design of the cupola, enabling them to fit the final carved and painted pieces into the trapezoidal panels before mounting. These traces of the design and construction process left by individual carpenters help us to reconstruct a workshop context within which multiple carpenters were working to a written design.

The cupola has been dismantled and reassembled at least five times since it was first removed from the Alhambra in 1891.[79] The repeated dismantling of a structure made of many separate pieces of wood, has led to inevitable changes in how the cupola fits together. There is some structure missing on the longitudinal sides of each of the trapezoidal panels at the points where they meet each other. The photographs of the cupola in Gwinner's house in Berlin show that the damage had already been done by this stage. The trapezoidal panels were cut in order to dismantle the structure and to enable the cupola to fit into a lower ceiling structure than that for which it was made, probably in one of Gwinner's houses. The lack of these sections, while only millimetres wide, slightly disturbs the overall geometric coherence of the cupola today.

Fig. 2.25
Reverse of a carved and painted wooden section from one of the 14th century ceilings undergoing conservation in the Alhambra, showing the carpenter's mark as a scratched swirl.
Photo by the author.

The architects of the Partal and of its cupola worked to achieve a particular aesthetic and sensory experience in its design. Stand in the mirador today and you feel the breeze on your face, smell the flowering plants from the Generalife and gardens, and hear the trickle of water from the pool and the sound of birdsong and people talking below. This was achieved through the combination of materials, techniques, motifs, and design elements adopted from existing buildings and previous dynasties, in particular the Almoravids, together with a new interpretation of a palace pavilion that linked, for the first time, the inward-looking palaces of the Alhambra with the city below. Using materials chosen and imported for specific parts of the cupola, the carpenters drew on their networks across North Africa and al-Andalus to obtain the specific materials required. The bright colours in which the cupola was painted would have complemented the similarly painted plasterwork and the glazed and cut tiles that covered the walls: colours that would have made the visual impact of the mirador space one of rich intensity, entirely coherent with the rest of the pavilion. As Ibn al-Jayyab described:

> A fortress it appears yet inside it shelters a brilliant palace of glowing radiance.
> It boasts of excellent work of proportional odd and even symmetry.
> The fabric of the tiles on its floors and walls is like marvellous brocade.[80]

As the following chapter will reveal, to understand how this carefully constructed cupola and its mirador functioned for the people who commissioned and used it, it is important to consider its relationship with its immediate surroundings—those of the Alhambra gardens and the city of Granada—and the objects that accompanied it, to reveal the nature of Muhammad III's patronage in the early fourteenth century.

Chapter Three:
A Royal Pavilion:
1300–1492

I declare that among the loveliest things we can see are the reflections of shin-ing stars, candles, and lamps on the surface of pure, calm waters in streams, rivers, channels and inlets.
—Ḥāzim al-Qarṭājannī, *Minhāj al-bulaghā' wa-sirāj al-udabā'* or *The Path of the Eloquent and the Lamp of the Educated*

In order to situate the Partal and its cupola within the early fourteenth century and to understand how this freestanding pavilion was conceived and, crucially, what might have been its function, it is important to ex-amine the building in its own immediate context. The ambitious devel-opment of the Alhambra in the century after the Partal was constructed included the building of the celebrated palaces of the Court of the Lions and the Comares, which came to overshadow the rest of the Alhambra complex in fame to the extent that today they epitomize what is consid-ered a typical Alhambra palace: an enclosed courtyard structure with columns and full *muqarnas* ceilings. Subsequently, by the time the Partal began to be studied seriously as part of the Alhambra complex of palaces in the early nineteenth century, the building was no longer considered by many as a structure in its own right, but as a stub, as all that remained of what must have once been a larger, enclosed palace similar to those courtyard palaces of the Comares or the Generalife.[81] Owen Jones in 1846 suggested that the Partal was once part of a courtyard palace that was attached to the royal palace buildings to the west.[82] In this theory, repeated in much of the popular literature on the Alhambra, the Partal was once the northern wing of an enclosed courtyard around the large Partal pool, with a similar layout to that of the later courtyard palaces of the Alhambra.[83]

However, there is no archaeological or documentary evidence for these "missing" palace structures in the Partal.[84] Excavations of the site by Leopoldo Torres Balbás in the 1920s revealed several ambiguous structures on a higher terrace to the south of the pool, which may have been related buildings, but may equally be the remains of houses built in subsequent centuries.[85] Nor is there evidence of buildings around the Partal pool in the earliest descriptions and images of the Alhambra. In a plan of the Alhambra from 1767,[86] which is remarkably detailed in its drawing of ruins as well as standing buildings, there is no trace of such buildings around the Partal pool.[87]

This lack of evidence of any further structures means we must consider the possibility that the Partal was a complete structure in its own right.[88] There is plenty of historic and physical evidence to support the idea that it was built as a freestanding pavilion set within the new formal gardens of the residential palaces, in the tradition of such pavilions in those of the western Mediterranean. The near contemporary palace of the Cuarto Real de Santo Domingo, just outside of the Alhambra in Granada, was described as such a pavilion in a garden, intended for temporary use, with its richly decorated series of rooms used as places of rest and pleasure in a series of formal gardens.[89]

It is important therefore to consider the existing structure of the Partal in its own right, and crucially, to analyse the importance of the landscape and surrounding elements to its function and meaning. The roles of both water and light were integral to how the Partal worked, how it was viewed, and how people would have interacted with the building both in the past and today, and it is through a close examination of these elements that we can form an idea of how the building was conceived and how it functioned.

Water

The large rectangular water pool that measures 25.3 metres long by 13.6 metres wide, reaches south from the building, and is almost as wide as the facade of the Partal portico (15.5 m). The pool is wider and closer to the building facade than the other pools of the other Alhambra palaces, producing the extraordinary illusion of a palace standing on water when seen

from the southern side of the pool: the side from which the building is usually approached (Figure 3.1). The columns (which were originally brick pillars) seem to rise from the water, while the entire facade is reflected in the pool. The water surface is also close enough to the building to reflect the sun and illuminate the interior, where sunlight dances into the darkest corners, particularly onto the carved cupola in the tower's mirador.[90]

The proximity of the pool to the facade of the building and its unusual width mean that the way to enter the Partal is not immediately obvious. One must step through the narrow gaps between the pool and the arch at either end of the portico facade in order to enter the building.[91] The pool must be skirted around, avoided; there is no proper, elegant, or ceremonial way to enter. Large water features are among the defining elements of Nasrid palace architecture, but other palaces, such as the Comares or the Generalife, allow for elegant and easy access to the buildings along the side or on a walkway through the centre of the water pools: this is not the case at the Partal.

This awkward access was entirely deliberate and served two functions: aesthetic and practical. The main approach to the Partal was from the south, higher up the hill from the mosque or the residential palaces of the Tendilla and the Convent of San Francisco, from which you would come down through the formal gardens to the south side of the pool (Figure 3.2). From across the pool, the Partal appears perfectly reflected in its still waters. This was the extraordinary aesthetic illusion that the builders of the Partal wanted to create, working within an established tradition of using water as a feature of formal design. The writer and philosopher from al-Andalus, Ḥāzim al-Qarṭājannī (1211–85), wrote an extensive treatise on poetry in which he examined the power of images reflected in water and related them to the use of metaphor in poetry. He explained how the reflected image enhanced the beauty of the original object, writing:

> I declare that among the loveliest things we can see are the reflections
> of shining stars, candles, and lamps on the surface of pure, calm wa-
> ters in streams, rivers, channels and inlets. Also the image of trees
> with their fruits and leaves reflected on the water's surface: when

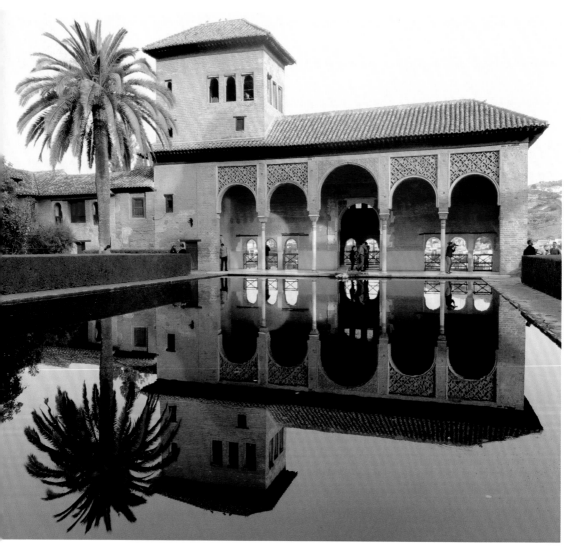

Fig. 3.1

The Partal Palace, Alhambra.
Photo by the author.

Fig. 3.2

Plan of the land around the Partal formerly known as the Huerta de Santa María, by Leopoldo Torres Balbás, 1928. Cyanotype, 69 x 94cm. APAG/Colección de Planos/P-008274.

treetops meet over a stream and are reflected in its clear depths, it is one of the most marvellous and pleasing things that one can gaze on. Something similar happens in imitation, when a beautiful connection unites through language a real thing with something like it by means of imitative representation or metaphor. [...] Seeing the images of these things is different from contemplating the real objects, because it is less common for people to see them reflected in water than to see them in reality, they are much more rare.[92]

There was also a practical reason for situating a large pool close to the building: privacy and retreat. In 1348, the Andalusian scholar and poet

Ibn Luyūn (1282–1349) wrote an agricultural treatise including advice on soil types, irrigation, and plant cultivation.[93] One of the most well-known sections is a set of instructions on where to build one's house within a garden setting. Although his text is largely derivative and somewhat generic, it nevertheless gives an idea of a particular type of building that was desirable within an ideal residence in the fourteenth century: a pavilion with views in which one could hold private conversations. Ibn Luyūn wrote of Almería: "In the centre of the garden let there be a pavilion in which to sit, and with vistas on all sides, but of such a form that no one approaching could overhear the conversation within and whereunto none could approach undetected."[94] The Partal fits this model, with its steep hill on one side and large pool on the other acting as buffers between the palace and the garden (Figure 3.3). Ascend the narrow stairs to the mirador, with its windows in all directions, and the sense of a private, secure space is very clear—a valuable asset in the precarious life of a Nasrid sultan.

Fig. 3.3

Section drawing of the Partal Palace, by Leopoldo Torres Balbás, June 1923.
67 x 51cm. APAG/Colección de Planos/P-000636.

Light

The second striking aspect of the Partal is that the building is practically transparent. The thirty-one openings in the Partal, including the five bays of the portico and the windows (fifteen plus nine) of the mirador and *qubba* towers, make this the most open and luminous of the Alhambra palaces.[95] From across the pool, you can see right through the Partal's windows to the hill of the Albaicín on the far side of the Darro River valley. From inside the building in the mirador and the lower tower, you can see in all four directions: to the Generalife above, to the Albaicín and Granada below, to the fortress of the Alcazaba to the west, and onto the gardens and pool to the south. This porous, lace-like quality was already celebrated in a poem by the Zirid poet Abū Isḥāq de Elvira (d. 1067), who wrote: "If it were not for winter, for the heat of summer, for fear of thieves, to preserve food and because women need to be hidden, I would build myself a house of spider webs."[96]

These extraordinary openings, unlike the internal and enclosed residential palaces of the Alhambra, suggest that the primary function of the Partal was as a place to look at and to look from. For the ruler, these openings in the building acted as a framing device for the landscape of the city, garden, and palace, positioning the ruler in a privileged place of power and dominance.[97] Inscribed in the walls and frames surrounding the entrance and windows of one of the later Alhambra miradors are the words of a poem by Ibn Zamrak. The poem, composed for the ruler and the mirador, contains the common metaphor of the garden as a face, within which the pavilion mirador is the eye—the place from which to see—and inside that, in a position of power, is the ruler, the eye's pupil: "In this garden I am an eye filled with delight and the pupil of this eye is, truly, our lord Muhammad V. [...] In me he looks from his caliphal throne toward the capital of his entire kingdom."[98]

The porous quality of the Partal, however, means that there are few enclosed spaces in the building. There is nowhere one might comfortably sleep—no alcove or side rooms off the portico—unlike in the larger Nasrid palaces. Even the lower tower room has too many low-set windows and is too open to be used as a private domestic space. Despite being surrounded by water and a steep hill, making it difficult to approach without being

seen or heard, the building is at the same time very visible and open to its surroundings—it is not easy to remain hidden here with so many windows and openings. Privacy in daily life, particularly for the women of the royal household, would have been difficult to maintain in the Partal.

It is clear, then, that the Partal—with its wide pool that impedes access but gives the tremendous impression of a floating palace, and the light-filled, lace-like quality of the building—was never meant to be a royal residence. Instead it was built as a pavilion that seemed to float on water, in the long tradition of such palaces in western Mediterranean architecture. These water palaces were built as architectural wonders, as meeting places, hunting lodges, and as pavilions set in a wider landscape of formal gardens that included controlled water channels and pools and the careful framing of wide views beyond.

The Partal's situation within the newly established formal gardens of the Alhambra indicate that it may have functioned as part of a ceremonial landscape that included a stopping or meeting point from which to admire the views and enjoy the breeze. It sits on the fortress walls between the Alhambra Mosque and the Generalife, along a route that led from the mosque past the Partal and down through the Puerta del Arrabal, then directly up to the western end of the Generalife palace. Although most of the original street layouts have been erased, there is evidence of a route from the residential palace of the Convent of San Francisco to the area of the Partal that follows the route of the *Acequia Real*, or royal canal.[99] There are several examples of this kind of stopping-off building, including in Marrakesh, where the Almoravid ruler Ali b. Yusuf built a domed kiosk, known as the Qubbat al-Barudiyyin (1117), with complex internal and external domes and *muqarnas* stucco vaulting. The function of the building is debated, but it has been suggested that it was a stopping point between mosque and palace: a freestanding garden pavilion set in a formal landscape, much like the Partal in Muhammad III's new expansions on the Sabika Hill.[100]

A Historic Form

This combination of formal water feature alongside a palace pavilion with wide views of the landscape has its precedents in early Islamic ar-

chitecture; for example, at the Abbasid palaces of Samarra, which themselves were said to emulate the Sassanian palace of al-Khawarnaq.[101] Water played an important role in these buildings, with its control and supply symbolizing the power and generosity of the ruler, while the practical functions of water storage and thermal cooling were widely prized.

In the tenth century, Muslim rulers built the palace of al-Rummaniya on the outskirts of Córdoba. Rummaniya was a palace complex with terraced gardens, at the top of which was a monumental pool some fifty metres wide, twenty-eight metres long, and three metres deep.[102] A pavilion was built beside the basin, between the water and the terraces, from which the views to the landscape past the gardens were framed. As at the Partal, the pavilion was both a place to be looked at, across the water, and a place from which the landscape could be viewed. This way of framing views of the landscape symbolized the ruler's claim to rule that landscape, situating the privileged viewer, the person in the hall, as the possessor of those lands.[103]

Similar palaces that featured large water pools flanked by free-standing pavilions were found across the western Mediterranean lands. At Raqqada, on the outskirts of Kairouan, the Aghlabid dynasty built the Qasr al-Bahr (Palace of the Sea) in the early tenth century, featuring a large basin of water with a palace built on one side.[104] At the twelfth-century palace and garden known as Buhayra near Seville (no longer standing), the Almohad rulers built a pavilion alongside an enormous pool of water in a garden.[105] At Agdal south of Marrakesh, a pavilion structure (Dar al-Hana) was built alongside a large pool of water within an irrigated landscape in the Almohad estate, also known as Buhayra.[106] In twelfth-century Sicily, the North African styles adopted by the Norman rulers included the building of a pavilion, La Cuba (1180), in the hunting gardens of Palermo, which were known as the Genoardo. The large, free-standing pavilion was situated in the middle of an artificial rectangular lake, which was only accessible via footbridge, creating the illusion of a building floating on water.[107]

Four centuries after the Rummaniya was constructed, its key features can be found in the Partal, with its combination of an arcaded portico that

frames panoramic landscape views, and in the formal manipulation of water in its many forms, particularly of reflected buildings.[108] In building a pavilion set on water at the Alhambra, Muhammad III was therefore consciously echoing the palatial architecture of previous Muslim dynasties. Perhaps we can read into this an early Nasrid preoccupation with establishing themselves as legitimate rulers in a precarious political climate in which there were many rivals who could lay claim to their hold on power. In his buildings at the Alhambra, Muhammad III used architecture as a visual language to signal his legitimate rule of the dynasty that his grandfather had founded in Granada, adopting the architectural types of his predecessors, in particular those of the earliest Arab rulers of al-Andalus, as part of a visual language that placed him in a long line of Muslim rule.[109]

The Mirador

Within the transparent and reflected pavilion of the Partal, the mirador tower offered a private space from which the ruler could look down on the formal gardens and the city. An enclosed space that protruded above or beyond the line of the palace or pavilion, pierced by windows that offered wide views, the mirador would become one of the defining features of the Alhambra palaces that drew from a long tradition of such rooms with views in al-Andalus and the Maghreb (Figure 3.4).[110]

The Partal is one of the earliest surviving examples in the Alhambra of a mirador, contemporary with a mirador in the Generalife palace, which may have also been built by Muhammad III. With its fifteen windows in all directions, the panoramic view afforded by the Partal mirador was one of extraordinary privilege.[111] During the Nasrid era, this kind of space was described in Arabic as a *bahw*, and while we are used to the idea of a mirador as a place from which to look out, many of the uses of the term *bahw* allude to these spaces as places where the ruler could be seen. The word *bahw* was used to describe a private royal room in one of the earliest Islamic palaces, the eighth-century Umayyad palace of Khirbat al-Mafjar in Syria.[112] A poem composed in honour of Muhammad V, probably written by the Nasrid court poet Ibn Zamrak, is moulded in stucco around the window frames of the mirador in the palace of San Francisco, from those parts of the building that date to around 1370. In the poem

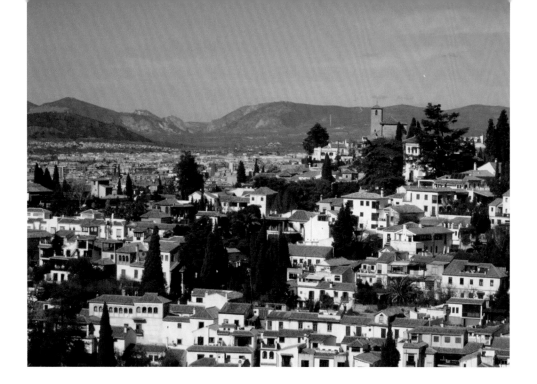

Fig. 3.4

View from the Partal mirador towards the Albaicín and Granada city.
Photo by the author.

the mirador speaks in the first person, describing itself as a *bahw* of extreme beauty that crowns the palace as a place of *appearance*—a place where the ruler could be seen.[113]

In an Alhambra tower to the west of the Partal, known as the Machuca tower, the main square room was described as the *bahw an-Nasr* or "Victory Mirador" by the court vizier and poet Ibn al-Khatib, in his description of the celebrations for *mawlid* (the festival to celebrate the Prophet Muhammad's birth) held in 1362.[114] Another Alhambra mirador, known as the Lindaraja, has a quotation from the Qur'an inscribed on its walls, "he who strives for the highest place will triumph," alluding perhaps to the status of the viewing point for the ruler.[115]

The term *bahw* described a reserved chamber for viewing and being viewed. However, as mentioned, access to the Partal mirador was (and remains) very restricted, via a single narrow staircase, making it an unlikely place for regular public appearances or receptions by the ruler. Within the Partal, the lower square tower room (the *qubba*) with its axis to the southern open facade may instead have been used for that kind of reception. But the mirador's situation in a prominent position on the brow of the Sabika Hill, overlooking the city of Granada, suggests that it may have had a wider function as a place in which the ruler's presence could be both seen and felt from the city below. The many windows of

the mirador also indicate that the tower was a place from where those below could in turn be seen and heard. Stand in the Partal today and you can hear the children playing in the grounds of the school in the Albaicín district opposite. In his description of the Machuca tower, the mirador built under Yusuf I (r. 1333–54), which is situated to the west of the Partal, Ibn al-Khatib wrote that "the pavilion looks right over the town, and whoever is inside it can see the guard posts and the boundaries and hear the sound of water running down from the cisterns in the fortress and even the coughing of people in their houses, besides other things."[116]

This idea of listening-in may have extended to the surveillance of the palace interior, courtyards, and gardens. Indeed, we have an illustration of just such a mirador tower as a listening device in action. The "Hadith Bayāḍ wa Riyāḍ" (Vat.ar.368) is an illustrated manuscript from thirteenth-century al-Andalus.[117] It tells a love story between an outsider, a young merchant from Damascus—Bayad—and an insider, a royal ladies' maid in al-Andalus—Riyad. He falls in love with her and, in the various scenes, plays music for her and the royal lady within the palace gardens. Many of the scenes are set within palace confines, and while the palace remains anonymous, the paintings of the buildings with their towers and brick facades look similar to those of the Alhambra. The themes of the story include palace etiquette and how one should behave in court. In one of the paintings, the room at the top of the palace tower, the mirador, has a very deliberately open window, a visual reminder of the watching eyes and listening ears of the court (Figure 3.5). In the Partal mirador, from where the ruler could listen to the sounds of the city of Granada below to the north, he could also watch and listen to the sounds inside the palace through the windows of his most diaphanous of pavilions, allowing no court intrigue or indiscretion to pass unnoticed.

Fig. 3.5

Folio from the illustrated Arabic manuscript Hadith Bayaḍ wa Riyāḍ, al-Andalus, 13th century.
Biblioteca Apostolica Vaticana, Vat.ar.368 f3v. Paper, 28.2 x 20cm.
Image © Biblioteca Apostolica Vaticana.

Practically, the mirador was probably also used for politically sensitive meetings and intimate gatherings.[118] As Felix Arnold has recently suggested, these miradors of Nasrid architecture were places of recreation and personal reflection.[119] In a description of a much later room in a similar context, the Spanish traveller known as Ali Bey, wrote about his visit in 1803 to a palace in Fez, Morocco, in great detail. He described a small room, which was accessible by stairs, and in which the sultan sat on a chair or reclined on a bed and received people who had obtained special permission to enter the room.[120] The small size and restricted private entrance to the Partal mirador would have made it suitable for similarly intimate and sensitive gatherings.

Object Patronage

The Partal is among the scant evidence that remains from Muhammad III's short reign and patronage in the Alhambra: evidence of a bold building programme that visually linked the Alhambra with Granada in a way that would be imitated and enlarged by his descendants in the building of the Throne Hall and other palaces on the edge of the escarpment decades later. His use of historic forms connecting him with powerful past regimes was made explicit in one of the few surviving royal objects from his reign. Alongside the bronze mosque lamp made in 1305 (Figure 2.4), there is a magnificent marble basin that was made in Córdoba in the tenth century, before being brought to Granada the following century and then re-used by Muhammad III in the Alhambra. This basin, hewn from a single block of marble over a metre in length, was one of a group of richly carved marble objects that were made under the patronage of Abū ʿĀmir al-Manṣūr, who was regent to the third Umayyad caliph, Hisham II in Córdoba, and de-facto ruler of al-Andalus for thirty-four years (976–1002).[121] The basin was decorated on all four sides with carved images of heraldry and power, including lions attacking gazelles, which served to promote al-Mansur's image as an ideal ruler among the Cordoban elite (Figure 3.6).

The basin was moved to Granada by the Berber ruler from the Sanhaja tribal group, Badis ibn-Habbus as-Sanhaji (r. 1038–73), of the Zirid dynasty, which built the original fortress at the Alhambra. We know this history of the basin only because over two centuries later, in 1305, Mu-

MVSEO ARQVEOLÓGICO NACIONAL.- Pila arábiga de abluciones- Granada- Siglo VIII H. XIV J. C **35**

hammad III re-carved the inscription in the basin with the story of his own patronage of the object, recalling its journey from Córdoba to Granada and its subsequent installation in the Alhambra by the Nasrid ruler.[122] Owen Jones would later publish his drawing of the basin in a niche in the fortress of the Alhambra in 1834.

By re-using and inscribing this marble basin that had been moved by his Berber predecessors, Muhammad III was engaging in a practice of spoliation that was common among the Berber Almohad and Almoravid rulers in the eleventh and twelfth centuries. The deliberate reuse of luxury historic materials, particularly of carved marble capitals and basins from Córdoba, was a means by which these rulers engaged with a glorified period of the past through its ruins.

From very soon after its dissolution in the early eleventh century, the caliphal period in Córdoba was considered a golden age in the political history of al-Andalus and its ruined tenth-century caliph's palace of Madinat al-Zahra featured in descriptions as a site of wonder. In a poetic description of a visit to the palace ruins composed shortly after the Cordoban palaces in Madinat al-Zahra were looted, Muslim visitors contemplated the marble remains scattered among the ruins as they thought nostalgically about the past.[123] This theme of picnicking among historical traces was common in medieval Arabic literature. Elegiac poems known as *qasidas* were composed on the theme of lost love encountered in the

Fig. 3.6

Carved marble basin, late 10th century Córdoba, moved to Granada 11th century, inscription added by Muhammad III in 1305. Museo de la Alhambra, Granada. 61 cm (h.) x 137.4cm (l) x 49cm (d) x 88cm (w). APAG/ Colección de Fotografías/ F-13126.

traces of historical ruins; in the case of Madinat al-Zahra the marble ruins acted as the material traces of a lost dynasty.[124] It was through this sense of both nostalgia and wonder that sites of antiquity were encountered and described throughout the medieval Arab world. As subsequent dynasties ruled during more fractious times, they looked to the apparent unity of caliphal rule in al-Andalus as a historic ideal. They acquired luxury objects from the caliphal palace, particularly carved marble capitals and basins from Madinat al-Zahra, to place in strategic positions within their palaces and mosques as visual links with this important past.

Almohad and Almoravid rulers in particular brought luxury objects from Córdoba to their palaces and religious buildings at their imperial capitals in Marrakesh and Fez, where they were conspicuously displayed within new constructions. The movement, re-inscription, and placement of these often-unwieldy objects linked the rule of these Berber dynasties to that of a revered period in western Islamic history: by paying homage to the Umayyads through the citation of objects that were once part of the Cordoban royal elite. A very similar basin to that reused by Muhammad III, also made in Umayyad Córdoba, was brought to Marrakesh by the Almoravid ruler Ali b. Yusuf in the 1120s, alongside a shipment of marble capitals that were used in the congregational mosque and palace he was building in the city.[125] Transporting a basin weighing approximately 1,200 kilograms eight hundred kilometres south to Marrakesh represented the concerted effort by the Berber ruler to acquire these historic objects. The Marrakesh basin was subsequently moved and reused again by the Marinids in a *madrasa*—the Madrasa Ben Yousef, also in Marrakesh—in a process of re-spoliation that was similar to Muhammad III's reuse of the basin mentioned above. This practice of spoliating marble from Cordoban antiquity was not restricted to Muslims: at the Alcázar in Seville the Castilian ruler Pedro included caliphal-era Cordoban capitals in his royal palace building, demonstrating that the status of these luxury objects from a powerful historic dynasty was as relevant to Christian kings as it was to Muslim rulers.

The reused object, the spolia, often bore the genealogy of its gifting, acquisition, or transport in its inscription. At the Alhambra, Muhammad III's inscription on the basin with the history of its movement linked

him not only with the Umayyad period, but also with his direct dynastic predecessors in Granada, the Zirids.[126] By inscribing this genealogy on the marble fountain, Muhammad III wrote himself into the story of the object's long history, but more importantly into the long history of both Granada and successful Muslim rule in al-Andalus. This was the lineage in which he saw himself at the Alhambra and his inscription provides an insight into what he might also have been trying to achieve in his building projects. Muhammad III was drawing from the past (both caliphal and Berber) through its objects, buildings, and styles, and was placing himself within the long story of Muslim dynastic rule at a formative time in Nasrid history. We can read the style of the cupola and the architecture of the Partal pavilion in a similar way (that is, as examples of the use of historic building styles and established carpentry techniques), but they are also placed within a daringly new context on the side of the Sabika Hill overlooking the city, in a mirador of unprecedented lightness and aesthetic appeal.

The Later Nasrid Partal

For much of the fourteenth century the Alhambra must have looked like a rather busy building site. As successive rulers constructed new palaces and adapted existing ones, including the Court of the Lions and the Comares palace, the business of building the Alhambra would have continued to employ a large number of skilled workers from the city of Granada. In his detailed contemporary description of the Alhambra from the later fourteenth century, Ibn al-Khatib described the development of the area around the Mexuar, to the west of the Partal, as a place that had just been renovated during the second reign of Sultan Muhammad V (1362–91), with sections demolished, enlarged, and expanded for the *mawlid* celebrations in December 1362.

There was also plenty of building activity directly around the Partal pavilion in the decades after it was completed. Under the reign of Yusuf I (1333–54), a series of houses were added to the west of the Partal, forming an L-shape around the water pool. At around the same time, a separate small mosque (the Partal oratory) was constructed to the east, oriented towards Mecca. This was a place for private prayer, its access restricted to members of the royal court. It was probably used by the ruler on all

but Fridays, when he would have led prayer from the main Alhambra Mosque. The addition of these buildings altered the way the Partal worked, changing it from a freestanding pavilion in a garden and water setting, to a building that was part of a complex of residential buildings within the Alhambra city. The small houses adjacent probably functioned as residences for the royal family and its entourage.

In the early twentieth century, on the walls of one of these small houses, a series of paintings from the fourteenth century was discovered preserved under plasterwork. The paintings are arranged horizontally in long panels and, though greatly deteriorated, they depict scenes of people on a journey, with tents, soldiers, camels, and lions. They are unique in the Alhambra and are a hugely important testimony to the presence of figural painting in these palaces. Their presence alongside the enigmatic Sala de los Reyes ceiling paintings hints at a livelier figural painting tradition in medieval al-Andalus than has been presumed. These paintings may have been commissioned to commemorate a particular journey to Mecca, as their details suggest, or as part of a wider visual programme that linked with the images of royalty suitable for the decoration of residences of the Nasrid families.[127] Their presence in the houses adjacent to the Partal suggests that these were probably houses for people of a high status: probably members of the royal Nasrid house.

Remains of paint were found during the conservation of the house now adjacent to the Partal, on the same facade where the decorative wall paintings were found on a lower layer of paintwork, representing what was once the external wall of the Partal. This paintwork covered the exterior of the building, and its presence confirms the theory that the Partal was originally a freestanding pavilion structure.[128] The evidence of remaining paint preserved from this original exterior facade shows that the Partal was once painted with *trompe l'oeil* brickwork in red and white, as well as a calligraphic banner containing an inscription in Arabic that ran horizontally across the building along the top of its arches (Figure 3.7). In his diary of restorations to the Alhambra, Torres Balbás describes how he cleaned the exterior walls of the Partal mirador, parts of which had remains of the original paint that imitated brick.[129] This bright colour scheme for the building may seem rather extraordinary today, but

similar red and white *trompe l'oeil* painting was discovered on the exterior of the later fourteenth-century building known as the Casa de Astasio de Bracamonte, behind the oratory,[130] while much earlier palaces such as the Rummaniya in Córdoba were painted with similar red and white colour schemes.[131]

The cupola remained in place in the mirador of the Partal throughout the rest of the Nasrid reign. As the Alhambra medina changed around it, the mirador probably continued to be used as a private royal room by those who occupied the buildings. Its cupola remained, even as the Nasrid regime began to fall to pieces in the later fifteenth century.

Fig. 3.7

Arabic writing uncovered on the plasterwork of the walls of the Casa de las Pinturas, the building adjacent to the mirador of the Partal. Photo by the author.

Chapter Four:
A Soldier's Residence:
1492–1812

The year 1492 stands as a pivotal point in history: the moment when Muslim political power left western Europe, and the centre of influence and interest began to shift towards the New World across the Atlantic. For Spain's Catholic monarchs Ferdinand and Isabella, whose marriage in 1469 united the kingdoms of Aragon and Castile, the conquest of Granada and the end of Muslim rule was their ultimate victory, finally bringing Spain together under their political control. For the non-Christian populations of Granada this victory would prove disastrous. Despite a guarantee in 1492 from the new Christian rulers that their rights would be protected, within thirty years Granada's Jews and Muslims had been enslaved, compelled to convert, or forced to leave the country.

For the Alhambra palace, however, and for the Partal in particular, it was not the change from Muslim to Christian rule that would endanger the fabric of the buildings over the next few centuries. Rather it was the sudden change in the status of the Alhambra in 1492 that would determine its fate. The Alhambra went from having been the primary residence of a small royal kingdom to becoming one of many royal residences in a growing empire. Although the Alhambra was immediately claimed as a royal palace by the new monarchs in 1492, it was not their only palace. Their court was a peripatetic one, whose members went from palace to palace in a newly expanded kingdom, leaving the Alhambra in the hands of an appointed governor in their absence.[132] This lack of permanent royal residents, alongside the eventual expulsion of the Muslim population, which gradually decreased the need for a strong military presence in Granada while leaving it short of skilled craftsmen to repair the palace buildings, led ultimately to the official neglect of the site. The importance

of the Alhambra as both a royal residence and military base declined, and funding for the maintenance and repair of its buildings was cut to the minimum.[133] It was this change in status—from being *the* royal palace in a small kingdom to one of many in an ever-growing empire—rather than a change in the religious or cultural identity of the rulers, which would ultimately endanger the very survival of the palaces and lead to dramatic changes in the function and fabric of all the buildings of the Alhambra, including the Partal.

For Ferdinand and Isabella, the Alhambra was a symbolic palace claimed from a symbolic victory. The conquest of Granada in 1492 meant so much to them that they even put Granada into their coat of arms, as a pomegranate sitting below the emblems of Castile and Aragon. The pomegranate is still present in Spain's coat of arms today—a symbol of a victory that in time would signify more than the simple taking of one kingdom by another: the birth of the new nation of Spain.

It might seem surprising today that the Alhambra, seat of an Islamic dynasty, was immediately taken as a royal palace by the new, avowedly Christian rulers. We might presume from our contemporary perspective that the new Christian monarchs would have rejected the palace as being too Islamic in form and decoration, with its vivid interiors inscribed with Arabic writing and *muqarnas* motifs. However, in 1492, the Alhambra style that we know today was not associated exclusively with Muslim culture, but was a style that was shared among Muslims, Christians, and Jews in medieval Iberia. This style had grown out of thirteenth-century Berber-Andalusi aesthetics and was popular in palaces and religious buildings across the Muslim and Christian regions of North Africa and Iberia.[134] It had come to stand for a certain wealth and sophistication that led to it being enthusiastically adopted by non-Muslim patrons and rulers.

Buildings such as the synagogue of Samuel ha-Levi (El Tránsito) in Toledo (1357), the chapel of San Bartolomé in Córdoba, or the Castilian palace of the Alcázar in Seville,[135] were decorated with what we might think of today as typically Islamic motifs: coloured tiles and plasterwork, with bands of Arabic or pseudo-Arabic inscriptions, *muqarnas*, and geometric

compositions based on the star or *sebka* motif, for example. They used these motifs not by accident but by design: as early as 1275, the Castilian king Alfonso VIII completed his royal pantheon at the Cistercian Monastery of Las Huelgas in Burgos, in which he included plasterwork decoration that copied the Islamic luxury textiles that were used as funerary shrouds in the same building.[136] At the palace of Pedro I in the Alcázar in Seville, the Castilian ruler decorated the walls of his palace with plasterwork and Arabic inscriptions in designs that would have been equally at home in the Nasrid palace in Granada.

Isabella and Ferdinand would have perceived the buildings of the Alhambra not as foreign or *Islamic* in style, but as a fine example of a contemporary palace that was as much in fashion in Castile as it was in Granada. Despite the end of Muslim political rule in Iberia, the visual language of al-Andalus was still associated with refinement, sophistication, and the antiquity of Muslim power in Iberia. The particular symbolic associations of the Alhambra with a historically powerful yet defeated Nasrid dynasty would have added to the palace's caché under the new Christian rulers. The use of the Alhambra therefore allowed Ferdinand and Isabella to demonstrate their new sovereignty to their own subjects within Spain as well as to visitors from abroad. The new queen felt at home in the Alhambra, so much so that she asked to be buried in a chapel in the Convent of San Francisco, a building that had until very recently been a Nasrid palace.[137]

The new monarchs put two influential figures in charge of Granada: an archbishop for Granada, Hernando de Talavera (1428–1507), who was also the Queen's confessor, and a governor, Íñigo López de Mendoza, the Count of Tendilla and Marquis of Mondéjar (1440–1515), who was also captain general in charge of the garrison of the Alhambra. The governor was granted a tenancy in the Tendilla palace, one of the largest and oldest of the Alhambra palaces at the time (since destroyed).[138] For the next two centuries that governorship would be held by his descendants, the counts of Tendilla. Guided by the *ordenanzas* or military regulations that were written by the kings in May of 1492, the governor held the power of civil and criminal justice, regulating the lives of the soldiers and maintaining the buildings of the Alhambra.

After the conquest, the Alhambra was divided into four broad areas according to function: the royal residences, the home and offices of the governor, the seat of the military, and the home of the religious order of the Franciscans. The royal residence was in the Nasrid palaces of the Mexuar, Comares Hall, Throne Hall, and Court of the Lions. These were internally renovated between 1492 and 1494. The governor's residence was the Tendilla palace, while its neighbour, the Partal, came under the jurisdiction of the governor's properties and together with its adjacent houses was used by members of his administration including his captain general. The Franciscan order was granted the former Nasrid palace to the east of the Alhambra, known as the Convent of San Francisco, the palace in which Queen Isabella would be buried, which was converted to a convent. The Alhambra Mosque was immediately converted to a church, before its structure was rebuilt.[139]

This partition of the Alhambra into separate functions by the new rulers would have long-lasting consequences that would determine how the Alhambra would be conserved and experienced right up until the present day. When you enter the Alhambra today, your timed ticket to the "Nasrid palaces" brings you through those areas that the new Christian kings had reserved as their royal palaces, entering through the Mexuar to the Comares palace and the Court of the Lions. Other parts of the site—the Partal for example—are included in the general entrance ticket, but they are not identified among these *official* royal palaces. The consequence of this division into royal, military, governance, and religious functions in 1492 was that those palaces that were not among the official royal residences of the Christian kings were left vulnerable, with significantly more radical changes made to their structures than to those of the official palaces over the following centuries; changes that in some cases (such as the governor's house) would lead to their complete destruction, while in the case of the Partal, would lead to the removal of large parts of their original structure.

From Royal Pavilion to Military Residence

After 1492 the renovations for the new rulers still required the labour of the skilled Muslim craftsmen who had worked on the buildings under Nasrid rule and who were capable of repairing the plasterwork and car-

pentry, and maintaining and repairing the water systems of the Alhambra. One of the clauses of the handover of Granada stipulated that some of the Muslims who had been taken prisoner after the conquest should stay on in Granada to carry out the immediate repairs in the fortress.[140] However, many Muslims stayed on beyond that initial period to work in the Alhambra, although from 1492 Muslims were forbidden from living there, so they had to descend to Granada at night.

Münzer, the scholar from Nuremberg who had visited the Alhambra in 1494, noted that Granada was full of Muslims building houses and repairing the Alhambra. He witnessed the presence of these Muslim craftsmen restoring the palace, writing that on "26 October, when we were there, we saw many Saracens adorning and restoring the paintings and other things with their own skill; we enjoyed a magnificent spectacle there."[141] He counted over two hundred mosques in the city of Granada and described hearing the Muslim call to prayer, testament to a continuing, active Muslim population after the conquest. He described the walk up to the Alhambra passing through many iron doors and stands of soldiers, and the presence of five hundred cavalrymen in the Alhambra under the governor's command. He was greeted by the Alhambra governor Iñigo López, the Count of Tendilla, who showed Münzer and his party a palace with white marble floors, gardens with fruit trees, rooms of armaments, and water fountains. Münzer was astounded and wrote that he thought there was nothing in Europe as magnificent or majestic.[142]

As described by Münzer, Granada was a thriving and productive place, with a large military presence, plenty of investment in the repair and maintenance of the buildings, and a population sustained by fertile market gardens, hunting grounds, and plenty of running water. He was, however, writing as a Christian who was made welcome by the new rulers. For Muslims, whose status had suddenly become extremely precarious and who would shortly be forced to choose between their religion and their home, the situation was more dangerous.

Münzer's first-hand account reflects the immediate circumstances of the city after a conquest in which the rights of Muslims to practice their

religion and remain in the city was enshrined in laws that were initially obeyed, and in which the Alhambra palace was the prized jewel in the new crown.[143] After this initial period of tolerance, however, the situation in Granada rapidly began to change. Under the archbishop Talavera, in 1498 Christians were banned from renting property to Muslims, wearing Arab dress, or buying meat from Muslim butchers. By 1499, the legal situation of the Muslim population deteriorated significantly with the arrival of the new archbishop Francisco Jiménez de Cisneros (1436–1517), who brought with him authoritarian measures to force Muslims to convert to Christianity. Physically, the city of Granada was changed to suit the new rulers, as the streets were widened, markets constructed, and houses pulled down. The Jewish quarter of Granada was destroyed, as was the congregational mosque, and a hospital and cathedral built in their place.[144]

Archbishop Cisneros rescinded much of the Treaty of Granada, in which the religious rights of the population were enshrined, by enforcing laws that restricted the use of Arabic language and the wearing of Arab-style dress. He ordered mosques to be consecrated as churches and the forced conversion and baptism of the Muslim population. Riots and disorder led to an organized revolt of the Muslims in 1499, which was violently put down by the new rulers. Cisneros famously wrote in a letter dated 4 January 1500 that "there is now no-one in the city or round about, who was not Christian; 50,000 souls [out of a total of 200,000] have been converted; all the mosques are now churches where masses are sung."[145] In reality, many of the converts continued to live as crypto-Muslims for decades to come, until the revolts of the remaining Muslim converts (then known as Moriscos or forced converts to Christianity) in the 1570s led to mass expulsions and renewed efforts by the authorities to identify and convert any remaining non-Christians.

While the Alhambra palace changed from being a permanent to a temporary royal residence, for the Partal palace, paradoxically, the change from Nasrid to Christian rule meant that the pavilion, which had been a place of *temporary* residence at most, became a place of *permanent* residence by a high-status member of the military. The governor's residence was in the adjacent Tendilla palace, so it is highly likely that the Partal was

adopted as the residence of one of his officials: possibly the head of the army.

In the 1570s the Partal was described in a census of buildings and their occupants as a "tower and chambers in which Alvaro de Luz lived."[146] Alvaro de Luz (1520s–71) was the captain of the artillery and secretary to the governor of the Alhambra: Tendilla. Alvaro and Isabel de Luz had a son, Diego de Luz, who was named captain of the artillery after his father's death. When the census was taken in 1571, the tower would have been inhabited by de Luz's widow and family.[147]

It was this inhabitation of the Partal and indeed of all of its towers that would initially protect the buildings from neglect and destruction. The story told in the nineteenth century by visitors to the by then crumbling palaces was one in which the local people were ignorant of the importance of the palaces and complicit in their neglect and sometimes even their destruction. However, a closer reading of the records reveals that far from neglecting them, the population who lived in the Alhambra fought hard to maintain its water courses, to repair its walls and interiors, and to protect its buildings from destruction. It was instead the official neglect of the palaces from a royal household that threatened their existence.

Once the threat of a Muslim revolt had receded with the expulsion of the Muslim population in the second half of the sixteenth century, the focus of the Spanish royal household began to move elsewhere. Under Charles V, who visited the Alhambra with his new wife in 1526, the palace was the recipient of some investment with the remodelling of the area between the Partal and the Court of the Lions as the Emperor's chambers, and the beginning of the much larger and ultimately unfinished project of the large palace adjacent to the Comares Hall.

By the end of the sixteenth century, the seat of royal power in Spain had moved permanently to Madrid and the Crown's focus had moved to the New World. With this move, the Alhambra lost its two primary functions: as an important military and royal seat. The impact was profound. The numbers of soldiers stationed in the Alhambra fell from 450 troops in 1493 to 80 in the early 1600s. Active troops were replaced by the Invalid

corps: invalided soldiers with an average age in 1616 of over forty-one. Even those soldiers who were supposed to occupy and protect the Alhambra, which remained a distinct part of the city, often preferred to live down in the livelier city of Granada proper instead.

The exodus of what had been a skilled and relatively wealthy Muslim population from the city in the sixteenth century, combined with a lack of investment from the royal household, had a profound effect on the economy of Granada generally and specifically on the fabric and function of the Alhambra. The maintenance of the water courses and irrigation channels that ran through the Alhambra was one area in which a lack of skilled workers and consistent investment in their repair began to take its toll on the structure of the building.

For the Partal, the upkeep of the pool was the cause of particular problems (Figure 4.1). Documents from the period show how a lack of maintenance of the water systems threatened the buildings around the pool. A crisis occurred in 1633 when the water flooded and caused the collapse of a wall and group of houses on the hill below. In a letter to the king, the caretaker complained that those who had previously cleaned out the Partal pool no longer did their job and that it was in danger of collapse or flooding. Another letter to the king noted that a wall had collapsed because of water from the Partal and cited an administrator of the water systems who said that the workers were demanding more money for their work, but were being offered less than they would get in Granada itself. A letter from the same year complained that the water course through which the water should run into the forest was not clean, and that the boy who tried to clean it didn't fit through the irrigation canal because of the build-up of leaves and plants! The same year, the water administrator (Francisco de Potes) complained that women were washing their clothes in one of the large water pools.[148]

The picture painted is one of neglect, not through ignorance of the value of the buildings or lack of awareness of the need for repairs, but through a severe lack of financial resources and skilled labour to maintain them. Letters written between the king and the Alhambra governor in the late sixteenth and seventeenth centuries reveal an Alhambra that was

ignored by royal officials, where local officials' requests for money for basic repairs to the structure of the building were made in increasingly desperate tones. In 1617 for example, money was requested for work in one of the towers of the Alhambra in which a soldier was living—to put in a staircase to a new floor in the tower. In 1684, a mayor of the Alhambra wrote in a letter to the king that the towers occupied by the soldiers were in a very bad condition and risked ruin for lack of money for repairs (Figure 4.2).[149]

Despite the disrepair, a population continued to live and work in the Alhambra. The census of the buildings in the Alhambra and their occupants from the 1570s noted: 34 towers, 17 royal houses, 2 house shops, and 1 shop belonging to the king; 171 houses and a shop belonging to private individuals; as well as a store house, warehouses, and the artillery and munitions store.[150] In total it listed 230 properties with 228 houses and towers with 166 people.[151] This population was a mix of invalided soldiers, their families and widows, gardeners, artisans, and textile workers and those who provided for them, as well as the governor and his entourage, who established a life within the former palaces that was distinct

Fig. 4.1

The Partal pool during restoration, viewed from the Partal palace. Photo by Manuel Torres Molina, early 20th century. APAG/Colección de Fotografías/ F-00512.

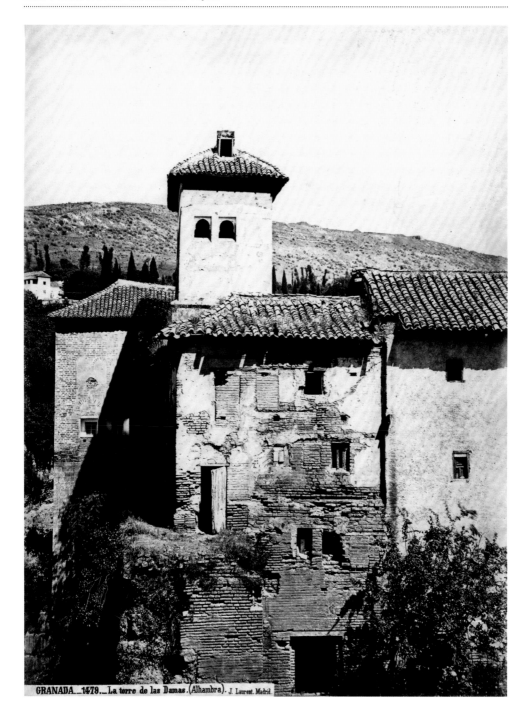

GRANADA.—1478.—La torre de las Damas.(Alhambra). J. Laurent. Madrid.

Fig. 4.2
Side view of the Partal.
Photo by Jean Laurent, c.1874. 25 x 33.5cm. APAG/
Colección de Fotografías/F-05256

from that of the city of Granada below. Many of the ex-soldiers worked as gardeners in the Alhambra precinct. The non-military population worked in small enterprises fabricating silk and ceramics in particular. Private individuals even set up textile looms in the buildings of the Alhambra palaces; documents describe how the looms were banned from the towers as they damaged the walls and made too much noise.

The Alhambra was no longer a thriving royal city, but neither was it abandoned or wilfully destroyed by its residents. They worked hard to maintain its water courses and its buildings, some recognized as royal, others converted by now to religious or private use, while the local Alhambra authorities sought to maintain the integrity of the royal palaces and fought against the ravages of time and a lack of skilled labour or money. Despite their physical decline and official neglect, the royal residences (that is, the Comares, Mexuar, and Court of the Lions) were always recognized as special reserved places that needed to be particularly cared for. This is clear, for example, in the documentation of a dispute in 1616, in which a freed slave, Maria de las Nieves, was reprimanded for allowing visitors to enter the Hall of Comares on payment of a fee without regard for its condition.[152] In 1624 a works foreman, named as Minjares, tried to prevent "people of all kinds from being allowed to enter the Royal Houses."[153] This continued awareness of and concern for the Alhambra's historic buildings counteracts a narrative that became established in the nineteenth century, in which the ruinous condition of the buildings was attributed to the ignorance and lack of interest of the local people and the authorities.

Throughout the eighteenth century, the Partal continued to be occupied by members of the military. Archival documents, such as those that provide estimates for the cost of repairing the buildings of the Alhambra, reveal that many of its towers were occupied by soldiers and needed repairs to their roofs and facades. For instance, a document from 1721 includes a reference to the Torre de las Damas, which needed new roof tiles.[154]

It was in the eighteenth century that the royal household's interest began, slowly, to return to the Alhambra. In 1730 the Partal was among many of the Alhambra buildings and gardens that were renovated to

prepare for the visit of King Felipe V, who was the first king to stay at the Alhambra since the visit of Felipe IV in the spring of 1624. The roof and exterior facade of the Partal were repaired in preparation. Excavation of the Partal area in the 1920s uncovered several copper coins from the reign of Felipe V, perhaps indicating that it was renovated or more used in that period.[155] It may have been for this royal visit that the Partal was converted from an open pavilion with a tower and a portico to a residence with closed arches on the facade, with a second storey inside and internal room divisions making the space more comfortable (Figure 4.3). The king's visit was short: arriving on 23 March 1730 he stayed only a few days at the Alhambra before moving in April to a residence closer to the royal hunting grounds of Soto de Roma outside of the city, leaving only the most junior members of the royal family to stay in the Alhambra.

Antigüedades Árabes and the French Invasions

Shortly after the visit of Felipe V, one of the best-preserved palaces of the Alhambra was demolished. The governor, the Count of Tendilla, had been expelled from the Alhambra by Felipe V for not supporting the Bourbons in the Spanish Wars of Succession (1701–13). The governor's properties were confiscated, and his former palace, the Nasrid palace that had in all likelihood been the residence of Muhammad III, was torn down between 1734 and 1735, its interiors having been stripped out and sold.[156]

Fig. 4.4

View of the Alhambra, ink and colours on paper, c.1770.
49.5 x 74cm. Plate from the publication by José de Hermosilla y Sandoval (et al) Antigüedades Arabes de España, c.1787. Real Academia de Bellas Artes de San Fernando, Madrid. Public domain.

What followed was a period of unstable governorship in the Alhambra, during which many of its buildings deteriorated. It was at this time, when the survival of the Alhambra palaces was most at risk, that the scholars and artists of Spain's fine arts academy, the Real Academia de Bellas Artes de San Fernando in Madrid, which had been founded in 1752, began to show a new interest in the documentation and preservation of the buildings of the palace. In 1766 the architects José de Hermosilla, Juan de Villanueva, and Juan Pedro Arnal began an architectural study of the Alhambra commissioned by the Real Academia on the Islamic architecture of Spain.[157] The resulting publication included plans, elevations, and drawings of details of the Alhambra, using the latest measuring instruments, including the camera obscura, with a new attention to detail and accuracy (Figure 4.4). The Partal appears in the plan,

Fig. 4.3

The Partal in the early 20th century.
Photo by Manuel Torres Molina. APAG/Colección de Fotografías/F-13057.

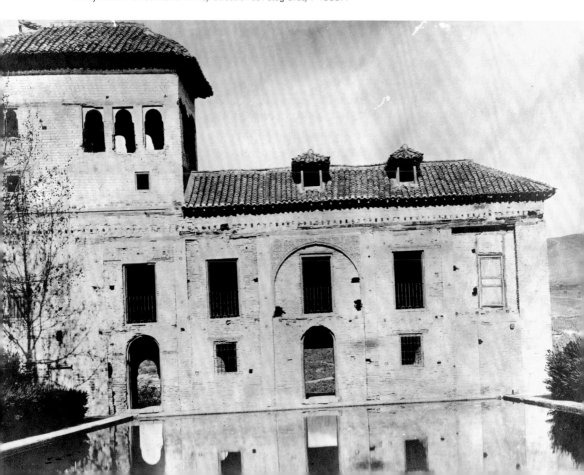

with a wall alongside the pool that probably marked the division of land between the royal palaces and the lands of the governor (Figure 4.5). The remains of the Tendilla palace are visible on the hill.

The two-volume publication of *Antigüedades Árabes de España*, which included a study of the Córdoba Mosque/Cathedral, focused national attention on the architecture of al-Andalus.[158] Produced and compiled by a variety of different architects, this multi-volume publication included studies of the Alhambra. This was the first time that Spain's Islamic architectural heritage had been officially recognized and its importance nationally acknowledged through the royal academy's publication. The publication also marked the beginning of new official interest in the art and architecture of Islamic Spain both within Spain and abroad. It would culminate in nineteenth-century attempts to catalogue historic architectural heritage that was considered of national significance to Spain, including with the publication of the *Monumentos Arquitectónicos de España* (1856–82).[159] The new architectural and scientific approach that was evident in both the *Monumentos* and the earlier *Antigüedades* publications would influence the approach taken by foreign scholars when they arrived to study the building in the 1830s.

The *Antigüedades* came at a pivotal time in the palace's history, recording the palaces just before the French occupation of Granada under Napoleon. While this occupation would severely damage many of the Alhambra's buildings, its condition before the occupation was already poor. A survey of the buildings in 1801 recorded that the roofs of the royal palaces were at risk of falling down. The first detailed written description of the Partal and its interior was recorded before the occupation of the Alhambra by Napoleon's troops in 1810. It is found in the three-volume book on the Alhambra and Granada by the lawyer, scholar, and antiquarian Simón de Argote, and was published in 1805–7 (Figure 4.6).[160] Argote's account of the Partal—which he calls the Palacio del Príncipe, possibly after the visit of the king in 1730—described it as one of a number of buildings to the east of the royal palaces that were "completely disfigured from having been used as accommodation by poor families, but that still preserved evidence of having been used by important people in the period of Islamic rule."[161] The Partal he visited was divided into

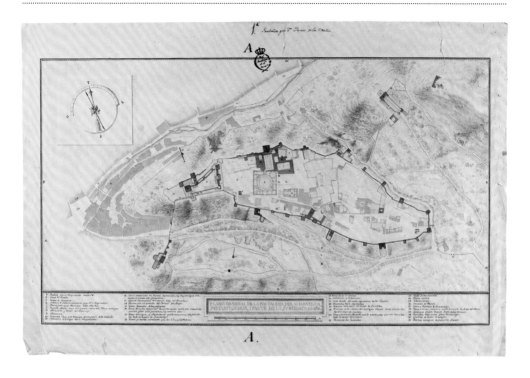

two storeys and partitioned into rooms, each with remains of gilded and carved decoration. Argote noted the mirador's exquisite ornament and the beautiful colours of gold and silver that decorated the rooms and further mentioned the columns that separated the two parts of the mirador—columns that would be missing in a drawing of the mirador from 1833. The facade of the Partal had been destroyed, Argote wrote, but what remained were the five arches, the central one larger, with some of the stucco decoration, in front of a pool that was, he noted, now used to cultivate plants and trees, serving as a garden to the house.

Fig. 4.5

Plan of the Alhambra attributed to José de Hermosilla y Sandoval published in *Antigüedades Arabes de España*, 1787. Real Academia de Bellas Artes de San Fernando, Madrid. Public domain.

Argote's description of life in the Alhambra is of a poor but industrious district. He described the market gardens that flourished on the narrow site, the largest of which was in the gardens of the Convent of San Francisco, which provided fruit and vegetables for all the community as well as selling to the city below. He noted the poverty of the people who lived there, who were soldiers and peasants (*paysanos*) of all ages and sexes, which he counted at 488 people, who lived in discomfort and poverty apart from the governor, the priest, and their families. Their main source of income was in the manufacture of silk, and even though much of this industry had been lost to the city of Granada, there were still sixty trimmings looms, of which only twenty worked, each consuming ten ounces

Richard Ford. Granada. 1833.
qarà no expiñou de Argita
✳
the author.

NUEVOS PASEOS

HISTÓRICOS, ARTÍSTICOS,

ECONÓMICO-POLÍTICOS,

POR

GRANADA

Y SUS CONTORNOS.

CON LICENCIA.

EN GRANADA EN LA IMPRENTA DE D. FRAN-
CISCO GOMEZ ESPINOSA DE LOS
MONTEROS.

of silk, and six machine looms. There was also a pottery that used local clay and whitening in the making of containers, using quartz instead of sand in the clay. On the ruins of the Tendilla palace there was a *yeso mate* factory for making a hard white plaster that was used to whiten walls. There was a plan to establish an industry making cheesecloth fabric (*estameña*) dyed with indigo, a production that he noted could employ many more people in the Alhambra. The Alhambra supported only one shoemaker and one carpenter: an invalid soldier who mostly worked in the city.[162] Argote's is an exceptional account of the state of the Alhambra palaces before the radical changes to the site by the French military. It is the first comprehensive and ordered description of the entire site, produced in the rational tradition (though lacking the resources and scale) of the *Description de l'Égypte* compiled during the first decades of the nineteenth century under Napoleon's expedition to Egypt.

Most of this indigenous population of the Alhambra was forced to leave in 1810, when Napoleon's troops arrived in Granada led by the Corsican general Count Horace-Francois-Bastien Sebastiani. Napoleon visited the Alhambra on a number of occasions, possibly accompanied by Argote, and was no doubt familiar with its history (he corresponded with Alexandre Laborde, author of *Voyage pittoresque et historique de l'Espagne*, from 1806).[163] He lamented its poor condition and ordered the repair of the royal residences (those used since the conquest by the Catholic monarchs). He put in place his general, Sebastiani, to direct the restorations; however, this care was limited to the repair of the official royal palaces and their gardens. The rest of the Alhambra site, including the Partal, was used as a barracks to house over six hundred soldiers and sixty horses, and to store firewood, gunpowder, and cannons.[164] The Partal was probably among those towers used to house soldiers, but unlike many of those destroyed when the troops mined the towers before they withdrew in 1812, the Partal and its cupola survived.

Fig. 4.6

Simón de Argote *Nuevos paseos históricos, artísticos, económico-políticos, por Granada y sus Contornos* **vol.3 (1806), title page.** This copy is one of three volumes now in the British Library, London, that were given by Argote to the writer Richard Ford in 1833. Photo by the author.

The impact of the occupation was profound. The degradation of the buildings combined with the depopulation of the site under the occupation led to the Alhambra, and the Partal that Argote had described as "exquisite," entering the nineteenth century as a virtual ruin. It was in this crumbling condition that it would be depicted by the many artists and writers who would begin to visit in great numbers in the coming decades.

Chapter Five:
An Artist's Home:
1812 – 1885

The architecture is so peculiar and elaborate that it would take months to do it justice. […] Now I am going to smoke a cigar and go to bed, to dream of Moors and Christians, tournaments and battles, painting and architecture.
—David Roberts, in a letter to his sister from Granada, 13 February 1833

There is a sketch by the British artist John Frederick Lewis (1804–76) labelled "Mirador in Sánchez' Cottage, Alhambra", from 1833. Sketched in pencil with watercolour highlights, this drawing of the mirador's interior clearly shows the distinctive shape of the cupola crowning the room below, whose walls are in a ruinous condition (Figure 5.1). This unique sketch is the only known image of the cupola in place in Granada. It was made by Lewis while he stayed at the Partal in the 1830s, when it was a private home frequented by visiting artists. For the foreign artists and writers who visited Granada, the Alhambra provided an oriental experience close to home, an "exotic" palace that was at the same time accessible and ruinous, a romantic fantasy that fulfilled their dreams of the picturesque. Its buildings became the stage set for stories, plays, operas, and paintings that re-enacted the fall of Muslim power in Spain, often contrasting that medieval period with the contemporary view of a ruined palace inhabited by poor and powerless locals. Many artists, including Lewis, Richard Ford, Owen Jones, Joseph-Philibert Girault de Prangey, Carl von Diebitsch, and George Vivian, made drawings and watercolours of the Partal during their visits. Their depictions are both a valuable record of the condition of the building at the time and an insight into how the artists viewed the palace. For the Partal, this was a perilous period of changing ownership and tenants; a time during which the building's image was recorded and published many times, while its interior and exterior were being radically transformed.

Fig. 5.1

John Frederick
Lewis, 'Mirador in
Sanchez' Cottage,
Alhambra', 1833.
Tate Collection,
London Inv.Nr.:
N02202. Graphite
and watercolour on
paper. 21 x 28cm,
© Tate, London
2019.

The Sale of the Partal

In 1828 the Partal was sold by the Royal household, and for the first time in its history of over half a millennium the building and its adjacent land, including the pool, entered into private ownership.[165] By this time the buildings of the Alhambra were in an alarming state of disrepair following the withdrawal of French troops in 1812. Many of the families who had lived in the Alhambra before they were forced to leave their homes during the French occupation, slowly began to return after 1813, only to find their houses rendered uninhabitable, a combination of having been occupied by the French troops and a lack of maintenance of the water courses and buildings during the occupation.

In 1827 the new governor to the Alhambra, Francisco Sales Serna, produced a report outlining its poor condition. He described the water leaks that had been discovered in all the key buildings, including the Court of the Lions, and warned of the risk that the Torre de Comares would fall

down.[166] Serna's priority as the new governor was to consolidate and conserve the royal property of the Alhambra, following a regulation passed in 1828 that required the royal houses to be kept neat and their state of conservation periodically overseen.[167]

The Partal was sold in response to this pressure on the governor to maintain the buildings of the royal household combined with the lack of money to do this across all parts of the Alhambra. While the governor would have been fully aware of the Partal's historic significance among the Nasrid palaces, it did not have the status of one of the official royal palaces—as did the Comares, Mexuar, and Court of the Lions—that had been identified after the Christian conquest as *the* royal residences. In 1826 the Partal was already inhabited by Nicolás Ximénez, who was paying a monthly rent of twenty-five *reales*.[168] The sale in 1828, probably to the same Ximénez, relieved the governor and the royal household of the financial obligation to maintain and repair its structure and interior at a time when resources were being directed towards the maintenance and repair of the "official" royal palaces: those parts of the Alhambra that were last used as palaces by the Christian kings. It was those core buildings that were now the focus of money and restoration.

The new governor began to regulate admission to the royal palaces: he introduced a limit on the hours of visitation, and for the first time, charged visitors a tariff to enter. A visitors' book was opened by a Russian prince, Dolgorouki, in 1829, in which visitors from across the world left their signatures, visiting dates, and home countries, as well as occasionally a poem or sentence about their impressions of the Alhambra. The first signature in the book was that of the writer Washington Irving (1783–1859), who arrived in 1829 to write his popular *Tales of the Alhambra*: romantic stories that conjured up the Muslim history of Granada through the crumbling ruins of the palace.

The sale of the Partal in 1828 transferred responsibility for its maintenance to the new private owners, which led directly to the deterioration of its interior in the following decades. After the French wars, private individuals in Granada were not equipped to maintain and repair the palaces. One year after its sale in 1828, the Alhambra accountant and survey-

or Francisco María Muñiz explained that "many of the houses were sold off, with the obligation in their contracts to repair and maintain them in good condition; this essential circumstance had no effect as many of the houses at the time, which had been in a good state, are now ruined and destroyed."[169] For some of the returning Alhambra residents, the financial burden of the repair and maintenance of the houses in the Alhambra was too high and many chose to live in the city of Granada instead.

Although the population of the Alhambra recovered after the Napoleonic invasions, reaching 315 inhabitants in 1819, the growth of Granada city, physical decline, and the relative isolation of the Alhambra from the city's industry drew many people down to the city.[170] The Convent of San Francisco had been closed under Napoleon's occupation and only partially reopened after the French retreat in 1812. The Alhambra church of Santa María was only occasionally used; the number of people registered at the church dropped from a total of 406 in 1824, to 254 in 1852, of whom 100 were prisoners and 8 resided in the barracks.[171] Successive outbreaks of cholera did not help the population, especially in 1833 to 1834, when a particularly severe epidemic reached Granada. Attempts were made to isolate the Alhambra from the outbreak, but nevertheless it was during one of these episodes that the artist and friend of Owen Jones, Jules Goury, died in the palace in August 1834. Cholera deaths left many houses in the city of Granada empty, which may have further encouraged residents of the Alhambra to move from the neglected palaces to the city.[172]

Artists in the Partal

While the permanent population of the Alhambra decreased during the nineteenth century, the site grew increasingly popular as a destination for foreign visitors, particularly those from France, Britain, Germany, and the United States. The British travel writer Richard Ford (1796–1858) was one of the early visitors to stay at the Partal. He was travelling through Spain to compile his illustrated travel book *A Handbook for Travellers to Spain*. Initially, Ford stayed in the official royal palaces, as Washington Irving did in 1829, then later stayed at the "Casa del Gobernador," in the Cuarto Dorado in 1831, although he soon decided it would be more comfortable for him and his young family to take over an entire house: the Partal.

By the 1830s, the Partal was a two-storey house in poor condition, but it was made habitable with a chimney built onto the front of the building and the addition of several entrances, as Ford's drawing of the house from 1833 illustrates (Figure 5.2). The pool in front of the Partal was overgrown, though its parameters were still visible. In the contemporary sketches of the building by Jones (Figure 5.3) and by Lewis (Figure 5.4), the pool was reduced to a small square in front of the centre of the facade. Ford moved into the Partal with his wife Harriet and their children and stayed there from April to September 1833. He rented it from the tenant, Francisco Sánchez, whom he described as "honest Sánchez" the muleteer. In his diaries Ford described the Partal as "most picturesque inside and outside, and beloved by every artist."[173]

It was on Ford's recommendation that Lewis came to stay in the Partal in 1833. Lewis knew the Partal as the Casa Sánchez, naming his sketch of the mirador's interior mentioned above as "Mirador in Sánchez' Cottage."[174] Lewis was working on a series of twenty-six drawings of the Alhambra, a publication that would lead him to be known for a time as "Spanish Lewis," before he went to live in Ottoman Egypt from 1841 to 1851.[175] Lewis's sketchbook from the period also included a wide view of the exterior of the Partal as a private house surrounded by trees and vegetation (Figure 5.5). The mirador tower peeps out between two tall trees that grow in the gardens and the Albaicín hill is visible to the left of the tower.

He would go on to become one of the leading western painters of Cairo. His detailed and careful paintings often portrayed interior domestic scenes with a sensitivity that was at odds with the orientalist fantasies painted by many of his contemporaries.

In his coloured sketch of the mirador interior (Figure 5.1), Lewis highlighted the ruinous state of the mirador, with plants growing in through the windows, cracks in the walls, and damage to one of the window frames. The marble columns that Simón de Argote had described in situ over two decades earlier, columns that supported the arch that separates the two rooms of the mirador, are not present in Lewis's sketch. The glazed ceramics that had adorned the walls are missing, the floor is cracked, and there are large holes where the decorative plasterwork has been damaged.

Fig. 5.4

John F. Lewis 'Casa de Sanchez, an old house of the Alhambra'
[sic], lithograph, plate V from Lewis *Sketches and Drawings of the
Alhambra, made during a Residence in Granada in the years 1833-34*
[London: Hodgson, Boys & Graves, 1835]. 26 x 36.7cm.

Fig. 5.2

Richard Ford, 'Casa Sánchez', 1833.
Drawing on paper. Public domain.

Fig. 5.3

**Owen Jones, 'Casa
de Sanchez'**
[sic], plate LI, from
Jones, *Plans,
Elevations, Sections
and Details of the
Alhambra vol.1.*
[London, 1842-5].
Woodblock print on
paper. Public domain

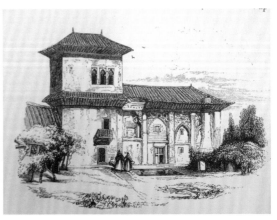

Fig. 5.5

John Frederick Lewis, Sheet from a sketchbook used in Spain, c.1833.
Tate Collection, Inv.Nr.: T09622. Graphite and gouache on paper,
10.3 x 13.7cm. © Tate, London 2019.

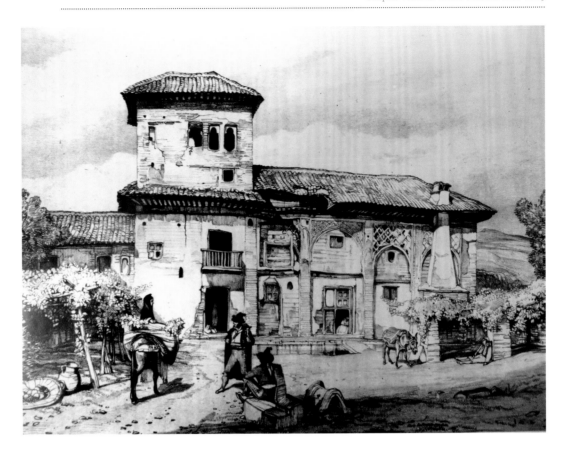

Among his published Spanish lithographs is one finished drawing of the exterior of the building in which Lewis depicted something of everyday life in the Partal in the early nineteenth-century (Figure 5.4). In this drawing we can see that the brick pillars and arches of the facade have been filled, although are perforated by windows, balconies, a chimney, and doors. The main entrance is through the door in the bricked-up arch to the left. The plaster on the facade is visibly crumbling, and the roof seems to have been damaged in parts. A small section of water is still visible in front of the building, reflecting the pillars. Despite its crumbling condition, Lewis populated the Partal with people; perhaps those who inhabited the building. A woman sits inside the central doorway, while to the right of the picture a man lies with his donkey beneath vine leaves. A young woman sitting on a horse seems to be selling something, perhaps food, to two rakish looking men, possibly soldiers, who are waiting outside the house.

Owen Jones (1809–74), the prominent design reformer and theorist, also populated his sketch of the Partal with two standing women and a seated figure, showing the building as inhabited (Figure 5.3). Jones first visited the Alhambra in the summer of 1834 and returned in 1837. Although he didn't stay in the Partal, he included a detail of plasterwork from the mirador of the Partal in the second volume of his publication *Plans Elevations and Sections of the Alhambra*, in which he described the Partal as a "ruin," which nevertheless contained "some of the most minute and beautiful specimens of plaster decoration that are to be found in the Alhambra."[176]

Jones included a small woodcut of a drawing he made of the exterior of the Partal, under the section "Torre de las Infantas". In a note, Jones added that "the Casa de Sánchez no longer possesses the picturesque appearance shown in the woodcut. In 1837 the whole front was *restored* and *beautified*, and the pond converted into a garden by one of the resident military officers of the fortress" [italics in original].[177] The restoration Jones was referring to was probably the insertion of dormer windows above the main portico and in the west roof of the mirador in the 1830s. The mirador windows were partially filled in, presumably to control the temperature of the interior, indicating that despite its ruinous condition as depicted by Lewis, the mirador was used as a residence at this time.

One year before Jones's first visit, the Scottish artist David Roberts (1796–1864) spent two weeks in Granada drawing the palace and city in 1833. In one of his paintings Roberts pictured the Partal palace with its tower in a view from the later Nasrid palaces that would become popular with artists, with the Generalife and Sierra Nevada mountains in the background, setting the Partal within the wider romantic context of the royal palace. Lewis and Roberts corresponded while both were in different parts of Spain drawing and painting its sights; Lewis wrote to Roberts in February of 1833 that "I trust you may meet with the same satisfaction and delight I did in the short time I stayed there."[178] In a lively description that Roberts wrote to his sister, he explained that "the architecture is so peculiar and elaborate that it would take months to do it justice. [...] Now I am going to smoke a cigar and go to bed, to dream of Moors and Christians, tournaments and battles, painting and architecture."[179] Roberts views of Spain accompanied Thomas Roscoe's hugely successful series of illustrated travel and history books *The Tourist in Spain* (1835).[180]

The French artist Joseph-Philibert Girault de Prangey (1804–92) visited the Alhambra in the same year as Lewis (November 1832) and described the Partal interior in his 1841 essay on the architecture of the Alhambra. He described two storeys, with three rooms in each, with stairs that led up to an "exquisite mirador."[181] His publication included paintings of some of the details of interior decorative panels of the Partal.[182]

Around the same time, Carl von Diebitsch (1819–69), a German architect and designer, also spent several months in the Alhambra drawing and copying its interiors with sketches and paper moulds, including a sketch of the Partal (Figure 5.6). Like Jones, Diebitsch was interested in the application of design ideas from the Alhambra to contemporary buildings. He was responsible for several "Moorish" houses around Berlin, and made available his cast-iron Alhambra-style columns and capitals, which he had copied from moulds made in the Alhambra.

These artists and writers were attracted by the picturesque setting of the Partal with its dramatic backdrop of mountains and valleys and the visible remnants of Nasrid motifs on its crumbling, picturesque facade. It was widely known that along with other buildings outside of the of-

Fig. 5.6

Carl von Diebitsch, 'Wohnhaus in Spanien', sketch on paper of the Partal. 25 x 36.3cm. ©Architekturmuseum der Technischen Universität Berlin in der Universitätsbibliothek. Inv. Nr.: 41873.

ficial royal palaces, it had been part of the Nasrid palace complex, but as a two-storey converted building with its water pool filled in and its portico walled up, it bore little resemblance to the Comares or the Court of the Lions. In the sketches and paintings of the Partal by artists in the 1830s, many show the Partal as Argote described it in his writing: a crumbling edifice with only traces of Nasrid decoration visible on the facades. The Partal also appears in a popular view painted from a mirador in the royal residences, the Peinador de la Reina mirador. The framing of some of these Partal depictions reveals the lens of romantic nostalgia through which the Alhambra and much of southern Spain was viewed at the time. In a print published in his 1836 collection of lithographs from Spain, "Distant View of the Sierra Nevada,"[183] Lewis painted a view of the Partal with the Sierra Nevada mountains beyond (Figure 5.7). A seated lady with her small dog gazes back towards the Partal from a viewing balcony (in the Peinador de la Reina) across the steep hill that separates them. The Partal dominates the image, its facade highlighted with white paint and shown as a palace rather than a mere house, while the crumbling brickwork reveals its deteriorated condition. The wistful, backwards gaze of the young woman towards the Partal embodies the nostalgic lens through which the whole of the Alhambra was seen.

Fig. 5.8

George Vivian (1798-1873)
Lithograph, plate XXVIII, from *Spanish Scenery* (London: P. and D. Colnaghi, 1838). 43 x 28cm.

The same view was painted by the artist George Vivian (1798–1873) in 1835 as "Part of the Alhambra from the Tocador de la Reina,"[184] in which a male figure sits under the arch, gazing back towards the Partal, the facade crumbling and its windows blocked up, while a small troop of soldiers approach from below (Figure 5.8). Vivian had travelled around Spain in 1835 and 1837 and as he explained in his introduction to the publication of his collection of lithographs, he wanted to preserve the traces of buildings that remained in the face of the emptying of the monasteries and convents across Spain, which he had observed. He wrongly identified the Partal as the Convent of San Francisco in his introduction, having probably been inspired by Lewis's sketch.[185]

It was also around this time that Washington Irving's *Tales of the Alhambra* were enjoying their greatest popularity. In his literary sketchbook stories Irving revived the Islamic past through historical tales set in the present-day Alhambra. The palace was described in nostalgic terms that

Fig. 5.7

John F. Lewis
'Distant View of the
Sierra Nevada'
lithograph, plate VIII
from Lewis *Sketches of Spain and Spanish Character made during his Tour of that Country, in the Years 1833-34* [London: F.G. Moon, 1836], 54.7 x 37.5cm.

blamed the decrepit state of the building on the contemporary inhabitants of Granada, while celebrating those crumbling ruins as emblematic of a lost golden age in western European history.

The Removal of Parts

For some visitors, the Alhambra became a site for spolia, a place from which souvenirs and structures were taken. One of the worst offenders was Richard Ford, whose stay at the Partal in 1833 may have contributed to the loss of some of its original interiors. Ford was not unaware of the Partal's significance: he included sketches of the Partal in his successful publication on Spain and knew the "Casa Sánchez" had once been a Nasrid building. He had met Argote and bought all three volumes of Argote's books on Spain, the third volume of which included the detailed historic description of the Partal. The interest of Ford's contemporaries such as de Prangey and Jones in the Partal, including in its interior decoration, would not have escaped Ford's notice. This was not a forgotten or unknown part of the Alhambra, but a palace of recognized and well-known historic significance.

Nevertheless, on his return to England, Ford built himself an Alhambra-style tower at his home in Heavitree, Devon, using carved panels (probably plaster) that he had taken from the Partal (Figure 5.9). A catalogue entry (number 15) in an exhibition about Ford from 1974 notes that a sketch by Ford of the Partal is inscribed on the back "Casa Sánchez in which we lived, 1833. Alhambra, Granada."[186] Another entry in the catalogue describes a "Section of Moorish Carving from the Casa Sánchez" measuring 2.3 metres long as follows: "This carving was used by Richard Ford as part of the cornice in a bathroom at Heavitree House." It is not clear whether this refers to a carved stucco or carved wood section, nor is it clear from which part of the building it was taken. Heavitree House was pulled down in the 1960s and the present location of this carved piece is unknown.

Ford's removal of parts of the Partal is extraordinary when we read his scathing criticism of the local population's perceived lack of care for the Alhambra. He accused them of "vandalism in labouring to mutilate, what the Moor laboured to adorn." In a passage in his "Gatherings from

Fig. 5.9

Photograph of the 'Moorish' tower in the gardens of Richard Ford's Heavitree House in Exeter, before 1878. From Richard Hitchcock, 'Richard Ford of Heavitree', from the Heavitree Local History Society Newsletter, September 2016 www.heavitreelocalhistorysociety.co.uk.

Pl. Ib. *Photograph, before* 1878 : The Moorish Tower in the gardens of Heavitree House (162)

Spain," Ford describes the Spanish as "Asiatics" unable to appreciate history or beauty. He wrote:

> The Alhambra, the pearl and magnet of Granada, is in their estimation little better than a casa de ratones, or a rat's hole, which in truth they have endeavoured to make it by centuries of neglect; few natives even go there, or understand the all-absorbing interest, the concentrated devotion, which it excites in the stranger; so the Bedouin regards the ruins of Palmyra, insensible to present beauty, as to past poetry and romance. Sad is this non-appreciation of the Alhambra by the Spaniards, but such are Asiatics, with whom sufficient for the day is their to-day; who care neither for the past nor for the future, who think only for the present and themselves, and like them the masses of Spaniards, although not wearing turbans, lack the organs of veneration and admiration for anything beyond matters connected with the first person and the present tense.[187]

Ford's reference to Palmyra is pertinent, as this important site in Syria was undergoing a similar transformation in the nineteenth century from a place of continuous habitation by a local population who lived in and maintained its structures, to one in which the local Bedouin population were removed to a new town so the archaeological site could be preserved as a historical site of antiquity.[188] Like the Spanish in the Alhambra, who for Ford "lack the organs of veneration and admiration for anything beyond matters connected with the first person and the present tense," the Bedouin who lived in Palmyra were cast as lacking the ability to know what they saw, a framing which enabled the authorities to emp-

ty the site of its resident and nomadic populations. French scholars who had control of the Palmyra site were interested in the preservation of a particular sanitized version of antiquity that favoured a long-dead population over the living, contemporary population on the site. As Wendy Shaw has recently argued, "the resurrection of ruins comes at the cost of the destruction of the living aspect of the very heritage that ruins are supposed to represent."[189]

Ford's description of the Spaniards in Granada as Asiatics in all but dress—"not wearing turbans"—reveals the orientalist lens through which the Alhambra and much of southern Spain was viewed by westerners (including by those in Madrid) at the time. He described the local population as inherently ignorant of its own history and surroundings. This way of thinking would ultimately permit the ownership and responsibility for the site of the Alhambra to be taken away from the local population and placed into the hands of those who, according to Ford and his contemporaries, really understood the history and significance of the palaces. According to Ford, it was the task of the western scholar to save the Alhambra and its buildings from the apparent ignorance of a local population, which he argued had lost any connection with its own tactile past, monuments, and history. Despite the evidence that the resident population who had lived in the Alhambra had maintained its buildings and water courses while attempting to forge contemporary lives within its precincts in the face of neglect and lack of investment from the central authorities, Ford and his contemporaries saw this indigenous population as responsible for the site's decline. This would culminate in the declaration of the Alhambra as a national monument in 1870 and the subsequent clearing of the local resident population from the entire Alhambra site in the course of the twentieth century.

Meanwhile Ford participated directly in the destruction of the site by taking parts of the building for his own use. The Partal was not in any imminent risk of destruction and it was recognized by scholars and authorities as a historic Nasrid structure, albeit one that was in poor condition. But it was this twisted narrative in which the building had to be saved from an ignorant and careless local population that allowed Ford to remove parts of the building for his own personal use.

A similar process was involved when others, including Gwinner in the 1890s, removed parts of the Alhambra in the following decades. The widespread framing of the resident population as ignorant and careless of these globally significant buildings, allowed others to justify their actions as restoration, salvation, or simply taking what would inevitably be destroyed anyway. The chipping away at the walls of the Alhambra by visitors for souvenirs was parodied in a cartoon by the French artist Gustave Doré in 1874, in which a well-dressed foreign couple surreptitiously steal tiles from the walls of the Alhambra (Figure 5.10). Some of these pieces ended up in the collections of museums across the world, donated years later by the descendants of individuals who had visited the palace.[190]

While foreign visitors in the nineteenth century were showing a new and sometimes destructive interest in the Alhambra, the Spanish royal household, responsible for the upkeep of the royal complex, was indulging in oriental fantasies staged in the grounds of the palace itself. Although the palace was considered unsuitable as a royal residence by this time as it was too run down, too insecure, and above all too far from Madrid for the princes, this did not stop it from being used as a theatrical

Fig. 5.10

Gustave Doré, 'Les voleurs d'azulejos a l'Alhambra' from Jean Charles Davillier *L'Espagne* (Paris: Librairie Hachette, 1874), p.162.

set for staging royal events. In 1832 Prince Francisco de Paula and Prin-
cess Luisa Carlota announced a visit to Granada.[191] That visit culminated
in a meal and party in the Alhambra, which was decorated with orien-
tal-style furniture and hung with oriental-style fabrics for the event.
Five hundred guests were invited, and the palaces lit with over four thou-
sand lamps in an oriental style apparently reminiscent of the Arabian
nights.[192] A contemporary description by a dramatist from Freiburg of
the parade of the prince through Granada described how, "as night fell,
all of Granada was lit up in the most festive way. A sight that reminds one
of the fairy tales from the 1001 Nights and of the Mohammedan para-
dise."[193]

Just as the royal household was selling off parts of the Alhambra, such as
the Partal, it was simultaneously participating in an exoticized, Alham-
bresque fantasy both behind the crumbling facades of the building itself
and within the walls of its own palaces in Madrid, where versions of a
re-coloured, embellished Alhambra were being erected with the rise of
the global Alhambresque style, as the next chapter will describe.

Chapter Six:
From Granada to Berlin:
1885–1978

He has been to every country there is; he is familiar with their languages and customs and just as much at home in Madrid as in Constantinople, in New York as well as London or Paris.
—Description of Arthur von Gwinner, head of Deutsche Bank, from a 1910 financial publication

In a photograph from around 1928, the Partal cupola appears in the home of the German banker and industrialist, Arthur von Gwinner (1856–1931) (Figure 6.1). The photograph shows the interior of a bourgeois home that is formally furnished, but with unusual features: the room in the foreground is crowned with the wooden cupola, complete with an oriental-style lamp hanging from its centre. The walls beneath the cupola are decorated with patterned ceramic tiles and moulded plasterwork. Through the open doors in the background, a large painting of a tower hangs over a sideboard. In a note handwritten in Spanish by Gwinner on the surround of the photograph, he identifies himself as the painter and names the tower featured in the painting as the Partal.[194] He reveals that he painted it in 1882, "not knowing that three years later, the Torre de las Damas would be mine." Almost a century after the photograph was taken, Gwinner's granddaughter would recall sitting in this room beneath the cupola with her grandfather as he showed her his collection of fossils from around the world.[195]

Gwinner was an educated and cultured man, who spoke French, English, and Spanish and was a keen collector of coins, minerals, fossils, and botanical specimens from his travels (Figure 6.2).[196] But it was not the old and distinguished Gwinner who bought the Partal palace and disman-

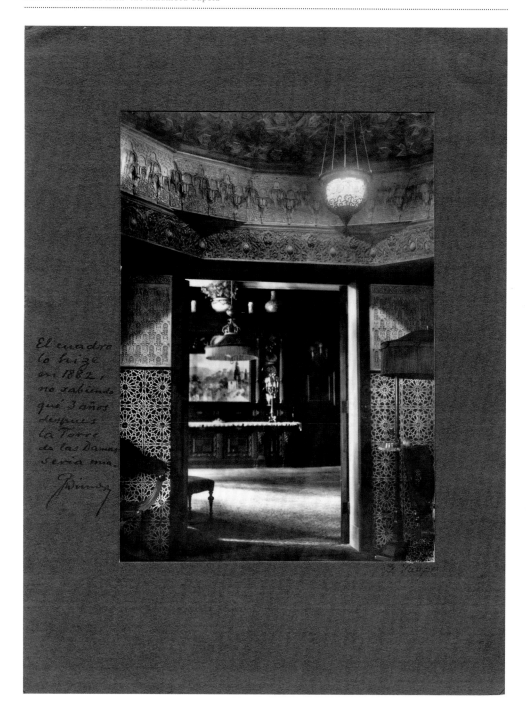

Fig. 6.1

**Photograph of the Alhambra cupola installed in
the Berlin home of Arthur von Gwinner**
c.1928, with a handwritten note by Gwinnner
on the paper mount. Private collection.

Fig. 6.2

Arthur von Gwinner
c1910. © Historisches Institut der
Deutschen Bank, Frankfurt.

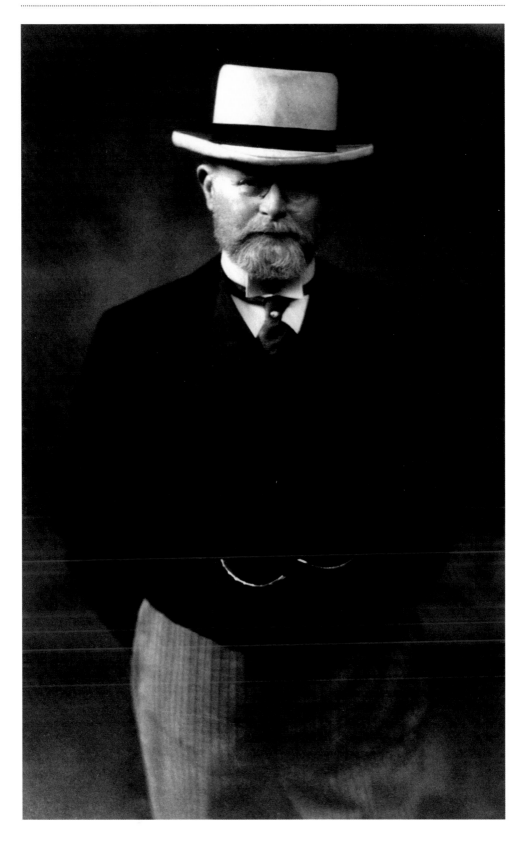

tled its cupola, but a much younger man in his late twenties. Indeed, it was probably not even in Granada but rather in London that Gwinner first encountered the Alhambra. In the late 1870s the young Gwinner moved from his home in Frankfurt am Main to London, where he stayed for four years. He worked for the merchant bank Schuster Sons & Co., a bank that had been founded by German Jewish banker Leopold Schuster (1791–1871) and was involved in financing the expansion of the railways in the south of England. Gwinner had contacted the bank through the connections of his parents, probably through the Frankfurt branch of the Schuster family. Felix Schuster (1854–1936) was a contemporary of Gwinner's in Frankfurt, who went to London around the same time to work in his uncle's bank. It was under Schuster's guidance that Gwinner began his lifetime involvement in the railway industry that was to become such an important part of his later career at the Deutsche Bank. It was also through Schuster that Gwinner first encountered the Alhambra.

London in the mid-nineteenth century had been gripped by a kind of "Alhambra fever" through the work of Owen Jones, the prominent design reformer and theorist. Jones had published his detailed study of the Alhambra palace in *Plans, Elevations, Sections and Details of the Alhambra* (1842–45), which was followed by his very successful book on global design, *The Grammar of Ornament* (1856).[197] Jones's fully illustrated books were successful across the world, but it was through his building of a scaled reproduction of one of the Alhambra palaces that Jones reached his greatest public audience in Britain. Specifically, Jones produced a scaled replica of the Court of the Lions in one of the Fine Arts Courts that was introduced to the version of the Crystal Palace that was erected at Sydenham in 1854. Jones had been a member of the committee for the original Great Exhibition of 1851 and was responsible for the colour scheme that was used to decorate the interior of the Crystal Palace building that Joseph Paxton had designed to house the exhibition in Hyde Park. When the Great Exhibition closed and was dismantled in October 1851, a private consortium of financiers decided to erect a second and larger version of the Crystal Palace outside of central London, in the suburb of Sydenham. This second Crystal Palace received millions of visitors annually to its permanent exhibitions, concerts, and theatrical performances.

For this new version of the Crystal Palace, Jones and his collaborators built a series of replicas of architectural courts as a showcase for historical styles from across the world. The courts included examples from Egypt, Greece, Byzantium, Rome, and the Renaissance, but Jones's Alhambra Court was the only one dedicated to a single building. Jones relied on the plaster casts, paper moulds, drawings, and colour studies that he had made of the Alhambra during his stay at the palace in Granada as sources for his London version of the Alhambra court. He wrote:

> The authorities which have served in this reproduction of a portion of the "Alhambra" are, the plates of my published work, and a collection of plaster casts and impressions on unsized paper (which were taken by me in the Spring of 1837) of every ornament of importance throughout the palace of the "Alhambra," the low relief of the ornaments rendering them peculiarly susceptible of this process. From these casts and paper impressions, full-sized drawings have been made with great fidelity, by my pupils Albert Warren and Charles Aubert, and the ornaments carved, moulded, cast, and fixed by Mr. Henry A. Smith and his two sons, assisted by a very intelligent body of English workmen.[198]

Jones insisted that he did not aim to create a perfect replica, but rather a re-creation of the spirit of the palace, intended to educate and inspire rather than to imitate. Jones died in 1874, before Gwinner moved to London, but his Alhambra Court continued to be visited by millions of people each year at the exhibition at Sydenham. Gwinner's boss at the bank, Leopold Schuster, had been a member of the consortium that had relocated the Crystal Palace from Hyde Park, while Schuster Sons & Co. was also involved in financing the railway that brought visitors south from central London to Sydenham.[199] For part of his time in London, Gwinner lived directly on the edge of the park in Sydenham, where the Crystal Palace was erected (now known as Crystal Palace park) and would have visited the exhibition and Jones's Court. In his memoirs he describes swimming in the landscaped lakes of the park early in the mornings. His friendship with one of the assistant keepers of the South Kensington Museum, Johann Wilhelm Appell (1829–96), led him to the heart of

cultural events in London—openings of the Royal Society, theatre, and art—where he later wrote that he hoped to learn about the "soul of the English people."[200]

Before he left London for Madrid in 1880, Gwinner had already encountered the version of the Alhambra that by the end of the nineteenth century had become popular across the world: that mediated through Jones. In Jones's accurate and detailed published drawings and built model of the Alhambra he replaced the colour that had been lost over the centuries, re-imagining the plasterwork and carved wood interiors of the palaces in the chromatic fullness of his published images. In both literature and music, the Alhambra became the backdrop for a certain type of romanticized nostalgia that was popular in the nineteenth century.

This re-imagined Alhambra, an exotic place of lost power among near-ruined buildings, entered popular consciousness through the success of novels by writers such as Washington Irving, whose stories, mentioned above and first published in 1832, imagined the palace as the site of his romantic and fanciful historical tales.[201] Popular operas and musical compositions from across Europe staged similar themes of nostalgia and loss in the Alhambra palace; for example, the story of the last Muslim ruler of Granada was explored in Moritz Moszkowski's *Boabdil der letztet Maurenkönig / Boabdil the Last Moorish King* (Berlin and Leipzig, 1892), while the Spanish composer Francisco Tárrega paid homage to his memories of the Alhambra in his famously evocative guitar solo *Recuerdos de la Alhambra / Memories of the Alhambra* (1880s).

Travel guides and history books also introduced the Alhambra to both the armchair and travelling tourist. Both David Roberts and Richard Ford published their drawings and descriptions of Spain as travel guides. Ford's *A Handbook for Travellers in Spain* was immensely successful as one of the first of many instructional guidebooks aimed at the intrepid tourist to be published by John Murray, whose guidebooks paved the way for the handbooks of Baedeker and the Blue Guides in later years. Gwinner recalled that it was the historical travel book on the art and poetry of Spain and Sicily by Adolf Friedrich von Schack (1815–94) that first inspired him to visit Granada in the autumn of 1882, where he made his

painting of the Partal.[202] Like many of his generation, Gwinner fell for the romanticized charm of the Alhambra depicted in its pages.

Gwinner moved to Madrid in 1880, where he spent the next six years working for a subsidiary of the Paris-based bank Union Générale, while at the same time acting as honorary consul to the German Empire in Spain. Shortly after arriving in Madrid he met Anton Widmann (1856–85), a young German architect who was living as a tenant in the Partal at the time and convinced Gwinner about the potential of restoring the building.[203] Both Widmann and Gwinner would have been very aware of the significance of the building as a historic Nasrid palace and of the potential value of the building once restored.[204]

The Sale

In 1885 the Partal belonged to Modesto Landa Lluch, a forty-six-year-old former opera singer from Granada.[205] Landa had bought the building in 1873 from Ricardo Morales y Castro, in whose private hands it had remained despite the fact that in 1870 the Alhambra was declared a national historic and artistic monument (*Monumento Nacional, Histórico y Artístico*) by royal decree. By 1885 Landa had accrued significant debts against his property, including a loan of 10,000 *pesetas* from someone whose name Landa apparently could not remember at the time of sale.[206]

Widmann had been residing in the Partal as a tenant and no doubt knew of Landa's debts, as it was from Widmann that Gwinner learnt that the Partal was for sale. Although the sale document from 1885 was between only Landa and Widmann, according to Gwinner's memoirs it was bought with Gwinner's own money.[207] The document includes a clause that stated that the tower and its mirador were excluded from the sale, and would initially remain in Landa's possession.[208] Widmann purchased the portico with its lower tower and the garden, which had been planted over the former water pool (Figure 6.3). The total price of the Partal was agreed at 34,750 *pesetas* for the house with its garden and water source. For this property, Widmann and Gwinner agreed to pay 15,000 *pesetas* in silver and gold coins and to pay the remainder on the same date (8 June) of the following year (1886).

However, the sale agreement included another crucial clause, which stipulated that the cupola, referred to as the "old Arab ceiling," in the mirador that had been retained by Landa, would be removed by Widmann, who agreed to replace it with a new one at his own expense. Widmann also retained the right to purchase the tower and mirador after a period of one year, for an additional 1,000 *pesetas*.[209] This important clause proves that Widmann (who was acting with Gwinner's money) intended to remove the cupola when he first purchased the Partal. Gwinner suggests in his memoirs that the cupola was removed as a last-minute, sentimental gesture, an afterthought that occurred to him before he donated the Partal to the Spanish state in 1891. However, this clause indicates that a different process was in place: one in which Gwinner and Widmann had identified the cupola as a desirable object and wrote their intention to remove it into the sale document, right from the time of purchase.

Widmann began the work of restoring the Partal in the summer of 1885, apparently going some way towards revealing the dimensions and surviving details of the windows in the lower part of the building.[210] But on 8 August 1885, a mere two months after purchasing the Partal, Widmann died of cholera in the building aged only twenty-nine, leaving his early restoration work unfinished and the cupola still in place. Gwinner then quickly acquired the building from Widmann's family, who had inherit-

MUSEO GRANADINO. — Fachada de ingreso à la Torre de Ismael, desde el carmen llamado de las Damas.

Fig. 6.3

The Partal before the pool was restored, photographed in c.1886 by Antonio Almagro Cárdenas for his publication *Museo Granadino de antigüedades árabes. Colección de estudios arqueológicos sobre los monumentos árabes de Granada que hoy se conservan en poder de particulares y datos sobre otros que ya han desaparecido* (Granada: Imprenta de la Lealtad, 1886). Private collection.

ed it after their son's untimely death.[211] Shortly afterwards he bought the remaining rights to the rest of the tower and mirador from Landa, who remained as a tenant in the absence of Gwinner and Widmann.[212] It must have been soon after this date that Gwinner had the ceiling removed.[213]

The question of exactly when it was dismantled can be narrowed down to within just over two years between late 1888 and early 1891. The cupola was still in place in the mirador in 1888, when it was described by members of a local cultural group, the Centro Artístico, Literario y Científico de Granada, who made an excursion to the Partal in October 1888 and published a record of their findings.[214] They describe the Partal as "one of the most sumptuous buildings in the Alhambra" that was "sold for a tiny amount, passing through the hands of various individuals until it arrived to those of a foreigner, to the shame of Granada and the nation which does not appreciate its artistic value, exposing its monument to irreparable mutilations." They described the interior of the mirador, with its cupola still in place, as in a better state of conservation than the building's other ceilings.

By 13 March 1891, however, the cupola had been removed (Figure 6.4). It was on this date that ownership of the building was transferred, apparently by donation, from Gwinner to the Spanish state, although Gwinner retained possession of a small modern building in the garden of the Partal, known as the Casa de Ayala, until 1921.[215] Gwinner ceded this final property to the Spanish state on 27 April 1921, shortly after which it was pulled down (Figure 6.5).[216]

Gwinner's donation of the Partal to the State was a pivotal moment in the building's history, marking its entry into public ownership for the very first time. It is likely that these "donations" were encouraged by the passing in Spain of the Expropriations Act of 1879 (Ley de Expropiación Forzosa), which allowed authorities to claim the properties. However, his donation of the building was an act for which the authorities were grateful enough to erect a plaque recording the event in the Partal portico.[217]

The Cupola in Berlin

The cupola is not a naturally portable object. Like other architectural elements that have been taken from their original sites—the Mshatta facade

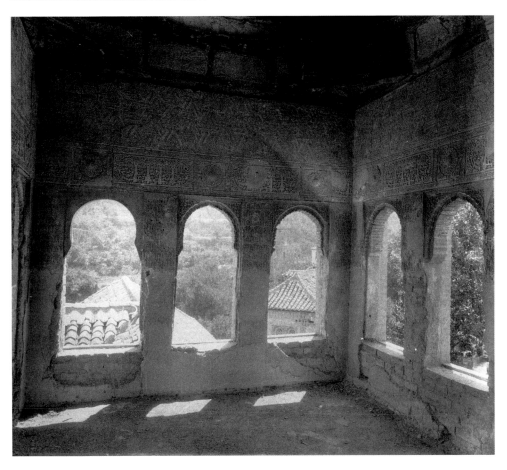

Fig. 6.4

The interior of the Partal mirador in around 1901, with its cupola missing.
Photo: M.I.K. Archive, Berlin.

in Berlin, or the wooden *mudéjar*-style church ceilings at the Archaeological Museum in Madrid, for example—these buildings and their parts were made to be immovable. They were designed to relate to their immediate environment: to the topography of the landscape, the cycle of daily light and shade, the direction of the wind, and the humidity of the air, as well as to engage with surrounding structures. Although more portable artworks like paintings, sculptures, ceramics, or tapestries were often created with a specific cultural space and purpose in mind, they were nevertheless made with the inbuilt possibility of their movement: they were provided with nails, handles, hooks, and frames.[218] Architectural artefacts were not given handles. The possibility of moving the Mshatta facade from Jordan to Berlin was not something its builders ever took into consideration. The craftsmen who built the Alhambra cupola did not make it to be moved.

Fig. 6.5

View of a street alongside the Partal, showing modern houses (right) that were subsequently demolished in the 1920s.
12 x 17cm APAG / Colección fotográfica del Museo de Arte Hispano Musulmán / F006554.

It must have taken much effort, expense, and determination on Gwinner's behalf to dismantle the cupola, box it up, and send it from Granada to Berlin to be re-erected in his home. It was not, in other words, a simple question of buying a ceiling on a whim; it required a not inconsiderable desire to acquire this object. The movement inevitably had a permanent impact on the fabric of the cupola as well as on the Partal mirador. Understanding why Gwinner might have wanted to bring it to Berlin and what he did with it once it was there, is therefore a crucial part of its story.

Gwinner himself provides deeply personal reasons for taking the cupola, describing how he was motivated to bring it to Berlin by nostalgia for his time in Spain after he had left the country. In his memoirs, he recalls the views from the mirador windows and the people with whom he had enjoyed those views who "are all now dead, but the cedar wood ceiling [...]

reminds me daily of those beautiful times gone by."[219] However, Gwinner's recollections long after the event omit the fact that he had decided to remove the ceiling as soon as he and Widmann bought the Partal. His identification of the "old Arab ceiling" and stated intention to remove it in the 1885 sale document suggests that one motivation for his purchase of the Partal was to acquire the materials he needed to create an exotic space within his Berlin home.[220]

At around the same time he had bought the Partal in 1885, Gwinner had bought a large house in Rauchstraße in Berlin. In 1886 he married Anna Speyer, a Jewish woman from the wealthy Frankfurt banking family Lazard Speyer-Ellisen. The newlyweds moved to Berlin, where Gwinner quickly became integrated into the lively intellectual and financial scene, and they visited Granada together on their honeymoon in 1886. However, Gwinner's increasingly successful career at the Deutsche Bank meant that he had little time to devote to his Nasrid tower.[221] At some point shortly after Widmann's death, Gwinner wrote to his tenant at the Partal, Modesto Landa Lluch, and asked him to dismantle the cupola and send it to Berlin.[222] It was in the house at Rauchstraße that he first used the cupola to furnish an oriental-style room; employing a master builder to help construct the house and install the cupola.[223] The family moved in 1928 to a house at Sophienstraße 25 in Berlin-Charlottenburg, where the cupola was re-installed and from which we have the photographs of the cupola installed (Figures 6.1, 6.6).

This curation of an oriental-style room within a domestic interior was the height of fashion among the wealthy and cosmopolitan elite in nineteenth-century Berlin. These exotic spaces were used for entertainment, for smoking or drinking coffee for example, and for the display of the patron's sophistication.[224] This style was popularized by its use in royal palaces in the first half of the nineteenth century. At the Winter Palace in St Petersburg, Empress Feodorovna's bathroom was decorated in an Alhambresque style complete with Alhambra-style vases (Figure 6.7). Prussian architect Carl von Diebitsch, discussed in Chapter Five, built a "Moorish Bath" (1857) at Schwerin for the Grand Duke Friedrich Franz II complete with furniture designed in an Alhambresque style, though sadly none of this survives.[225] In Spain at the Palacio Real de Aranjuez in Madrid,

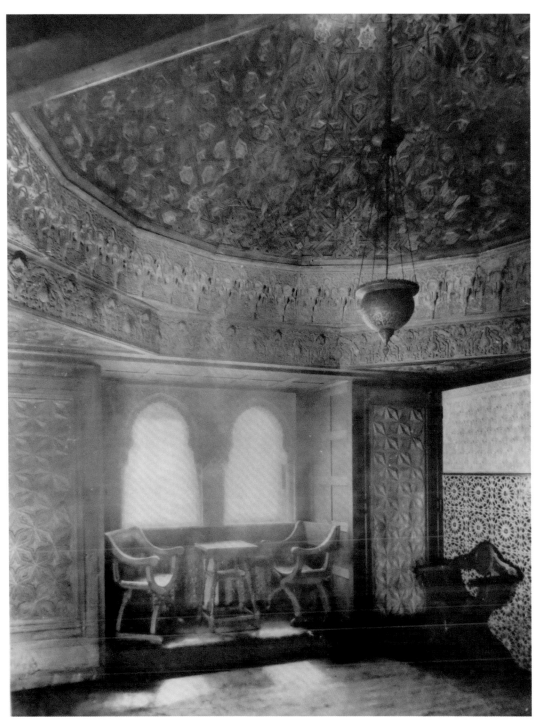

Fig. 6.6

Photograph of the Alhambra cupola installed in the Berlin home of Arthur von Gwinner c.1928.
Photo: M.I.K. Archive, Berlin.

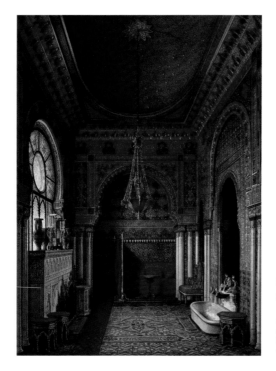

Fig. 6.7

Edward Petrovich Gau (1807-1887),
*The Bathroom of Empress Alexandra
Fyodorovna, Interiors of the Winter
Palace, Saint Petersburg*
Watercolour on paper, 41.7 x 30cm,
1877. Public domain.

Queen Isabella II commissioned the conservator of the Alhambra, Rafael
Contreras, to build her an "Arab room" based on casts taken by Contreras
from the Hall of the Two Sisters at the Alhambra (1847–51).[226] In Egypt,
the *khedive* Ismail had an Alhambra-style pavilion built at Gezirah pal-
ace, outside of Cairo, as part of his festival architecture for the opening
of the Suez Canal in 1869. Designed by European architects, including
von Diebitsch, with an interior possibly by Jones, the *khedive* intended
this summer pavilion as a residence for the visiting empress Eugenie, the
Spanish-born wife of Emperor Napoleon; a Spanish-style palace for the
Spanish-born wife of the French emperor whilst in Egypt.

This aristocratic trend spread, largely through images in illustrated pub-
lications, and was adopted by wealthy individual patrons in their private
homes. Gwinner's colleague at the Deutsche Bank, Emil von Stauß (1877–
1942), had an oriental room made for his own house, which had been
modelled on the Aleppo Room at the Kaiser-Friedrich-Museum Berlin.[227]
In nearby Potsdam, the banker Herbert Gutmann (1879–1942) had a
Damascus-style room built in his home.[228] In Britain at Grove House in
Hampton, Surrey, for example, John Charles Stutfield (d. 1925) built a
music room that closely followed Jones's Alhambra designs, complete
with gilded columns and coloured ceramics and plasterwork.[229]

These domestic interiors used a mix of "authentic" objects, such as original tiles and textiles that were bought on the market or sourced from dealers in Damascus or from sites such as the Alhambra, and replicas made by craftsmen who used plaster moulds and designs published in books like Jones's *Grammar of Ornament*. In Berlin, von Diebitsch made oriental-style wooden furniture and architectural accessories for the German market, including the cast-iron columns and capitals he copied from columns in the Alhambra, which he advertised for sale in the catalogue of the Lauchhammer foundry near Berlin.[230] Some individuals mixed original objects with bespoke pieces: in London, Lord Leighton (1830–96) built an Arab Room in his house in Holland Park (1877–79), a space that was created with the architect George Aitchison (1825–1910) in collaboration with the ceramic artist William de Morgan (1839–1917) to house Leighton's collection of Iznik and Damascus tiles, and was furnished with Arab-style chairs and side tables and a central fountain.[231]

Gwinner, like Leighton, decorated his Spanish room with furniture and wall decoration to complement his central, original object: the cupola. The photograph of the cupola in his home shows that he did not simply erect the ceiling in a generic Berlin interior, but actively curated the Spanish room, in which something of the atmosphere of al-Andalus and the mirador for which the cupola was created could be imagined. The cupola was positioned low in the room, above walls that were decorated with Nasrid-style tiles up to the level of the dado. Above this were panels of plasterwork moulded with *sebka* motifs, probably copies from moulds rather than originals taken from the Partal. The tiles visible in the lower part of the photograph may be sixteenth-century Spanish ceramics purchased by Gwinner in Granada or in Berlin. To complete the oriental effect, Gwinner had a double-arched window made and furnished the room with oriental-style tables and chairs (Figure 6.6).

This was a room in which an important figure such as Gwinner could entertain guests, host cultural gatherings, and demonstrate his sophistication and world travels to Berlin society. This was fitting, because Gwinner became one of the most influential political and cultural figures in Berlin between the 1890s and his death in 1931. He was a member of the management board of the Deutsche Bank from 1894 to 1919 and was its

spokesman from 1910 to 1919. His travels on behalf of the bank brought him across the world, from Baghdad to San Francisco to South America and between. He oversaw Deutsche Bank investments, so much so that it was claimed

> Gwinner is the bank's diplomat, he not only appears outwardly calm and dignified but also acts in the same way, facilitated by a certain cosmopolitan flair. He has been to every country there is; he is familiar with their languages and customs and just as much at home in Madrid as in Constantinople, in New York as well as London or Paris.[232]

His personal involvement in the large-scale infrastructural investments in the Middle East by the bank made it even more appropriate that Gwinner should display his worldly knowledge and sophistication through the erection of an oriental-style room in his home. More generally, by the late nineteenth century the German Reich had become deeply involved in the military, economic, and urban restructuring of the Ottoman Empire. This was a time when the intensity and pace of German interest in foreign investment was greater than ever before, with concerted efforts being made to increase Germany's economic and political influence across the world.[233] Gwinner and the Deutsche Bank were intimately involved in these investments, in particular with the financing of new rail infrastructure, a business Gwinner had first learned while working in London.

The Deutsche Bank was granted a concession to build and operate the railway network to link Istanbul with Baghdad, with the Anatolian railway starting in 1889 and then the Baghdad railway in 1903. Gwinner was chairman of the subsidiary company created by the Deutsche Bank to manage the project, the *Société du Chemin du Fer Ottoman d'Anatolie*, which demanded many of his diplomatic skills and to which he devoted over twenty years of his working life. It was Gwinner who signed the agreement alongside Turkish minister Mustafa Zihni Pascha (1838–1911) that gave the go-ahead for the construction of the first section of the Baghdad railway. Such was his national and international renown that the *Washington Post* called him "far and away the most powerful captain of finance, of commerce and of industry in the entire German empire."[234]

Gwinner's influence was not only in the worlds of finance and politics, however. He was an early member of the Berlin Club, a private members' club that was one of the most important places where bankers, industrialists, and intellectuals of the day would meet to discuss current issues away from their offices; a club which included among its members the banker Georg von Siemens (1839–1901), with whom Gwinner shared an office at the Deutsche Bank.[235] Gwinner was also a member of the Humboldt Society, a circle of sixteen leaders in the scientific and cultural worlds who met regularly for intellectual discussion in their private houses. It is entirely likely that this circle of cultural leaders met for their discussions under the canopy of the Partal cupola in Gwinner's home. It may have been at one of these cultural gatherings that Gwinner was introduced to Wilhelm von Bode (1845–1929), the director of the Kaiser-Friedrich-Museum in Berlin, and to Friedrich Sarre (1865–1945), the curator of its newly formed Islamic Department (later the Museum of Islamic Art). Sarre had suggested to Bode that Gwinner should be one of the founding members of his small team of expert advisors to the Islamic Department, who would meet to approve important acquisitions and find ways of financing the activities of the museum. Sarre was looking for ways to finance extensive new excavations of the ninth-century Islamic palace city of Samarra near Baghdad, so it was vital that Sarre proposed people who could be of direct assistance to the museum through their expertise, contacts, and influence in financial and diplomatic circles.[236] Gwinner's involvement would not only provide the Museum with a voice at the heart of the major international bank in Berlin, but he was also someone whom Sarre knew had an interest in Islamic art and culture, through his acquisition of the Alhambra cupola and his work with the Ottoman administration for the Deutsche Bank.[237] In a letter written in 1908 in which Sarre suggested Gwinner as a board member to Bode, he explained that as well as being chairman of the Anatolian Railway company, Gwinner had already shown an interest in "oriental art" as the owner of the "beautiful ceiling of the Alhambra."[238] Though they do not seem to have been close friends, Sarre's mention of the Alhambra ceiling indicates that it is very likely he would have seen the cupola installed in Gwinner's house in Berlin.

It was here, in the house of Gwinner and his family, whose lives and work were at the centre of German culture and finance, in a city, Berlin, from which the collection and study of Islamic art was starting to emerge, that the Partal cupola found itself in the early twentieth century. Gwinner's death in 1931 meant he could not have foreseen the dangers the cupola would face with the outbreak of World War II in 1939, nor witnessed its remarkable survival and eventual installation at the heart of Berlin's museum centre by the end of the century.

Chapter Seven:
From Private Collection
to the Museum

To find a large authentic architectural unit from the Alhambra and be able to purchase it for a museum, is a unique occasion. There are no better ceilings available anywhere and even in the Alhambra itself there is only one which can match it in quality, so this piece of interior architectural decoration is of supreme importance.

— Richard Ettinghausen, from his report written for Klaus Brisch, 1978

Despite Gwinner's close involvement with the new Department of Islamic Art at the Pergamon Museum in Berlin, he did not leave the cupola to the museum on his death in December 1931. The directors (Friedrich Sarre from 1904 to 1931 and then Ernst Kühnel from 1931) may well have been hoping or even expecting to be able to acquire it for the new building for the Islamic department that opened in December 1932. Its rooms had been especially designed to house the collection, including a large room for the Mshatta facade and seventeen rooms organized according to chronological, regional, and dynastic classifications. Despite the small number of objects from Islamic Spain in the collection, a room dedicated to Spanish art (Maurische Kabinett) was designed with precisely the correct dimensions for the cupola (at 3.55 square metres), apparently in expectation of its eventual arrival.[239]

Ernst Kühnel (1882–1964) had a keen interest in the development of this part of the collection, as he had spent time working in Spain and dedicated several publications to the art and architecture of al-Andalus.[240] One of his earliest articles on the subject, published when he was a young assistant to Sarre in 1908, concerned the ongoing restorations at the Alhambra in which he singled out for criticism the changes made to

the Partal and the destruction of parts of its interior. He directed sharp words at Gwinner, who remains unnamed, describing how, "in an unprecedentedly barbaric way, the lovely wall decorations were plastered over, the dainty windows walled in and broken into the wall to make modern apartments, and the last owner, a German, still had the tastelessness to take the unique tower ceiling with him when he gave the palace to the state."[241] Little wonder perhaps that Gwinner left the cupola to his daughter Charlotte von Wedel (b.1891), after his death, rather than to the Museum, leaving its Spanish Room, the Maurische Kabinett, to wait for almost sixty years before the cupola was installed.[242]

In 1942 Gwinner's family, including his daughter Margarethe (b. 1888) and her husband, the violinist Karl Klingler, removed the cupola from the threat of bombings of wartime Berlin and brought it to the Gwinner country house known as Krumke, near Osterburg in the Altmark region (Figure 7.1). It was stored there in cases when a small number of panels were, according to family history, burnt as firewood by Russian soldiers who had occupied the house towards the end of the war.[243]

The Gwinner family, being part Jewish and opposed to the Nazi regime, were in a precarious position at Krumke. Charlotte, a writer and photographer, left Berlin for the relative safety of Bavaria during the war. Karl Klingler was under surveillance by the Gestapo and his work as a musician was severely restricted. At some point, probably just after the end of the war and certainly before 1956, the cupola was brought out of what was then East Germany to Charlotte's house in Bavaria, where it was kept in storage.[244]

On the death of Charlotte in 1972, her nephew Wolfgang Klingler, the son of Margarethe and Karl Klingler, inherited the cupola. Wolfgang Klingler was keen to sell. He offered the cupola first to the Spanish government, at an asking price that had apparently been based on estimates by well-known European art dealers.[245] The then director of the Patronato de la Alhambra, Jesús Bermúdez Pareja (and subsequently Antonio Fernández-Puertas from January 1978), petitioned the Spanish ministry of culture for the funds to buy the cupola, but the purchase was not approved by the Director General del Patrimonio Artístico, the government culture

Fig. 7.1

Members of Arthur von Gwinner's family, including his wife Anna Speyer (centre), and his daughters Charlotte von Wedel (née Gwinner, centre left) and Margarethe Klingler (née Gwinner, centre right) and Margarethe's husband Karl Klingler (right)

Photograph c.1917. © SZ Photo / Scherl / Bridgeman Images

minister.[246] By this time a copy of the cupola that had been made in the 1960s (as we shall discover in Chapter 8), was in situ in the Partal, which may have discouraged the Alhambra authorities from completing the purchase. Spain in the 1970s was an emerging democracy, that had spent almost forty years under the fascist dictatorship of General Franco, a period of isolation from which it was only just emerging following his death in 1975. This political transition in the mid-1970s coincided with a time of great economic instability. It is not surprising that a lack of finances for cultural acquisitions such as the cupola would have con-tributed to the decision by the Spanish government not to purchase the cupola from Klingler. Klingler explained in a letter to Klaus Brisch in 1977 that the negotiations with the Spanish had been sluggish and that the government and Alhambra authorities had little money.[247] When An-tonio Fernández-Puertas examined the cupola in 1978 in Berlin to write an expert report for the Museum, he included some scathing criticism of the Spanish authorities. He identified the cupola as the only architectural

piece from the Alhambra that had left the palace *with* the knowledge and consent of the government.[248] He added that the asking price was very low, almost symbolic, but that the existence of a copy in the Alhambra and the difficult economy in Spain meant that it had not been viable for the Alhambra to purchase the piece and he recommended its purchase by Berlin.

In January 1977 Klingler offered the cupola to Klaus Brisch, the director of the museum of Islamic art in Dahlem, West Berlin.[249] The cupola was sent in pieces to the museum in Dahlem for examination. Brisch obtained expert reports from Antonio Fernández-Puertas and from Richard Ettinghausen, Professor of Islamic Art at the Institute of Fine Arts at New York University. Both men recommended the purchase for the museum in Berlin. Fernández-Puertas extolled its quality and veracity, writing that it was a masterpiece of its kind ("*una pieza maestra en su género*") and arguing that as it was not in the Alhambra, it was better that it was in the museum in Berlin than in private hands.[250] Ettinghausen was effusive in his report. He wrote that the cupola was "of supreme importance," and noted it was "a beautiful and rare ceiling."[251]

> If one or two outstanding buildings of the Near and Middle East should be singled out as of outstanding quality and of tremendous appeal to the Western mind, the Alhambra in Spain and the Taj Mahal in Agra come at once to one's mind. Both are national monuments of world fame and admired by uncounted multitudes of visitors and art lovers, especially the more accessible and more romantic Alhambra. To find a large authentic architectural unit from the Alhambra and be able to purchase it for a museum, is a unique occasion. There are no better ceilings available anywhere and even in the Alhambra itself there is only one which can match it in quality, so this piece of interior architectural decoration is of supreme importance. [...] I can see no better final resting place for this ceiling than the Islamic Museum in Berlin, where it would be a unique first-rate addition. I strongly recommend to the Berlin Museum the acquisition of this beautiful and rare ceiling.[252]

Brisch completed the purchase in July 1978 for a price of DM 500,000.[253]

Museum in Dahlem

Buying the cupola for the museum in Dahlem was an important symbolic step for this collection. Since 1954 there had been two world-class Islamic collections in Berlin: in the Pergamon in East Berlin and Dahlem in West Berlin. The Department of Islamic Art at the Pergamon Museum had closed at the beginning of World War II and subsequently reopened in 1954 with the part of the collection including the large architectural pieces such as the Mshatta facade, that had remained in situ and the objects returned from Russia after the war. Meanwhile in West Berlin, a new display of the large part of the Islamic collection that had been safeguarded in West Germany opened in the West Berlin suburb of Dahlem in 1954. The museum building in Dahlem had been intended to house the collection of non-western art before the war, but had instead been used as a storeroom for the ethnographical collection.[254] This had been intended as a temporary fix to the post-war situation, with Kühnel expressing a desire to see the collections reunited at some point.[255]

The erection of the Berlin Wall in 1961 put paid to that ambition, however, and the display of the Islamic collection in Dahlem became more permanent. In 1971 the collection became part of the new Museum of Asiatic Art (Museum für Asiatische Kunst) complex in Dahlem. Unlike in the Pergamon Museum in East Berlin, where the Islamic collection was integrated within the context of the classical and antique collections, in this West Berlin context, Islamic art was situated within a complex of non-western art comprising the Museum of Far Eastern Art (Museum für Ostasiatische Kunst) and the Museum of Indian Art (Museum für Indische Kunst) alongside the Museum of Ethnography (Museum für Völkerkunde).[256] The separation of western and non-western art collections in West Berlin was mitigated by the fact that the European Old Masters Gallery (Gemäldegalerie) and the Museum of Prints and Drawings (Kupferstichkabinett) were situated in the same building in Dahlem.

For the Museum in Dahlem, the cupola represented a large and important architectural acquisition that offered a substantial experience of Islamic architectural interiors to the museum visitor, one to rival that offered by a visit to the Mshatta facade at the Pergamon, a rivalry of

which the then director Klaus Brisch was aware.[257] The Museum was keen to develop the world class Islamic collection in Dahlem, as by that point it would not have been envisioned that reunification of the city and its museums would take place.[258] Brisch saw himself as continuing the legacy of Sarre and Kühnel and he extolled the cupola's unique qualities and its potential to attract visitors in his acquisition recommendation to the president of the culture ministry, writing that "it is a very important piece of interior design unit from the Nasrid Palace in Granada [...]. Inside and outside of Spain, such an object is never seen on the art market." He argued that it would attract visitors while offering a link with the Museum's founding principles outlined by Sarre:

> The experiences with the visitors of our museum indicate that objects of this kind, as we want to acquire them at the moment, exert a special attractiveness on the viewer. This experience goes back to the years after the founding of the museum in 1904. Therefore, the founder, Friedrich Sarre, has repeatedly sought to acquire units from the interior decoration of Islamic, religious, and civil buildings.[259]

The response to the acquisition was generally positive. In a letter of congratulations addressed to Brisch in 1977, Manuel Keene from the Islamic department at the Metropolitan Museum of Art wrote, "All I can say about your acquisition of the ceiling from the upstairs room of the Torre de las Damas is '*mashallah*' [God willed it]. I am sure you will do a beautiful job of installation and that thousands will be enriched by seeing it."[260] A German newspaper report on the purchase described how the cupola from "one of the most important Islamic monuments" would be hung in the centre of the collection of the Islamic museum in Dahlem.[261]

A Spanish newspaper report was rather less positive about the acquisition, however, when it reported on the call for clarification from the Spanish ministry for culture by a local cultural protection group that was asking why the cupola was not bought by the Alhambra authorities, and wondering whether it might be possible to buy it back from the museum.[262] The President of the foundation of Prussian cultural heritage (the SPK), Werner Knopp, who had authorized the money to buy the cupola for the museum, immediately wrote to Brisch on reading the article. He was, he

wrote, sure of the legal and moral position of the museum, but wondered about its implications.[263]

Brisch's response was no doubt reassuring; he was well aware that the cupola had already been offered to the Alhambra before Berlin had agreed to buy it.[264] He worked quickly to display the cupola, commissioning the manufacture of replacement parts for the small number destroyed during World War II from a local carpentry restoration firm.[265] By 1980 the cupola had been restored and was on show at the Museum in Dahlem. It formed a key part of the Islamic collection at the new premises, a collection that was displayed chronologically in a single large room, with objects in glass cases, carpets displayed vertically on the walls, and lighting for each object. Within this exhibition, the cupola hung in the centre of the room, suspended from a specially constructed black box with its own lighting.

German reunification in 1990 led to the eventual merger of the two Islamic art collections in Berlin to form a new collection called the Museum für Islamische Kunst (Museum of Islamic Art) in the Pergamon Museum. However, before the cupola was moved to the Pergamon, it featured as one of the star exhibits in the seminal 1992 exhibition at the Metropolitan Museum of Art, New York: *Al-Andalus: The Art of Islamic Spain* (Granada, 18 March–7 June; New York, 1 July–27 September), which was organized by the Metropolitan Museum in collaboration with the Patronato de la Alhambra (Figure 7.2).[266] The focus of the exhibition was on the complexities and multifaceted nature of the long history of Islamic rule in Spain, within the context of the five-hundredth anniversary of the end of Muslim political rule in that country. The cupola, with its exquisite craftsmanship and prestigious Nasrid provenance, was perfectly placed to tell a part of that story.

Under the direction of Jerrilynn D. Dodds, who was special consultant on the exhibition project, the exhibition went beyond a focus on the traditionally conceived high points of Córdoba and Granada to include the arts of the *Taifa* period as well as Almohad and Almoravid art. Several large, fragile, and uniquely important objects were loaned from collections all over the world, including: the so-called Pisa Griffin, a monu-

Fig. 7.2

Photograph of the structure within which the Alhambra cupola was displayed in the exhibition
Al-Andalus: The Art of Islamic Spain
[Metropolitan Museum of Art, New York, 1 July -27 September 1992]. Photo: M.I.K. Archive, Berlin.

mental bronze animal from eleventh-century al-Andalus loaned by the Museo dell'Opera del Duomo in Pisa; the unique thirteenth-century "Hadith Bayāḍ wa Riyāḍ" manuscript loaned by the Biblioteca Apostolica Vaticana in Rome; the "Toulouse" chasuble mentioned in Chapter Two, a large silk cape from early twelfth-century al-Andalus loaned by the Basilique Saint-Sernin in Toulouse; and the Hermitage Museum's "Alhambra vase" from Saint Petersburg. With the exception of the wooden minbar from the Kutubiyya Mosque in Marrakesh on loan from the city's Badī' Palace, the cupola was by far the bulkiest and most difficult piece to transport. The Metropolitan Museum paid for the dismantling, transportation, and insurance excess (after indemnity by the US government scheme) of the cupola from Berlin to New York and for its return to Berlin and eventual installation in the Pergamon in 1999. The director of the Metropolitan Museum, Philippe de Montebello, wrote a profuse letter of thanks to the director of the Museum, Michael Meinecke, stating, "I cannot express to you the delight and gratitude we feel toward you for so generously agreeing to send your magnificent Alhambra ceiling to New York. It will certainly be a dazzling centerpiece for the exhibition, and the Metropolitan Museum is profoundly in your debt."[267]

In the summer of 1999, following its return from the exhibition in New York, the cupola was brought to the unified collection of the Museum of Islamic Art in the Pergamon. It was installed in the Spanish room, the Maurische Kabinett noted previously, which had been created with the cupola in mind in 1932 but where it had never yet been displayed, a space into which it fitted perfectly.

Chapter Eight:
The Partal in the
Twentieth Century

The Alhambra is not a monument which is frozen in time; it is permanently built and rebuilt.
—Robert Irwin, *The Alhambra*

The cupola became increasingly visible to a general public in the twentieth century, as it travelled from Granada to Berlin and from there to New York and back; meanwhile in the Alhambra, the Partal mirador remained largely closed to visitors, its small size and narrow staircase making it impossible to accommodate safely the average of seven thousand visitors who come through the Alhambra's gates daily.[268] The story of how the Partal, without its original cupola, was converted from a private residence to a part of the heritage site of the Alhambra in the twentieth century mirrors that of the rest of the Alhambra, as gradually the site was depopulated of its inhabitants and the buildings restored and sometimes even partially rebuilt. The Alhambra did not stand still from the nineteenth to the twentieth centuries. Its history of change and development in the years following its designation as a national monument in 1870, demonstrates how sites of cultural heritage responded to political and economic upheavals and to the emergence of a heritage tourism industry that profoundly altered this unique site and its buildings. The history of the depopulation of the Alhambra and its creation as a heritage site is one that is only beginning to be told, by scholars including Barrios Rozúa and González Alcantud, and much remains to be investigated on this crucial period. As such, as well as being an integral part of the biography of the cupola, the Partal's recent history is also an important prism through which the larger history of the Alhambra, and of other globally significant cultural heritage sites, can be viewed.

Following the revolution of 1868, which led to the deposition of Queen Isabella II, the assets of the Spanish royal household were transferred to the new Spanish state, which declared the Alhambra a national monument in 1870.[269] The Partal was at this stage in private hands having been sold by the royal estate in 1828, a sale which the then conservator of the Alhambra, Rafael Contreras, regretted publicly in 1875, not least for the value of its original cupola, which at the time was still in place. He wrote that it was "sold for a small sum, inferior to its true archaeological value."[270] Without its cupola, the Partal became part of the Alhambra monument in 1891, after its donation to the state by Gwinner. The transfer of ownership from private to state was marked by little real change in the condition of the Partal, however, as it continued to be inhabited by Landa, the tenant and former owner who had been retained by the state as caretaker of the building. On his death in 1909 his tenancy was not replaced and for the first time, the Partal stopped being used as a residence. This vacancy reflects a wider depopulation of the palace site, which marked a significant change in the life of the Alhambra in the first decades of the twentieth century: a place considered a Spanish national monument of great historic interest, one that would continue to be visited and cared for, but no longer inhabited.

Spain's relationship with its own Islamic past was rapidly changing in the early twentieth century. The earlier publication of the multi-volume *Monumentos Arquitectónicos de España* (1856–82) with its inclusion of Islamic architecture as part of the larger national story, had helped to articulate a new vision from the Royal Academy in Madrid, in which its Islamic heritage was part of a national architectural style.[271] By 1878 the Alhambresque, a style that incorporated an eclectic mix of architectural references to the Islamic heritage of Spain, was the style chosen by the Spanish government committee for the national pavilion built to represent the country at the third Paris World's Fair (Exposition Universelle). It was clear by then that Spain's Islamic architectural heritage had become part of the national narrative.[272]

At the same time, within Spain and in the region of Andalusia in particular, Spain's Islamic architecture began to be used to demonstrate the deep historical ties between Spain and Morocco by intellectuals keen to

justify its new imperialist ambitions.[273] Following the loss of the Spanish colonies in the Spanish-American war of 1898, a new *africanista* ideology began to emerge that saw Spain look to its nearest Muslim neighbour, Morocco, as a place where it might be able to restore these ambitions. In 1912 the Treaty of Fez created the French and Spanish protectorates in Morocco, with the Spanish zones to the north and south of the country. The treaty marked the consolidation of zones of influence for international powers that had long seen Morocco as an important strategic area, fulfilling Spain's imperialist ambitions in the short term; however unrealistic they would prove to be.[274] In a speech in 1884, Joaquin Costa described these ties in terms of racial links between Andalusian and Moroccan people as a "blood brotherhood."[275]

Spain's built heritage played an important role in this new articulation of Spain's Islamic heritage in the context of these new political ambitions. The Alhambra was one of three structures of Islamic origin that had been classified as national monuments in Spain by 1900—alongside the Córdoba Cathedral/Mosque and the mosque of Cristo de la Luz in Toledo. Archaeology and conservation are closely tied with political ideology, so it is not surprising that in 1910 the early Islamic palace city of Madinat al-Zahra near Córdoba was first excavated by Ricardo Velázquez Bosco, and that the Alhambra became the subject of increasingly urgent attempts to present and "finish" it for the world by its conservators and directors.

Despite the previous depopulation of the Alhambra during the Napoleonic occupation and the rapid deterioration in the condition of the buildings of the Alhambra following the troops' withdrawal, its population had begun to recover during the nineteenth century. By the time the Partal was visited by artists in the 1830s, its inhabitants can be seen in the sketches and paintings they made of the building. However, the changing focus of the new administration and the new status of national monument from 1870 led to a drive to renovate the Alhambra that included the systematic clearing of its inhabitants during the first decades of the twentieth century. In 1914 a new Council of the Alhambra (Patronato de la Alhambra) was formed under the direction of the fine arts department of the education ministry (Dirección General de Bellas

Artes del Ministerio de Instrucción Pública), which was responsible for the administration of the site. Under this new administrative system, the architect Ricardo Velázquez Bosco (under the Alhambra directorship of Modesto Cendoya) drew up a conservation scheme for the Alhambra that was adopted in 1917, the *Plan General de Conservación de la Alhambra*. This scheme laid out a funded plan for the conservation and restoration of the buildings, including the Partal, and the foundation of an Alhambra museum (Figure 8.1). Central to this plan, indeed the first point written in the draft document, was the eviction of tenants from buildings of any historical, artistic, or archaeological interest. The Alhambra's tenants would not be left destitute; rather, Bosco suggested they be housed in buildings owned by the state but without such historical interest.

It was at this point that the Alhambra began to be systematically de-populated for the first time. Noting the pressure to achieve a "clean" and cleared historic site for foreign visitors, Bosco suggested that expropria-tions of property from those still living in the Alhambra would be desira-ble, but that given the potential financial cost of expropriation, he did not consider it a priority at that stage.[276] Nevertheless, tenants such as Landa were not replaced in the Alhambra, as private buildings were gradually expropriated and inhabitants rehoused outside of the site (Figure 8.2). By 1923 there were only a few people still inhabiting the buildings around the Partal (Figure 8.3). Gwinner had retained ownership of a small mod-ern house to the west of the Partal pool, the Casa de Ayala, until 1921 when it was expropriated and in 1923 was pulled down under Leopoldo Torres Balbás, only a few months after the last remaining inhabitant had moved out.[277]

Over the following decades the Alhambra gradually lost all of its resi-dents and native "children of the Alhambra" (*hijos de la Alhambra*) as it transformed into the site of heritage, tourism, and industry that it is today. Although the connection of the native Granadan population with the Alhambra remains a strong and personal one, with many still call-ing themselves its "children", few people today remember playing in its courtyards, harvesting vegetables in its gardens, or drawing water from its pools.[278]

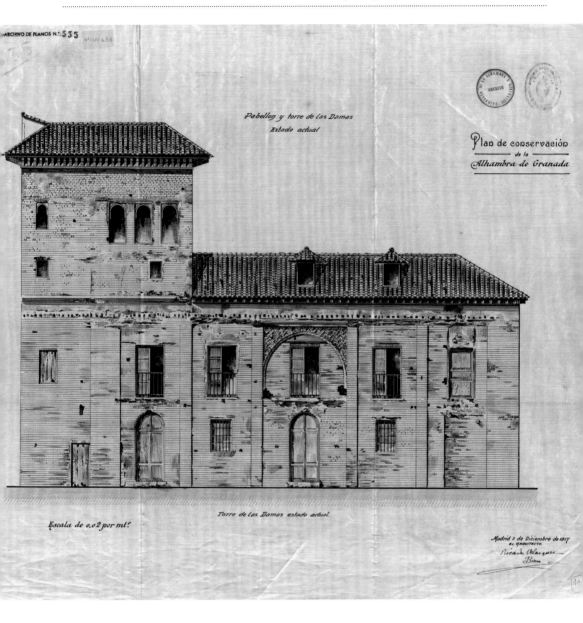

Fig. 8.1

Elevation drawing
of the Partal
façade, dated
3 December
1917, by Ricardo
Velázquez Bosco.
27 x 53cm, ink
on paper. APAG/
Colección de
Planos/
P-000638.

The erasure of this personal, individual experience of the Alhambra through its depopulation and the clearing of the site including the destruction of more recent residences inevitably involved acts of material destruction and the loss of a particular kind of knowledge and experience of the site. Stephennie Mulder has described the process of image-breaking and image-making involved in the creation of the ancient site of Palmyra in the early decades of the twentieth century, which

Fig. 8.2
Photograph of a female figure (inhabitant?) sitting inside the house adjacent to the Partal mirador.
Photo by Manuel Torres Molina, early 20th century. 18 x 24cm. APAG/Colección de Fotografías/F-00533.

Fig. 8.3
The Partal undergoing restoration, with three figures in the foreground, 1922.
Photo: Luis Seco de Lucena Paredes.
Public domain.

included the clearing of populations and erasure of a thousand years of subsequent life at that site. The result of this erasure, she argues, is a diminution in the complexity of our understanding of the site through the privileging by the French archaeologists of the classical structures, with the subsequent loss of knowledge about and evidence for the site's centuries-long inhabitation and changing function.[279] Similarly, the eventual clearing of the population of the Alhambra and the pulling down of many of its more modern structures demanded the prioritization of a particular history by its conservators and directors. The particular periods in history that were preserved were those that told the story of the Islamic palace at its height and that of the Christian conquest at a point of imperial domination by the Spanish monarchs. These were stories of glory and conquest, of luxury and the elite. The changing nature of the site from palace to barracks, soldier's homes to artist's landscape, and the everyday and continuous habitation and renovation of the site by the citizens of the Alhambra were the stories that were lost in this clearing process.[280]

The early twentieth century also brought a change in approach to the conservation of the buildings of the Alhambra. Velázquez Bosco's plan emphasized the need for the conservation of the buildings rather than their restoration or re-creation. This differed radically from the approach of the Contreras family (José, Rafael, and Mariano) who had successively served as conservator-directors of the Alhambra from 1828 until 1907.[281] The Contreras brothers broadly followed the ideology of the French architect Eugène Viollet-le-Duc (1814–79), who advocated a creative style of restoration that favoured restoring buildings to an often imaginary, "complete" state. The brothers adopted a policy of re-creation and replication at the Alhambra, following contemporary fashions for the romanticized exotic, rather than the conservation of the buildings through archaeological or historical study. Under their watch, for example, one of the pavilions in the Court of the Lions was given a new Persian-style dome, complete with coloured roof tiles, a feature entirely alien to Nasrid architecture, but one that was felt to have been more authentically "oriental" in look and feel than a more historically accurate four-sided roof.[282]

The Partal avoided the Contreras treatment, as it was largely in private ownership and inhabited for the duration of their directorship. It was

under Torres Balbás, who took charge after Modesto Cendoya in 1923 and remained director until 1936, that the Partal began to experience a more radical material change. Torres Balbás was influenced by the conservation theories of John Ruskin (1819–1900), who took the opposite view to Viollet-le-Duc, rejecting what he considered any falsification or rebuilding of a monument, an approach grounded in historical and archaeological investigation that was becoming increasingly popular in Europe at the time. This was an approach to conservation that insisted on what Ruskin called "honesty" in restoration: where rebuilding or the addition of new elements was required, these new elements should be clearly visible and distinguishable from the "authentic" antique elements of the building.[283] Torres Balbás's restoration of the Partal was a clear example of this approach, in which his aim was to reveal the original while leaving any alterations clearly visible to subsequent observant visitors.

Conservation of the Partal began in earnest as soon as Torres Balbás took office in 1923 (Figures 8.4, 8.5). His diaries describe the work that was

Fig. 8.4

Plan of the conservation project for the Partal and surrounding houses by Leopoldo Torres Balbás, June 1923. 71 x 99cm. APAG/Colección de Planos/P-000631.

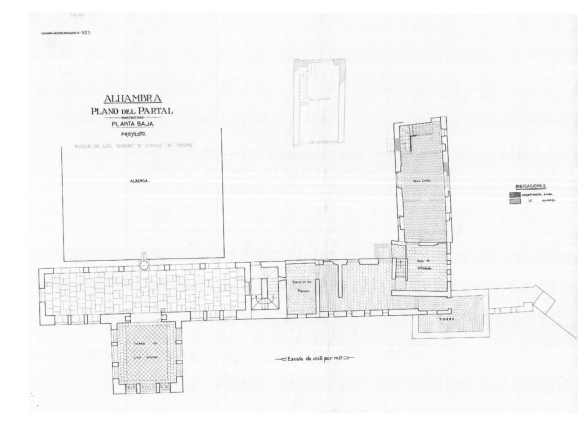

Fig. 8.5

Section drawing of the conservation project for the Partal by Leopoldo Torres Balbás, June 1923.
67 x 45cm. APAG/Colección de Planos/P-000637.

Fig. 8.6

Photograph of the Partal after its restoration by Torres Balbás, early 20th century.
Photo: Manuel Torres Molina.
21.5 x 15.5cm. APAG/Colección de Fotografías/ F-13056.

carried out on the building, including the removal of the internal floor divisions and the renovation of the roof of the mirador.[284] For the first time in over a century the south facade of the Partal was opened up and the portico's five arches revealed. In the mirador, Torres Balbás stabilized

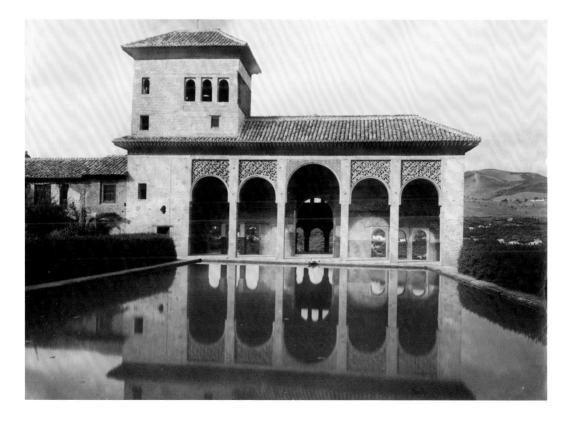

the roof and reinforced the original carved wooden eaves that remained. A photograph from 1900 shows the interior of the Partal mirador without its ceiling, with the frame that formerly held the cupola sitting empty above the decorated walls (Figure 6.1). Torres Balbás laid a floor of black and white tiles in the main mirador room, based on the design of an older floor he found there. The windows in the mirador were opened up, having been blocked for decades, and the eaves were conserved. He left the brick pillars of the main portico supporting the five arches of the facade in place, repairing some of them (Figure 8.6). In the spandrels of the arches, he replaced the carved stucco that had been almost completely destroyed with a modern and abstracted version that was not a replica but rather gave the impression of stucco from a distance.[285]

A different view of conservation dominated the mid-twentieth-century approach to the Alhambra under the direction of Francisco Prieto Moreno, who served throughout the duration of the Franco dictatorship and beyond, from 1936 to 1978. His directorship would have a very material impact on the structure of the Partal. In 1959 the brick pillars left by Torres Balbás were replaced with marble columns under the new director, who considered such columns to be more authentic to an Islamic portico.[286] However, in the sketches of Jones, Roberts, and Lewis from the 1830s (see Figs. 5.2-5.5), there is no evidence of such columns but instead some visual remains of the original stucco and the brick pillars. With the substitution of brick pillars for marble columns in 1959, the Partal was made to look more like the later palaces of the Court of the Lions, with its numerous columns, than it had before (Figure 8.7). This change has a profound effect on the overall balance of the building, however, giving it a less substantial and more unbalanced feel as a structure while allowing more light to enter the lower portico than before the pillars were replaced. As noted in Chapter Three, the Partal adopted many of the features of the early Berber and Andalusi building styles into Nasrid architecture, including the use of brick pillars, whose erasure contributes to the flattening out of the Alhambra palaces into a place in which a single "Islamic" style dominates—that of the later fourteenth century—rather than a series of complex buildings and styles that developed over the centuries. Like Contreras's inclusion of a Persian dome on the Court of the Lions a century before, Prieto Moreno's insertion of columns in the

portico seemed to be driven more by a concern to align the Partal with a more generic Islamic style popularized by the contemporary fame of the Court of the Lions and its replication in Alhambresque-style buildings in the nineteenth and twentieth centuries, than by an interest in historical accuracy.

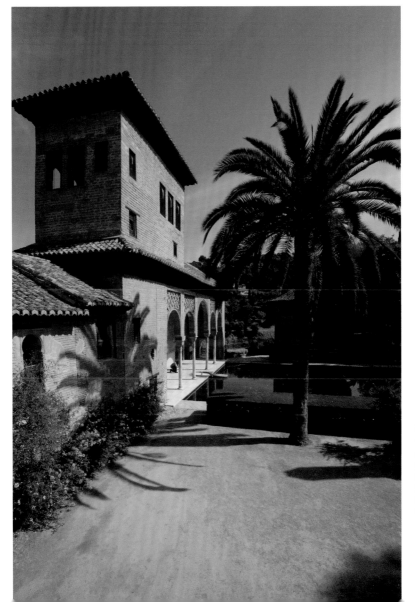

Fig. 8.7

The Partal palace today, showing the columns put in place by Prieto Moreno in 1959. Photo by the author.

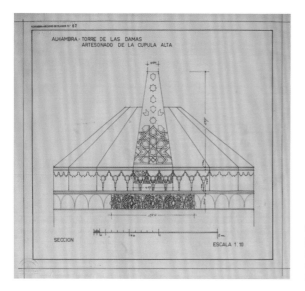

Fig. 8.8

Expanded section drawing of the Partal mirador cupola by Manuel López Reche, c.1960s.
44 x 47cm. APAG/Colección de Planos/ P-000103.

Later interventions in the Partal included the installation of the aforementioned replica cupola in the mirador, in place of the original, in 1964. There is an ongoing practice of replication and restoration of wooden parts of the Alhambra in the site's workshop, where expert carpenters continue to create doors, parts of ceilings, and other wooden elements for the palaces, using techniques and fixtures that were found in the original structures. The replica of the cupola was made by the carpenter José Romera Baena and was likely based on drawings of the cupola that were made by a technical artist who worked for the Alhambra, Manuel López Reche, in the early 1960s (Figures 8.8, 8.9). López Reche was probably working from older images of the cupola, perhaps made before it left Granada; some drawings have survived with German annotation in the

Fig. 8.9

Schematic drawing of the Partal mirador cupola by Manuel López Reche, c.1960s.
51 x 53cm. APAG/Colección de Planos/P-000113.

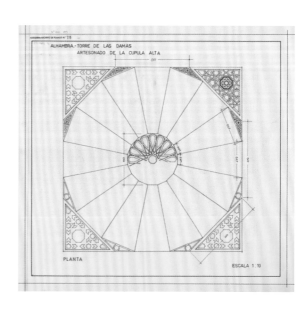

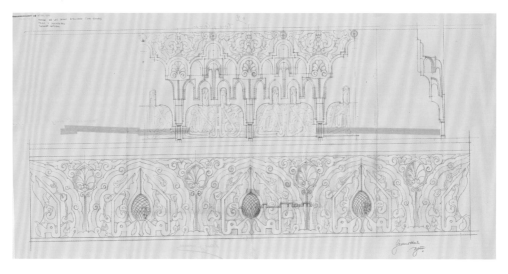

Fig. 8.10

**Anonymous pencil on paper drawing of
the frieze detail of the cupola**
79x155cm (to-scale). Undated. APAG/
Colección de Planos/P-000104.

Alhambra archives (Figure 8.10).[287] Drawings may also have been made
by members of the local cultural group, the Centro Artístico, Literario y
Científico de Granada, who visited the Partal in 1888 before the cupola
was removed (see Chapter Six). There are important differences between
the replica and the original; for example, in the transition from a sixteen-
to a four-sided shape, which is erroneous in the replica. In any case, it is
unlikely that either Romera Baena or López Reche would have had access
to the original cupola during the 1960s, as it was in private storage in
Germany from the end of the war until the 1970s.

Notwithstanding the existence of the replica, Alhambra scholars and
authorities continued to express their regret at the removal of the orig-
inal cupola. In a note at the end of his report on the new cupola in the
mirador, Bermúdez Pareja, director of the Museo Arqueológico de la Al-
hambra, invited the Gwinner family to return the cupola in exchange for
an excellent copy. "If one day the family of Mr Gwinner decide to return
the original to its place, they could be recompensed with this excellent
copy which covers the ugly empty space left in the roof by such a surpris-
ing emigration. Meanwhile, the observatory of the Casa Sánchez [...] will
have a dignified, beautiful and evocative cupola."[288]

Conclusion:
The Cupola between
Granada and Berlin

In a recent book on the role of museums today, Nicholas Thomas described what he calls a "lack of fixity" of objects in museums, noting that "almost anything likely to be encountered in a museum, bears a particular uncertainty: it is both what it was and what it is."[289] This uncertainty of the object is, he argues, due to the radical decontextualization of many of the works in museums, which both speak of their past lives and of their present condition. It is precisely this quality of being neither here nor there, together with the material traces visible on the object of these past lives, that allows the object on display to captivate its audience. This idea, a kind of "inbetweenness," sketched in the Introduction, can help us to understand this tension within the object in the museum, a tension born from its movements and dislocations, and offer a framework within which we can think about the cupola and its historical itineraries and multiple networks today.

The tension of its dislocation becomes particularly apparent when the cupola is at its most visible; at the opening of the new Islamic galleries in Berlin in 2000, for example, with the cupola freshly installed. The installation did not go unnoticed in Granada, as this newfound visibility of a large piece from the increasingly popular Alhambra palace led some in Spain to once again call for its return to Granada. The year of that opening, the Museum in Berlin received a request from Granada City Council for the cupola's return, sent by fax via the German embassy in Madrid.[290] Granada City Council claimed that the cupola had been taken out of Granada without official permission between 1892 and 1915, so should be returned. The Museum took legal advice and replied with their documentation from Gwinner on his legally approved purchase of the Partal with its

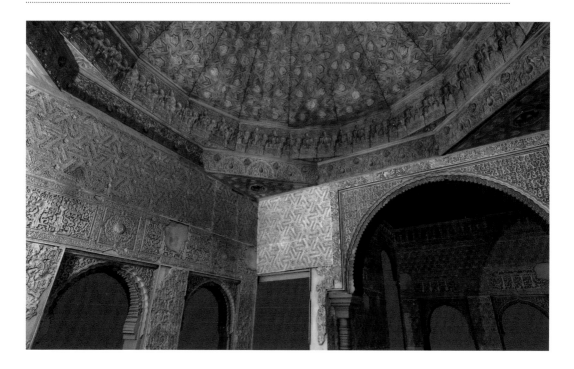

clause pertaining to the ceiling, in which the buyer stated in writing his intention to remove the "Arab ceiling" and to replace it. The legal case was clear. Nevertheless, there are those in Granada and the Alhambra who believe that an ethical case can be made for it to be returned to the place for which it was made.

The question of restitution is one that hangs over many architectural fragments in museum collections, today more than ever. Claims for the ownership and return of objects by source communities are some of the most urgent issues that today's museums must face, and it is vital that they do that with honesty and integrity. However, as the history of the Alhambra cupola in Berlin has demonstrated, these claims are often complex and contested. Despite the requests for its return from Granada and the legitimate regret expressed by individuals that it did not remain in the Alhambra, the legal case for its ownership by the Museum is well supported. It is also clear that, to a certain extent, the Spanish authorities were complicit in the loss of the cupola: from the sale of the Partal by the Spanish royal house in 1828 to the official permission granted in the sale document in 1885 to remove its cupola, to the failure of the Spanish government to purchase it when it was offered to the Alhambra for sale

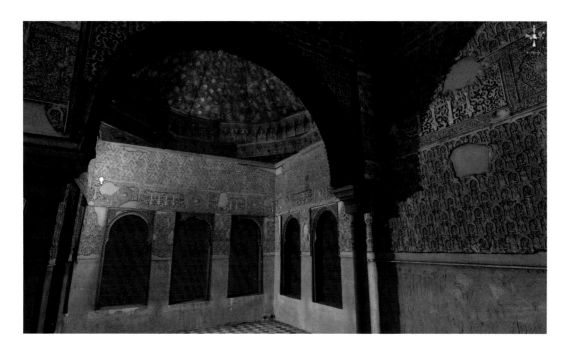

Figs. 8.11 and 8.12

Screenshot images of the cupola in Berlin virtually reunited with the mirador in Granada, from 3d scans of both, in the Unity 5.4 Game Engine. Images by Arie Kai-Browne and Sebastian Plesch, Hochschule für Technik und Wirtschaft Berlin. *Virt:Kult Kontextualisierung von Kulturgut mit Virtual Reality und Gametechnology*, 2016.

in 1978. As the biography of the cupola has revealed, there has been an historic neglect of the Alhambra by those authorities (the royal household and the national government) supposed to secure its buildings and contents, which led directly to the loss of the cupola, despite the immediate and consistent care of the monument by local individuals and officials. Recognition of Spain's historic ambivalence towards its Islamic past is fundamental to understanding the history of the cupola and why it has ended up in a museum in Berlin.

There is nevertheless an ethical question to consider that goes beyond the assertion of legal ownership. The cupola was lost to the Alhambra at a time when much of Spain's cultural heritage was under threat from foreign collectors, a threat that was exacerbated by Spain's relative economic impoverishment and lack of stable government. By the first decades of the twentieth century, Spain saw the loss in unprecedented numbers of its historic interiors, in particular its medieval wooden ceilings, by collec-

tors who took advantage of the lack of protection of buildings in Spain at the time. In particular in the 1920s and 1930s, the American industrialist William Randolph Hearst bought over eighty historic Spanish ceilings from historic buildings across the country, most of them through the often dubious and underhand activities of antiquarians Arthur Byne and Mildred Stapley in Madrid, whose approach to collecting for Hearst included, at times, the tearing down of buildings to access their historic ceilings. The extent of this material loss and the uncomfortable history of these lost ceilings is still being discovered today. [291]

Even as late as 1978 when the cupola was offered for sale by Klingler to the Alhambra, Spain's nascent democracy was not yet in a position to safeguard its historic objects from an increasingly powerful global museum culture, which wielded more nimble economic and cultural power than the Spanish authorities that might have enabled the Alhambra to return its cupola to Granada. Awareness of these ethical ambiguities and of the particular contexts within which objects can be lost must affect how museums display their objects today, particularly objects whose acquisition has been contested, whether legitimately or not. In the case of the cupola, the Museum must go beyond the dry legal argument that simply asserts ownership, and engage with the long history that brought the cupola to Berlin in all its complexities — to answer without flinching that question "What is it doing here?"

It is through telling these stories of how objects moved and what that means for institutions, for the people and buildings affected and for the object itself, and the subsequent bridging of these gaps, between institutions and individuals, local demands and legal requirements, that is the urgent purpose of museums and institutions like the Museum of Islamic Art in Berlin and the Alhambra today.

Perhaps it will be through the creative and imaginative use of new technologies that it will be possible to try to overcome some of these competing demands. A recent project involved the digital scanning of the cupola and the interior of the Partal mirador to a great degree of precision.[292] The application of this data within new virtual-reality technology allows a viewer to visualize and "experience" the cupola *in situ*, both in Granada

and in Berlin, or anywhere in the world (Figures 8.11, 8.12). This application of digital technology not only reunites these parts, but frees the physical objects and buildings from their institutional boundaries, allowing them to be viewed in extraordinary detail by more people around the world than ever before.[293]

But this kind of experience, although invaluable and attractive, is not enough. The cupola must somehow be allowed to tell its long and networked history to the museum visitors beneath. Perhaps the Museum's plans for a new display will enable the cupola's long history to be made visible, within the context of a permanent exhibition of Islamic art that aims to articulate the transcultural and migratory histories of the objects in its collection.[294]

If an object such as the cupola can do anything in a museum, it can tell stories. This ceiling is a masterpiece of medieval craftsmanship and a unique survivor, whose story can reveal a new history of Islamic art in western Europe: the story of its making, of the wood brought from all over al-Andalus to create it within the workshops of the early Nasrid rulers; of its conception as a crowning dome to a jewel-like mirador perched on the edge of the Alhambra escarpment, looking down over the woods to Granada city below. The story of its resilience and survival, as it witnessed the extraordinary changes that would take place in the Alhambra, in al-Andalus and in Europe over the next seven hundred years. Of how it remained in the Partal pavilion as it housed the governor's soldiers after 1492, then invalid soldiers, before the cupola was sketched by artists drawn to the Alhambra by its crumbling beauty and charm. It can tell the story of how these very artists who wanted to capture the Alhambra in their drawings ended up captivating the world with a romanticised, orientalised view of the building that would profoundly influence not only our idea of the palace, but also the Alhambra's material survival, leading to Gwinner to want to 'restore' the Partal and remove its cupola to create his own oriental-style room in Berlin.

The cupola's story is, finally, a history of the people who made the Alhambra, lived beneath it, and cared for it for centuries. It is also now inevitably a story about Berlin, those who cared for it in the intervening years,

who studied it and made it visible to a new public, as well as those who stand beneath it in the museum today. Listening to those disparate voices through the long history of the cupola allows us to begin to understand this extraordinary object for the first time and to contemplate its important place in the history of Islamic art in Europe.

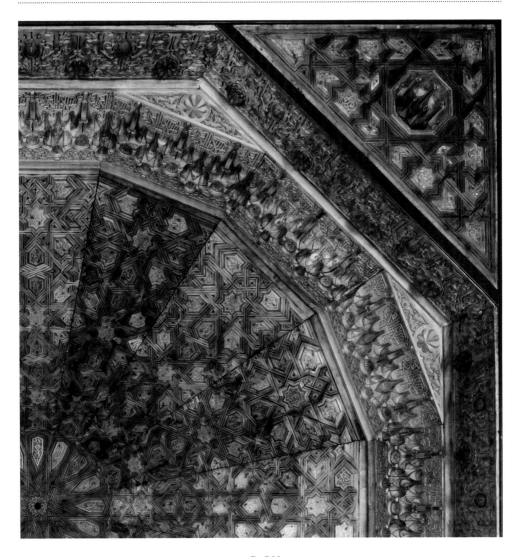

Fig. 8.14
The Alhambra cupola in Berlin, detail. Photo by Johannes Kramer.

Fig. 8.13

Photograph of the Partal, late1920s.
APAG/Colección fotográfica del Museo de
Arte Hispano Musulmán/F-007056.

Notes

AHA: Archivo Histórico de la Alhambra (Granada)
APAG: Archivo del Patronato de la Alhambra y Generalife (Granada)
MIK: Museum für Islamische Kunst (Museum of Islamic Art, Berlin)

INTRODUCTION

1 Richard Ettinghausen expert report, dated 9 March 1978, archives of the Museum für Islamische Kunst (MIK).
2 Arjun Appadurai, ed., *The Social Life of Things: Commodities in Cultural Perspective*, Cambridge, Cambridge University Press, 1986; Igor Kopytoff, "The Cultural Biography of Things: Commoditization as Process," in Appadurai, ed., *Social Life of Things*, pp. 64–94.
3 Alfred Gell, *Art and Agency: An Anthropological Theory*, Oxford, Clarendon Press, 1998.
4 Stephennie Mulder has argued for this object agency approach as a particularly promising method for disentangling the multivalent complexities of the creation, reception, and agency of Islamic art objects. Mulder, "Seeing the Light: Enacting the Divine at Three Medieval Syrian Shrines," in David J. Roxburgh, ed., *Envisioning Islamic Art and Architecture: Essays in Honor of Renata Holod*, Boston, Brill, 2014, pp. 90–91.
5 "As people and objects gather time, movement and change, they are constantly transformed, and these transformations of person and object are tied up with each other." Chris Gosden and Yvonne Marshall, "The Cultural Biography of Objects," *World Archaeology*, 31/2 (1999), p. 169.
6 Christopher Tilley, *Metaphor and Material Culture*, Oxford, Wiley, 1999, p. 76: "things create people as much as people make them." See also Kopytoff, "Cultural Biography of Things"; Jody Joy, "Reinvigorating Object Biography: Reproducing the Drama of Object Lives," *World Archaeology*, 41/4 (2009), pp. 540–56.
7 Pierre Nora, ed., *Realms of Memory: Rethinking the French Past*, Chicago, University of Chicago Press, 1998; Arthur von Gwinner, *Lebenserinnerungen*, ed. Manfred Pohl, Frankfurt am Main: Fritz Knapp, 1975, p. 45.
8 Gell, *Art and Agency*, pp. 69–71.
9 José Miguel Puerta Vílchez, *Reading the Alhambra: A Visual Guide to the Alhambra through its Inscriptions*, Granada, Patronato de la Alhambra y Generalife, 2011, p. 231. Extract from a poem carved in the window frames in stucco in the Mirador de la Lindaraja, written by Ibn Zamrak for Yusuf III.
10 Puerta Vílchez, *Reading the Alhambra*, p. 312. Extract from poem four carved in the tower of the Qalahurra (Tower of the Captive Princess), written by Ibn al-Jayyab for Yusuf I.
11 Svetlana Alpers, "The Museum as a Way of Seeing," in Ivan Karp and Steven D. Lavine, eds., *Exhibiting Cultures: The Poetics and Politics of Museum Display*, Washington, DC, Smithsonian Institution Press, 1991, p. 26.
12 Nicholas Thomas, *The Return of Curiosity*, London, Reaktion Books, 2016, p.51.
13 Paul Basu, *The Inbetweenness of Things*, London, Bloomsbury, 2017, pp. 1–20.
14 Thomas, *Return of Curiosity*, pp. 49–50: "almost any historical artefact, almost anything likely to be encountered in a museum, bears a particular uncertainty: it is both what it was and what it is. If this is most glaring with respect to ethnographic objects that were once given meaning in a flow of life and ritual, this is only because their travels are, as it were, overtly unsettling. Many works in mainstream art museums—once situated in churches, in the country houses of aristocrats or in

private or domestic settings—have been no less radically decontextualized, and hence speak of other and past lives, of "then" as well as "now", "there" as well as "here". The doubleness of the artefact—which is equally a doubleness of the natural specimen, the pressed plant or fossil—is thus also the paradox of physical immediacy and nebulous identity."

15 Lindsay Allen has documented her work on the Persepolis fragments at https://persepolitan.org/author/vastarchive/.

16 Eva-Maria Troelenberg, *Mshatta in Berlin: Keystones of Islamic Art*, Dortmund, Verlag Kettler, 2017. First published in German 2014.

CHAPTER ONE: EARLY NASRID GRANADA

17 Brian A. Catlos, *Muslims of Medieval Latin Christendom c.1050–1614*, Cambridge, Cambridge University Press, 2014, pp. 55–57.

18 Joseph F. O'Callaghan, *Reconquest and Crusade in Medieval Spain*, Philadelphia, University of Pennsylvania Press, 2004, p. 114. Catlos, *Muslims*, p. 75. Of those who fled to North Africa, many went to live under the Hafsid emir of Tunis; for example, Ibn Arabi and al-Qartajanni.

19 Recent archaeological evidence seems to confirm the hypothesis there was a Roman settlement at what would become Granada from at least as early as the first century AD. It was known as Iliberris / Florentia Iliberritana. Margarita Orfila Pons, "Granada en época romana: los restos arqueológicos, una visión global," *Revista del CEHGR*, 25 (2013), pp. 15–28. The Umayyads also established a small settlement and a fortress on the Sabika Hill.

20 Antonio Orihuela Uzal, "Granada, between the Zirids and the Nasrids Art and Cultures of Al-Andalus," in *The Power of the Alhambra*, Granada, Legado Andalusi, 2013, pp. 47–57. See also Orihuela Uzal, "Evolución urbana de Granada desde los primeros asentamientos ibéricos hasta la época nazarí," in Jordi Segura, ed., *Ibèria, Roma, al-Àndalus. El fi com a principi*, Barcelona, Imprenta Barnola S.L., 2017, pp. 150–53.

21 Hugh Kennedy, *Muslim Spain and Portugal: A Political History of al-Andalus*, New York, Addison Wesley Longman, 1996, p. 282. See also Ibn Khaldun's description, pp. 275, 277.

22 The population of the Kingdom of Granada was estimated at 200,000 by Aragonese envoys to the Council of Vienne in 1314 (O'Callaghan, *Reconquest and Crusade*, p. 460). Ladero suggests 300,000 (J.N. Hillgarth, *The Spanish Kingdoms, 1250–1516*, vol. I, New York, Oxford University Press, 1976, p. 30). It is likely that there were few native Christians in the Nasrid Kingdom—those that were there were merchants or resident foreigners (Leonard P. Harvey, *Islamic Spain 1250–1500*, Chicago, University of Chicago Press, 1990, p. 14).

23 As Abigail Balbale has argued for early thirteenth-century Sharq al-Andalus, while medieval Muslim leaders may have presented themselves as fierce religious warriors as part of a process of legitimation, maintaining power in al-Andalus in the thirteenth century often involved forging alliances with Christian neighbours and waging war against fellow Muslims. This web of alliances can be understood as "the articulation of a different kind of jihad than the one often outlined in doctrinal treatises." Abigail Balbale, "Jihad as a Means of Political Legitimation in Thirteenth-Century Sharq al-Andalus," in Amira K. Bennison, ed., *The Articulation of Power in Medieval Iberia and the Maghrib*, Proceedings of the British Academy 195, Oxford, Oxford University Press, 2014, p. 102.

24 Olivia Remie Constable, *Trade and Traders in Muslim Spain: The Commercial Realignment of the Iberian Peninsula, 900–1500*, Cambridge, Cambridge University Press, 1996, p. 246.

25 Constable, *Trade and Traders*, p. 221.

26 Constable, *Trade and Traders*, p. 213.

27 Constable, *Trade and Traders*, p. 247.

28 From Abu Abdullah Muhammad Ibn Battuta's accounts of his travel, known as the *Rihla*, as quoted in Constable, *Trade and Traders*, p. 220, note 40.

29 Mariam Rosser-Owen, "'From the Mounds of Old Cairo': Spanish Ceramics from Fustat in the Collections of the Victoria and Albert Museum," in *Actas del I Congreso Internacional Red Europea de Museos de Arte Islámico*, Granada, Patronato de la Alhambra y Generalife, 2013, pp. 163–86.

30 Adela Fábregas García, "El mercado interior nazarí: bases y redes de contactos con el comercio internacional," *Hispania*, 73/255 (2017), pp. 69–90.

31 Adela Fábregas García, "Other Markets: Complementary Commercial Zones in the Naṣrid World of the Western Mediterranean (Seventh/Thirteenth to Ninth/Fifteenth Centuries)," *Al-Masāq*, 25/1 (2013), pp. 135–53.

CHAPTER TWO: THE PARTAL AND ITS CUPOLA: A CAPTIVATING SPACE

32 Esther Cruces Blanco and Pedro Galera Andreu, "Las Torres de la Alhambra. Población y Ocupación del Espacio. Informes de Juan de Orea (1572)," *Cuadernos de la Alhambra*, 37 (2001), p. 47. The word 'Partal' may derive from the medieval Latin *portale* meaning porch. The other names for the building were coined since the eighteenth century.

33 Antonio Orihuela Uzal, *Casas y Palacios Nazaríes: siglos XIII–SV*, Granada, El Legado Andalusí, 1996, pp. 315–33.

34 The names of the buildings in the Alhambra are many and confusing. Some refer to recent functions (e.g., the Convent of San Francisco) while others can be traced to their Arabic origins (e.g., Generalife from Jannat al-Arif).

35 The Nasrid ruler, Muhammad III, is not often given credit for the scale and importance of his expansions to the Alhambra, possibly because the most important of his buildings (the mosque) has since been destroyed.

36 Antonio Fernández-Puertas, "Tipología de lámparas de bronce en al-Andalus y el Magrib," *Miscelánea de Estudios árabes y Hebraicos. Sección Arabe-Islam*, 48 (1999), pp. 379–92. J.D. Dodds, ed., *Al-Andalus: The Art of Islamic Spain*, New York: Metropolitan Museum of Art, 1992, pp. 276–77, cat. no. 57.

37 Leopoldo Torres Balbás, "La mezquita real de la Alhambra y el baño frontero," *Al-Andalus*, X (1945), pp. 196–214.

38 There is no date inscribed on the Partal, nor an inscription that tells us the name of its patron, or documents describing who built it (this is common throughout the Alhambra). The attribution to the reign of Muhammad III is based on analysis of the content of the poetry on the walls and on the close similarity between the plasterwork in the Partal and plasterwork in the Generalife palace dating from Muhammad

III's reign. Orihuela Uzal, *Casas y Palacios Nazaríes*, pp. 57–70; Antonio Malpica Cuello, *La Alhambra de Granada, un Estudio Arqueológico*, Granada, Universidad de Granada, 2002, pp. 160–75; Antonio Fernández-Puertas, *The Alhambra*, London, Saqi Books, 1997, pp. 221–22.

39 Puerta Vílchez, *Reading the Alhambra*, pp. 253–62.

40 The umbrella dome ceiling of the Puerta de la Rauda at the Alhambra demonstrates this kind of stone vaulted dome.

41 Puerta Vílchez, *Reading the Alhambra*, p. 259. Extract from poem two carved in plaster on the walls of the lower portico of the Partal palace, composed by Ibn al-Jayyab for Muhammad III.

42 Puerta Vílchez, *Reading the Alhambra*, p. 311. Extract from poem three carved in plaster in the tower of the Qalahurra, written by Ibn al-Jayyab for Yusuf I.

43 The measurement of 3.5 by 3.5 metres is of the external sides of the square base of the cupola.

44 Bibliothèque Nationale de France, Département des Manuscrits, Arabe 385, f.130. See also Nasrid silk, Metropolitan Museum of Art 29.22; Dodds, *Al-Andalus*, p. 335.

45 A poem by Ibn Zamrak moulded in plasterwork in the Hall of the Two Sisters makes explicit the connection between the cupola of the hall and the celestial sphere: "In the cupola such splendour does the chamber acquire that the palace competes with the very firmament." Quoted in Puerta Vílchez, *Reading the Alhambra*, p. 214.

46 Islamicate is the term used to describe those regions and cultures that were under the influence of the Muslim world, including but not limited to those under Muslim political rule.

47 Stephennie Mulder, "Shrines and Saints for Sultans: On the Destruction of Local Heritage Sites by ISIS," *Aktüel Arkeoloji*, 51 (2016), pp. 93–99.

48 Abigail Balbale, "Bridging Seas of Sand and Water: The Berber Dynasties of the Islamic Far West," in Finbarr B. Flood and Gülru Necipoğlu, eds., *A Companion to Islamic art and Architecture*, Hoboken, NJ, Wiley Blackwell, 2017, p. 365.

49 This kind of decorative ceiling with carved polygons in panels is often called *artesona-*

do, though the term strictly refers to a coffered ceiling.

50 The analysis in 1978 was undertaken by Arthur Brande from the Technische Universität Berlin with six samples from the cupola, the origins of which are only vaguely identified by a hand-drawn sketch. Report, dated 12 July 1978, MIK archives.

51 I am grateful to the wood conservator at the MIK Berlin, Jutta Maria Schwed, for sharing her findings on the wood types used in the cupola.

52 Eduardo Rodríguez Trobajo, personal communication, 4 June 2015.

53 Eduardo Rodríguez Trobajo, "Procedencia y uso de madera de pino silvestre y pino laricio en edificios históricos de Castilla y Andalucía," *Arqueología de la Arquitectura*, 5 (2008), p. 35.

54 Rodríguez Trobajo, "Procedencia," p. 37.

55 Rodríguez Trobajo, personal communication, August 2015.

56 Matilde Casares López, "La ciudad palatina de la Alhambra y las obras realizadas en el siglo XVI a la luz de sus libros de cuentas," *De Computis: revista Española de Historia de Contabilidad*, 6/10 (2009), p. 98, note 258.

57 In 1994, Maria Carmen López Pertíñez and Eduardo Rodríguez Trobajo analysed a total of eighty-one samples of wooden ceilings from the Museo de la Alhambra. They used a system of determining the species through a carbonized fragment (*analisis antracologico*, which is rapid and less destructive), which could give them dates and species. While they analysed samples from previous dynasties, the majority of their analysis was carried out on wood samples from the mid-fourteenth century period under Muhammad V. They noted the use of certain species of wood depending on the part of the ceiling that was made: unseen *tablazones* or backing pieces were made of poplar, which weighed less; *zafates* or carved *piezes*, *lazos*, and structural elements were made of a type of pine wood. They also found Scots pine or black pine (*Pinus nigra silvestris*), Aleppo pine (*Pinus halepensis*), poplar (*Populus* spec.), and walnut (*Juglans regia*), as well as occasionally plum (*Prunus*), and on a few late samples, fir (*Abies*). See López Pertíñez, *La Carpintería en la Arquitectura Nazarí*, Granada, Instituto Gómez-Moreno

de la Fundácion Rodríguez-Acosta, 2006, p. 55.

58 Jack Soultanian *et al.*, "The Conservation for the Minbar from the Kutubiyya Mosque," in Jonathan M. Bloom, *The Minbar from the Kutubiyya Mosque*, New York, Metropolitan Museum of Art, 1998, p. 73.

59 Rodríguez Trobajo, "Procedencia," p. 35.

60 Rodríguez Trobajo, "Procedencia," p. 36.

61 Cedar is not documented among the woods used in Nasrid ceilings after the mid-fourteenth century. See López Pertíñez, *Carpintería*, pp. 59–63.

62 Mariam Rosser-Owen, "Andalusi Spolia in Medieval Morocco," *Medieval Encounters*, 20 (2014), pp. 152–98.

63 Manuel Sánchez Martínez, "Comercio Nazarí y Piratería Catalano-Aragones," *Relaciones de la Península Ibérica con el Magreb*, Madrid, CSIC (1988), pp. 55, 72. The owner of the vessel and the person who ordered the goods was an Almerian merchant, Qasim ibn Hilal.

64 Leo Africanus, *Descripción general del África y de las cosas peregrinas que allí hay*, ed. Serafin Fanjul and Nadia Consolani, Granada, Fundación El Legado Andalusì, 1995, p. 308.

65 López Pertíñez notes that the tin has not been tested, but is referred to as tin because of its appearance. López Pertíñez, *Carpintería*, pp. 64–65.

66 Antonio Almagro Gorbea, "El color en la arquitectura nazarí," in J. Gallego, ed., *Revestimiento y Color en la Arquitectura*, Granada, University of Granada, 1996, pp. 99–107.

67 Examination report by Dr. Achim Unger, Rathgen Research Laboratory of the State Museums of Berlin, dated 13 July 1993, MIK archives.

68 Carolina Cardell-Fernández and Carmen Navarrete-Aguilera, "Pigment and Plasterwork Analyses of Nasrid Polychromed Lacework Stucco in the Alhambra (Granada, Spain)," *Studies in Conservation*, 51 (2006), pp. 161–76.

69 Carolina Cardell *et al.*, "Analysis of Nasrid Polychrome Carpentry at the Hall of the Mexuar Palace, Alhambra Complex (Granada, Spain), Combining Microscopic, Chromatographic and Spectroscopic Methods," *Archaeometry* 51/4 (2009), pp. 637–57.

70 Ana García Bueno, Maria del Carmen López Pertíñéz, and Victor Medina Flórez, "La

policromía en la carpintería nazarí," *Actas XV Congreso de Conservación y Restauración de Bienes Culturales*, Murcia, 2005, pp. 247–56.

71 Cardell *et al.*, "Nasrid Polychrome Carpentry," pp. 637–57. The transparent coating that was found on top of the paint layers in the Partal cupola was not analysed, but is probably a varnish that was added in more recent renovations. In his diary of the renovation of the Partal in 1923, Torres Balbás recorded how they cleaned the wooden ceilings and treated them with linseed oil and a clear varnish. Torres Balbás, "Diario de obras y reparos en la Alhambra 1923–1936," Archivo de la Alhambra L-440. His diary is published in *Cuadernos de la Alhambra*, 1–5 (1965–1969).

72 I am grateful to Jutta Maria Schwed, conservation expert at the MIK, for sharing her expertise on the conservation and condition of the cupola and for spending many hours up a ladder examining the cupola with me.

73 V&A collection, "Wall Decoration from the Alhambra," museum number 360-1901, available at: http://collections.vam.ac.uk/item/O449014/wall-decoration-from-unknown/.

74 Metallic foil was used in the early restorations of the Alhambra. Víctor Hugo López Borges, "Provenance, Collecting and Use of Five Nasrid Plasterwork Fragments in the Victoria and Albert Museum," in *Actas del I Congreso Red Europea de Museos de Arte Islámico*, Granada, Patronato de la Alhambra y Generalife, 2012, p. 23.

75 García Bueno *et al.*, "policromía," p. 255.

76 "*Las bóvedas y techumbres de las salas y cámaras son de oro, lapis lázuli, marfil y ciprés, formadas de tan varias labores que no pueden propiamente describirse.*"Hieronymus Münzer, "Jerónimo Münzer. Viaje por España y Portugal en los años 1494 y 1495," Alicante, Biblioteca Virtual Miguel de Cervantes, 2010. Digital edition from the *Boletín de la Real Academia de la Historia*, 84 (1924), p. 89. Translated from Latin to Spanish by Julio Puyol.

77 Angel C. López-López and Antonio Orihuela Uzal, "Una nueva interpretación del texto de Ibn al-Jatíb sobre la Alhambra en 1362," *Cuadernos de la Alhambra*, 26 (1990), p. 122. "*Láminas de oro cobrizo cubren sus letras, y se*

amontona a su alrededor polvo de lazulita."

78 Dede Fairchild Ruggles, *Gardens, Landscape and Vision in the Palaces of Islamic Spain*, University Park, Pennsylvania State University Press, 2000, p. 60.

79 After its first dismantling in 1891, it was reassembled in Berlin at Rauchstraße 1, the first of Gwinner's homes. Following this it was dismantled again when Gwinner moved to Sophienstraße 25. In 1942, during WWII, the cupola was dismantled and brought to his country house in Krumke in the Altmark. It was not reassembled, as far as we know, until it was bought by the MIK in 1978 and erected in 1980 in the Museum of Islamic Art, Dahlem. In 1992 the Museum lent it to the Metropolitan Museum of Art in New York where it was erected as part of the exhibition *Al Andalus: The Art of Islamic Spain*. The exhibition went to Granada in Spain, but the cupola did not accompany it; rather, it went back to Berlin where it underwent restoration and cleaning, before its erection in 2000 in the Islamic galleries of the new MIK in the Pergamon in central Berlin.

80 Puerta Vílchez, *Reading the Alhambra*, p. 309. Extract from poem one, composed for the tower of the Qalahurra, written by Ibn al-Jayyab for Yusuf I.

CHAPTER THREE: A ROYAL PAVILION: 1300–1492

81 See for example James Dickie, "The Palaces of the Alhambra," in Dodds, *Al-Andalus*, p. 148.

82 Owen Jones and Jules Goury, *Plans, Elevations, Sections and Details of the Alhambra, From Drawings Taken on the Spot in 1834 by Jules Goury, and in 1834 and 1837 by Owen Jones*, vol. 1, London, O. Jones, 1842–45, p. 336.

83 Dickie, "Palaces of the Alhambra," pp. 137–38.

84 Antonio Malpica Cuello, "La Alhambra que se construye. Arqueología y conservación de un monumento," in José Antonio González Alcantud, Antonio Malpica Cuello, eds., *Pensar la Alhambra*, Barcelona, Anthropos & Centro de Investigaciones Etnológicas "Angel Ganivet," 2001, p. 58.

85 During his 1923 excavations, Torres Balbás revealed some archaeological evidence of buildings to the south of the Partal pool that

might have related to the Partal. However, the fact that these buildings are not in axial line with the portico, but set at an angle, indicates that they were not part of a planned palace courtyard but rather additional domestic buildings, perhaps contemporaneous with the houses added to the west adjacent to the Partal. Fernández-Puertas alludes to these but gives no further details. Fernández-Puertas, *Alhambra*, p. 236.

86 José de Hermosilla y Sandoval, "Plano general de la fortaleza de la Alhambra, sus contornos, y parte de la jurisdicción," in Hermosilla y Sandoval *et al.*, *Antigüedades Árabes de España*, Madrid, Imprenta de la Real Academia de San Fernando, 1787 and 1804, vol. 1, plate II, engraved by J. De La Cruz 1770. The original drawing by Hermosilla is from 1767, the engraving by De La Cruz from 1770.

87 1767 plan drawn by José de Hermosilla (see previous note).

88 Bermúdez Pareja noted that no trace of the supposed lateral courtyard buildings at the Partal existed, and raised the possibility that such an interior-looking patio never existed. See Jesús Bermúdez Pareja, *El Partal y la Alhambra Alta*, Granada, Obra Cultural de la Caja General de Ahorros y Monte de Piedad de Granada, 1977, no page numbers. Similarly, Orihuela Uzal suggests that the Partal was one of a number of garden pavilions in the Alhambra in *Casas y Palacios Nazaríes*, p. 59.

89 Antonio Almagro Gorbea, "An Approach to the Visual Analysis of the Gardens of al-Andalus," *Middle East Garden Traditions: Unity and Diversity*," Washington, DC, Dumbarton Oaks, 2007, pp. 67–68.

90 Fernández-Puertas, *Alhambra*, p. 236: "With its once brightly painted projecting eaves standing out against the blue sky, it must have seemed an idyllic building, half real, half illusory when reflected in the water of its wide pool."

91 The earliest mentions of the Partal refer to it as a large pool or *alberca*. In the earliest plans of the area, the pool is consistently depicted as the same width as the facade of the building. The excavations by Mariano Contreras and Modesto Cendoya in the 1920s, in which the pool was reinstated after it had been filled in and used as a garden in the nineteenth century, found no evidence of internal structures such as walkways in the water basin.

92 Ḥāzim al-Qarṭājannī quoted in José Miguel Puerta Vílchez, *Aesthetics in Arabic Thought: From Pre-Islamic Arabia through al-Andalus*, trans. Consuelo López-Morillas, Leiden, Brill, 2017, pp. 399–401. The quotation was from Abu l-Hasan Ḥāzim al-Qarṭājannī, *Minhāj al-bulaghāʾ wa-sirāj al-udabāʾ* (The Path of the Eloquent and the Lamp of the Educated).

93 Ibn Luyūn (Abū ʿUthmān Saʿad ibn Aḥmad ibn Luyūn al-Tujībī) (d. 750/1349) wrote his *Treatise on Agriculture*, the *Kitāb ibdāʾal-malāḥa wa-inhāʾ al-rajāḥa fī uṣūl sināʾat al-filāḥa* in 1348. Written in verse, it is based on the work of Ibn Bassāl and al-Tighnarī. Ibn Luyūn, *Treatise on Agriculture*, ed. and trans. Joaquina Eguaras Ibáñez as *Ibn Luyun: Tratado de agricultura*, Granada, Patronato de la Alhambra y Generalife, 1975.

94 Ibn Luyūn, *Treatise on Agriculture*, ed. with Spanish translation by J. Eguaras Ibáñez as *Ibn Luyun: Tratado de agricultura*, Granada, Patronato de la Alhambra y Generalife, 1975.

95 Basilio Pavón Maldonado described the Partal as "*el mas jovial, trasparente y luminoso de cuantos existen en la Alhambra*," in *Tratado de arquitectura hispanomusulmana*, vol. 3, Madrid, CSIC, 2004, p. 451.

96 Quoted in Emilio Garcia Gomez, *Cinco poetas musulmanes: Biografías y estudios*, 2nd ed., Madrid, Espasa-Calpe, 1959, p. 125.

97 Fairchild Ruggles, *Gardens, Landscape and Vision*, pp. 207–8.

98 Quoted in Fairchild Ruggles, *Gardens, Landscape and Vision*, p. 203.

99 Malpica Cuello, "Alhambra que se construye," p. 58.

100 Yasser Tabbaa, "Andalusian Roots and Abbasid Homage in the Qubbat al-Barudiyyin in Marrakech," *Muqarnas: An Annual on the Visual Culture of the Islamic World*, XXV (2008), p. 144.

101 Jonathan Bloom, *Art of the City Victorious: Islamic Art and Architecture in Fatimid North Africa and Egypt*, New Haven and London, Yale University Press and the Institute of Ismaili Studies, 2008, pp. 37–40.

102 Al-Rummaniya survives only as a site of archaeological excavation.

103 Felix Arnold, *Islamic Palace Architecture in the Western Mediterranean*, Oxford, Oxford University Press, 2017, p. 110. Glaire Anderson, *The Islamic Villa in Early Medieval Iberia: Architecture and Court Culture in Umayyad Córdoba* Farnham, Routledge, 2013, pp. 50–61.

104 Marilyn Jenkins, "Al Andalus: Crucible of the Mediterranean," in *The Art of Medieval Spain A.D. 500–1200*, New York, Metropolitan Museum of Art, 1993, p. 84, note 6.

105 *Buhayra* was the term used to describe a large irrigated estate with a pool of water at its centre.

106 Julio Navarro Palazón *et al.*, "Agua, arquitectura y poder en una capital del Islam: la finca real del Agdal de Marrakech (ss. XII–XX)," *Arqueología de la Arquitectura*, 10/7 (2013), p. 7.

107 Rosa Di Liberto, "Norman Palermo: Architecture between the 11th and 12th Century," in Annliese Nef, ed., *A Companion to Medieval Palermo: The History of a Mediterranean City from 600 to 1500*, Leiden, Brill, 2013, pp. 163–65. Lev Kapitaikin, "Sicily and the Staging of Multiculturalism," in Flood and Necipoğlu, *Companion*, vol. 1, p. 388.

108 Anderson, *Islamic Villa*, p. 69. See also Arnold, *Islamic Palace Architecture*, p. 38.

109 Maribel Fierro, "Ways of Connecting with the Past: Genealogies in Nasrid Granada," in Sarah Savant and Helena de Felipe, eds., *Genealogy and Knowledge in Muslim Societies: Understanding the Past*, Edinburgh, Edinburgh University Press, pp. 71–88.

110 Dede Fairchild Ruggles, "The Mirador in Abbasid and Hispano-Umayyad Garden Typology," *Muqarnas: An Annual on the Visual Culture of the Islamic World*, VII (1990), pp. 73–82. See also Olga Bush, *Reframing the Alhambra: Architecture, Poetry, Textiles and Court Ceremonial*, Edinburgh, Edinburgh University Press, 2018, pp. 261–62, on the role of the *bahw* or mirador as a place in which the Sultan could see and be seen during the celebration of the *mawlid* (birth of the Prophet) in 1362.

111 Fairchild Ruggles, *Gardens, Landscape and Vision*, p. 107: "In al-Andalus, the panoramic view was not a privilege afforded to ordinary householders, but the ruler's exclusive prerogative, since he alone was responsible for conceptualizing and shaping the structure of the kingdom."

112 In poetry by the caliph al-Walid, *bahw* described the room decorated with stone mosaics in which Walid is said to have sat behind a curtain listening to music and poetry. In later periods, the term *bahw* was mostly used in western Islamic contexts to describe a tent or pavilion chamber situated beyond the rest, as well as an audience chamber. See G. Marçais, s.v. bahw, in P. Bearman *et al.*, eds., *Encyclopaedia of Islam*, 2nd ed., first published online 2012. Available at: http://dx.doi.org/10.1163/1573-3912_islam_SIM_1080.

113 Puerta Vílchez, *Reading the Alhambra*, pp. 294–95. Poem probably written by Ibn Zamrak, for Muhammad V. "My splendour and my pavilion [*bahw*] are of the most extreme beauty because it has been enlarged in the finest possible way. The kingdom ennobled in it with the firm seat of honour, and with it the palace is crowned with the most sublime place of appearance."

114 Puerta Vílchez, *Reading the Alhambra*, p. 42.

115 Puerta Vílchez, *Reading the Alhambra*, p. 231.

116 Ibn al-Khatib inscription in the Machuca Tower, also known as the *bahw an-Nasr* or "Victory pavilion", quoted in Puerta Vílchez, *Reading the Alhambra*, p. 42. See also Angel C. López-López and Antonio Orihuela Uzal, "Una nueva interpretación," p. 122.

117 *Hadith Bayad wa Riyad*, now in the collection of the Biblioteca Apostolica Vaticana (Vat.ar.368).

118 Dede Fairchild Ruggles, "The Eye of Sovereignty: Poetry and Vision in the Alhambra's Lindaraja mirador," *Gesta*, XXXVI/2 (1997), p. 188: "it is entirely likely that it held smaller meetings, perhaps for especially sensitive political negotiations and decisions or for literary gatherings of learned scholars and poets."

119 Arnold, *Islamic Palace Architecture*, p. 240.

120 Ali Bey el Abbassi, a.k.a. Domingo Badía y Leblich, *Viajes por Marruecos*, ed. Salvador Barberá Fraguas, Madrid, Editorial Nacional, 1984, p. 207.

121 Mariam Rosser-Owen, "Poems in Stone: The Iconography of 'Amirid Poetry and its 'Petrification' on 'Amirid Art," in Glaire D. Anderson and Mariam Rosser-Owen, eds., *Revisiting Al-Andalus: Perspectives on the Material Culture of Islamic Iberia and Beyond*, Leiden, Brill, 2007, pp. 83–98. The basin is in the Museo de la Alhambra (formerly Mu-

seo Nacional de Arte Hispanomusulmán) in Granada, Inv. Number 243. Height: 61 cm, length: 137 cm, width: 88 cm. See also Purificación Marinetto Sánchez, "Pila," in *Arte Islámico en Granada: Propuesta para un Museo de la Alhambra* Granada, Editorial Comares, 1995, pp. 277–80, cat. no. 73.

122 The inscription translated from Arabic reads:
Badis b. Habbus as-Sanhagi [transported] all the marbles to his palace in the capital, Granada—may Allah preserve it! And then […] the sultan, the king, the just, the victorious, assisted by God, the emir of the Muslims and defender of the faith, Abu Abd Allah, son of our master the emir of the Muslims, son of our master al-Galib bi-llah […] and that in the month of sawwal in the year 704 [27 April–25 May 1305] and the praise is with God, master of the world. Translated from Arabic to French by Évariste Lévi-Provençal, *Inscriptions Arabes d'Espagne*, Leiden, Brill, 1931, pp. 195–96. Jones, *Plans, Elevations*, vol. 1, plate XLVI. See also Richard Ford, *A Handbook for Travellers in Spain and Readers at Home: Describing the Country and Cities, the Natives and Their Manners, the Antiquities, Religion, Legends, Fine Arts, Literature, Sports, and Gastronomy; With Notices on Spanish History*, vol. 1, London, J. Murray, 1845, p. 133.

123 Ann Christys, "Picnic at Madinat al-Zahra," in Simon Barton and Peter Linehan, eds., *Cross, Crescent and Conversion: Studies on Medieval Spain and Christendom in Memory of Richard Fletcher*, Leiden, Brill, 2008, pp. 87–108.

124 On Muslim engagement with antiquity see Stephennie Mulder, "Imagining Localities of Antiquity in Islamic Societies," *International Journal of Islamic Architecture*, 6/2 (2017), pp. 229–54.

125 Mariam Rosser-Owen, "Andalusi Spolia," pp. 152–98. The Alhambra basin is in the Museo Nacional de Arte Hispanomusulmán in Granada. The Marrakesh basin is in the Dar Si Said in Marrakesh. A third basin, from the same period, was discovered in pieces in Seville and is now at the Museo Arqueológico Nacional in Madrid (Inv. 50428).

126 Rosser-Owen, "Andalusi Spolia," pp. 152–98.

127 Leopoldo Torres Balbás, "Las Casas del Partal de la Alhambra de Granada," *Al-Andalus*, XIV (1949), pp. 186–97; Manuel Gómez

Moreno, "Pinturas de Moros en el Partal (Alhambra)," *Cuadernos de la Alhambra*, 6 (1970), pp. 155–64. Originally published in 1916 in Granada by Ed. Sabatel.

128 Torres Balbás, "Las Casas del Partal," pp. 190–91.

129 Torres Balbás, "Diario" (1965), p. 72. See also Almagro Gorbea, "El color," pp. 99–107.

130 Almagro Gorbea, "El color," pp. 99–107.

131 Anderson, *Islamic Villa*, p. 72.

CHAPTER FOUR: A SOLDIER'S RESIDENCE: 1492–1812

132 For example, after Ferdinand and Isabela arrived in Granada in early 1492, they stayed at the Alhambra for some four months until 4 May of that year, when they left to spend Easter in Córdoba. Matilde Casares López, *Las Obras Reales de la Alhambra en el siglo XVI: un estudio de los libros de cuentas de los pagadores Ceprián y Gaspar de León (1528–1627)*, unpublished doctoral thesis, University of Granada, 2008, p. 38, note 10.

133 As Granada's importance declined, Madrid became the centre of the royal court of Spain under Felipe II, who built his Royal Alcázar (royal palace) there and constructed a royal pantheon at the Escorial just outside the city.

134 Abigail Balbale, "Bridging Seas," p. 374.

135 Juan Carlos Ruiz Souza, "Castile and al-Andalus after 1212: Assimilation and Integration of Andalusi Architecture," *Journal of Medieval Iberian Studies*, 4/1 (2012), pp. 125–34.

136 Maria Judith Feliciano, "Muslim Shrouds for Christian Kings? A Reassessment of Andalusi Textiles in Thirteenth-Century Castilian Life and Ritual," Cynthia Robinson and Leyla Rouhi, eds., *Under the Influence: Questioning the Comparative in Medieval Castile*, Leiden and Boston, Brill, 2005, pp. 101–31. Feliciano identifies this shared aesthetic vocabulary as "a pan-Iberian aesthetic unity that transcended ethnic, religious and political boundaries."

137 Ferdinand (d. 1518) and Isabella (d. 1504) were initially buried at the chapel in the Convent of San Francisco, formerly a Nasrid palace, in the Alhambra. Their tombs were transferred to the Royal Chapel beside the Cathedral of Granada in 1521 by their grandson, Charles V.

138 Carlos Vílchez Vílchez, "Los otros señores de la Alhambra. La tenencia de alcaldía del Generalife," in Rafael Jesús López Guzmán, ed., *Los Tendilla: señores de la Alhambra*, Granada, Patronato de la Alhambra y Generalife, 2016, pp. 93–97.

139 The mosque was initially consecrated and converted to a church, before the building was destroyed and replaced with the new church of Santa María in the mid-sixteenth century.

140 Specifically, it stated: "*dies días, en tanto que las dichas fortalesas del alhambra e alhiçan se reparan e proueen e fortalecen*". Quoted in Miguel Garrido Atienza, ed., *Las Capitulaciones para la entrega de Granada*, Granada, University of Granada, 1992, document XLVII, p. 239.

141 "*El 26 de octubre, cuando estábamos allí, vimos a muchos sarracenos adornando ya y restaurando las pinturas y las demás cosas con la finura propia suya; disfrutamos allí de un magnífico espectáculo.*" Hieronymus Münzer, *Viaje por España y Portugal 1494-1495*, Valladolid, Editorial Maxtor, 2019, p. 39.

142 Hieronymus Münzer, "Jerónimo Münzer. Viaje por España y Portugal en los años 1494 y 1495," trans. from the Latin by Julio Puyol, *Boletín de la Real Academia de la Historia*, 84 (1924), p. 89.

143 On this period see Harvey, *Islamic Spain*, pp. 307–23. See also L.P. Harvey, *Muslims in Spain 1500 to 1514*, Chicago, University of Chicago Press, 2008.

144 Antonio Malpica Cuello, "Las transformaciones de la Alhambra nazarí por la acción castellana," in José Antonio González Alcantud, ed., *La Alhambra: lugar de la memoria y el diálogo*, Granada: Editorial Comares, 2008, p. 17.

145 Richard Hitchcock, *Muslim Spain Reconsidered from 711 to 1502*, Edinburgh, Edinburgh University Press, 2014, p. 190.

146 As "*torre y aposento en que bibia Alvaro de Luz.*" Cruces Blanco and Galera Andreu, "Las Torres," p. 47.

147 Rodrigo de Luz Carretera, "El linaje de Luz durante el proceso de conquista y organización de la Granada moderna," in *Los linajes nobiliarios en el reino de Granada, siglos XV–XIX. El linaje Granada venegas, marqueses de Campotéjar*, Huéscar, Asociación Cultural Raigadas, 2010, pp. 173–206.

148 Archival documents cited in Casares López, "Las Obras Reales," pp. 819–20.

149 Francisco Sánchez-Montes González, "La Alhambra del siglo XVII," in López Guzmán, *Los Tendilla*, pp. 99–103.

150 "Memorial de Juan de Orea de las casas que se han reparado en el Alhambra a costa de su Magestad," in Rafael Jesús López Guzmán, *Colección de documentos para la historia del arte en Granada. Siglo XI*, Granada, University of Granada, 1993. The Juan de Orea document was an inventory of the towers and properties of the Alhambra, including their inhabitants, function, and condition from the 1570s. It exists in copy form, unsigned but with a marginal note "memorial de Orea" that indicates it was prepared by the master of works of the royal house of the Alhambra, Juan de Orea, who took over from his predecessor Luis Machuca in 1572.

151 Cruces Blanco and Galera Andreu, "Las Torres," p. 42. The figures cited are from the Archivo General de Simancas, Sección Contaduría Mayor de Cuentas, leg. 265.

152 The dispute was between the Alhambra administrator Don Gaspar de León and the governor of the Hall of Comares, Fernando Contreras, and "Maria de las nieves," a freed slave. Casares López, "Las Obres Reales," pp. 763–68.

153 Cruces Blanco and Galera Andreu, "Las Torres," p. 44.

154 Reference to archival documents from the Archivo del Patronato de la Alhambra y Generalife (APAG) L-206-5.1721, cited in Esther Galera Mendoza, *Estructura urbana y organización productiva en la Alhambra durante el Antiguo Régimen*, Granada, University of Granada, 2013, Appendix 8, pp. 139–41.

155 Torres Balbás, "Diario" (1965), p. 82. Maria Cruz Ramos Torres, "Preparativos en la Alhambra ante la venida de Felipe V," *Cuadernos de la Alhambra*, 8 (1972), pp. 91–98.

156 Carlos Vílchez Vílchez, *El Palacio del Partal Alto en la Alhambra*, Granada, Proyecto Sur de Ediciones, 2001, p. 132. The destruction of the palace by the new governor on the orders of the king is noted in an archival document from 1735, transcribed in Galera Mendoza, "Estructura urbana," APAG L-91-1, 1735, Appendix 7, p. 133.

157 Pedro Machuca drew a plan of the Alhambra in 1528–29 in his capacity as the architect of the palace of Charles V that was built

adjacent to the royal palaces, but his map featured only the later royal palaces and Alcazaba, not the Partal. The Machuca plan is preserved in the Biblioteca del Palacio Real de Madrid.

158 de Hermosilla y Sandoval *et al.*, *Antigüedades Árabes de España*. See also Antonio Almagro Gorbea, ed., *El legado de al-Ándalus. Las antigüedades árabes en los dibujos de la Academia*, Madrid, Real Academia de Bellas Artes de San Fernando, Fundación Mapfre, 2015.

159 *Monumentos Arquitectónicos de España. Publicados á expensas del Estado y bajo la dirección de una comisión especial creada por el Ministerio de Fomento*, Madrid, Imprenta y Calcografía Nacional, 1856–82. See Javier Ortega Vidal, "Los dibujos de la 'arquitectural mahometana' en Monumentos Arquitectónicos," Almagro Gorbea, *El Legado de al-Ándalus*, pp. 45–62.

160 Simón de Argote, *Nuevos Paseos Históricos, Artísticos, Económico-Políticos, por Granada y sus Contornos*, Granada, D. Francisco Gomez Espinosa de los Monteros, 1806. A copy of the third volume in the series is in a private collection in Granada. Another copy of this rare volume is among the three volumes of Argote's work that were owned by Richard Ford, now in the British Library in London. In a handwritten note signed by Ford, in the front of his copy of the *Nuevos Paseos* (vol. 1), he described how the third volume was printed after Argote fled Granada with the French and that the author never saw it in print. Ford thought he didn't possess a copy until he found it irregularly bound with other parts of the work. Ford met Argote in Granada in 1833; in the handwritten note he gave the following description of Argote: "decrepit, toothless, with a bald head and straggling white hair, with that peculiar monkey like character of face so common to Frenchmen when old he was very like [Devon?]. He had been educated as a lawyer in Peru, came early to Spain, became inculcated with French Philosophy and on their invasion attached himself to General Sebastiani to whom he was of great use in collecting pictures; he retired with the French into France, his prospect of what he regretted most his excellent library was confiscated, he was a lively old freethinker full of old conceits and landing his conversation with scraps of French."

161 Argote, *Nuevos Paseos*, vol. 3, pp. 18–19. Juan Calatrava Escobar, ed., "Un retrato de Granada a principios desl siglo XIX: Los 'Nuevos Paseos' de Simón de Argote," *Demófilo. Revista de Cultura Tradicional de Andalucía*, 35 (2000), pp. 95–110.

162 Argote, *Nuevos Paseos*, vol. 3.

163 Juan Manuel Barrios Rozúa, "El Generalife y las ruinas árabes de sus contornos. Un capítulo inédito de los *Nuevos Paseos* de Simón de Argote," *Al-Qantara*, 35/1 (2014), pp. 29–59. Rozúa reports (p. 33) that the correspondence between Napoleon and Laborde is conserved in the French national archives (381 AP/27).

164 Jesús Bermúdez López, "The Alhambra and Generalife Official Guide," Madrid, TF Editores, 2010, pp. 300–1. Juan Manuel Barrios Rozúa, *Granada Napoleónica: ciudad, arquitectura y patrimonio*, Granada, University of Granada, 2013, p. 154

CHAPTER FIVE: AN ARTIST'S HOME: 1812–1885

165 The purchaser was probably Nicolás Ximénez. See Juan Manuel Barrios Rozúa, *Richard Ford, un aristócrata en la Alhambra romántica. Granada. Escritos con dibujos inéditos del autor Richard Ford*, Granada, University of Granada, 2012, p. 12. The author references the Archivo Histórico de la Alhambra (AHA) 264-1.

166 Barrios Rozúa, *Richard Ford*, p. 43.

167 Barrios Rozúa, "La poblacion de la Alhambra: de ciudadela a monument (1814–1851)," *Boletín de la Real Academia de la Historia*, 205/3 (2008), p. 487. Archivo del Patronato de la Alhambra y Generalife (APAG) 10759/19 and AHA, pp. 203–5.

168 Galera Mendoza, *Estructura urbana*, p. 51, note 63, APAG L-71-18.

169 AGP Reinados Fernando VII 290/2, cited in Barrios Rozúa, "La población," p. 481.

170 Barrios Rozúa, *Granada Napoleónica*, p. 278.

171 Barrios Rozúa, "La población," p. 478.

172 Barrios Rozúa, "La población," pp. 475–76.

173 Richard Ford, *Handbook*, vol. 1, p. 381.

174 Lewis's signature is in the Alhambra Visitors' Book from 20 October 1832. He stayed there again in 1833, when he lived at the Partal from April until September with Richard Ford, his wife Harriet Ford, and their family. Ford wrote in a letter from the

end of 1832 that "I have Don Lewis staying in my house, he has made some beautiful sketches of Granada." Antonio Gámiz Gordo, "Los dibujos originales de los palacios de la Alhambra de J.F. Lewis (h.1832–33)," *EGA Expresión Gráfica Arquitectónica*, 20 (2012), pp. 76–87.

175 John Frederick Lewis, *Sketches and Drawings of the Alhambra, Made during a Residence in Granada, in the Years 1833–4*, London, Hodgson Boys & Graves, 1835.

176 Jones, *Plans, Elevations*, vol. 2, plate 22 number 34, "Ornament on the Walls, House of Sánchez" and plate 28 number 40, "Frieze in the Upper Chamber of the House of Sánchez." While plate 22 number 34 references existing plasterwork in the upper section of the mirador, plate 28 number 40 is not similar to surviving plasterwork or woodwork in the mirador. It is possible that Jones confused the identification of the plates, and plate 22 number 34 should instead refer to a "frieze in the upper chamber of the house of Sánchez." This print (plate 22 number 34) from the plasterwork of the mirador is included in his later publication, Owen Jones, *The Grammar of Ornament*, London, Day and Son, 1856, plate 42 number 5.

177 Jones, *Plans, Elevations*, vol. 2, plate 51.

178 James Ballantine, *The Life of David Roberts, R.A.: Compiled from His Journals and Other Sources*, Edinburgh: Adam and Charles Black, 1866, p. 49.

179 Antonio Giménez Cruz, *La España pintoresca de David Roberts*, Málaga, University of Málaga, 2002, pp. 141–43.

180 Thomas Roscoe, *The Tourist in Spain: Granada*, London, Maurice, Clark, and Co., 1835, illustrated from drawings by David Roberts. Plate 3 "Palace of the Generalife, Looking from the Hall of the Ambassadors," p. 29.

181 Joseph-Philibert Girault de Prangey, *Essai sur l'architecture des Arabes et des Mores: en Espagne, en Sicile, et en Barbarie*, Paris, A. Hauser, 1841, pp. 172–73:
"The mirador de buena vista, formed suddenly on the residence of a prince of the royal family. A large patio whose basins are still easily recognizable, precede the housing, consists of a first room and a larger room, that accompanies another room at the eastern end, both protruding on the wall of the fortress. On the first floor we find exactly the same layout. Then, to the west, above the staircase that led to the various rooms on the first floor, was the mirador, a belvedere without rival, even at the Alhambra, for the precious finesse of its sculptures and the unmistakable delicacy of its ornaments and its inscriptions, dominated the whole dwelling."

182 Joseph-Philibert Girault de Prangey, *Choix d'ornements moresques de l'Alhambra, ouvrage-faisant suite á l'Atlas in folio, Monuments arabes et moresques de Courdoue, Séville et Grenade*, Paris, A. Hauser, 1842, plate 30, numbers 2, 3, 4 (Ornements divers, Palacio del Principe).

183 John Frederick Lewis, *Sketches of Spain and Spanish Character, Made during His Tour in that Country, in the Years 1833–4, Drawn on Stone from his Original Sketches Entirely by Himself*, London, F.G. Moon, 1836, plate 8.

184 George Vivian, *Spanish Scenery*, London, P. and D. Colnaghi, 1838.

185 Vivian, "Introduction," in *Spanish Scenery*.

186 Brinsley Ford, *Richard Ford in Spain*, exhibition catalogue, 5 June–12 July, London, Wildenstein, 1974. See Cat. 19 for the carved section.

187 Richard Ford, *Gatherings from Spain*, London, J. Murray, 1861, pp. 275–76.

188 Mulder, "Imagining Localities," pp. 229–54.

189 Wendy Shaw, "In Situ: The Contraindications of World Heritage," *International Journal of Islamic Architecture*, 6/2 (2017), p. 361.

190 See for example the Victoria & Albert Museum collection, which includes a piece of plaster from the Partal portico, inventory number 360-1901.

191 Juan Manuel Barrios Rozúa, "La Alhambra de Granada y los difíciles comienzos de la restauración arquitectónica (1814–1840)," *Boletín de la Real Academia de Bellas Artes de San Fernando*, 106–7 (2008), p. 138: "El evento iba a demostrar que el orientalismo no era ya una mera excentricidad de viajeros extranjeros, sino que penetraba entre las elites granadinas y que constituía la mejor baza para impresionar a unos visitantes ilustres."

192 Juan Manuel Barrios Rozúa, *Alhambra Romántica. Los comienzos de la restauración arquitectónica en España*, Granada, University of Granada, 2016, p. 53.

193 Joseph von Auffenberg, *Humoristische Pilgerfahrt nach Granada un Kordova im Jahre 1832*, Leipzig and Stuttgart, J. Scheible, 1835, p. 361: "*Mit Einbruch der Dunkelheit wurde ganz Granada auf das festlichste beleuchtet. Ein Unblick, der an die Mährchen von 1001 Nacht und an die Gloriennacht des mohammedanischen Paradieses erinnert.*"

CHAPTER SIX: FROM GRANADA TO BERLIN: 1885–1978

194 Gwinner wrote, "*El cuadro lo hice en 1832, no sabiendo que 3 años despues la Torre de las Damas sería mía*" (I made the painting in 1832, not knowing that three years later the Torre de las Damas would be mine). I am grateful to Carlos Sánchez for making me aware of this photograph.

195 Personal letter to me from Mareti Schönbeck, dated July 2014. I am very grateful to Frau Mareti Schönbeck for sharing her memories of her grandfather Arthur von Gwinner with me.

196 Obituary for Arthur von Gwinner, *Monatsheft für die Beamten der Deutschen Bank und Disconto-Gesellschaft* (1932), pp. 1–10.

197 Jones, *Plans, Elevations* and *Grammar of Ornament*.

198 Owen Jones, *The Alhambra Court in the Crystal Palace*, London: Crystal Palace Library and Bradbury and Evans, 1854, introductory note.

199 Jones's Alhambra Court was partially destroyed in a fire at the Crystal Palace in 1866, but subsequently was one of only two courts rebuilt and re-opened in 1868. Jan R. Piggott, *Palace of the People: The Crystal Palace at Sydenham 1854–1936*, London, C. Hurst & Co., 2004, p. 172.

200 Gwinner, *Lebenserinnerungen*, p. 35, my translation.

201 Washington Irving, *The Alhambra: A Series of Tales and Sketches of the Moors and Spaniards*, London, Henry Colburn and Richard Bentley, 1832. Revised by the author and republished in 1851 as *Tales of the Alhambra*.

202 Adolf Friedrich von Schack, *Poesie und Kunst der Araber in Spanien und Sicilien*, Berlin, W. Hertz, 1865. Gwinner, *Lebenserinnerungen*, pp. 42–45.

203 Gwinner, *Lebenserinnerungen*, pp. 42–43.

204 The Partal is included in many publications about the Alhambra as one of the earliest of the palaces, with fine decoration. In particular, we know Gwinner read Schack's *Poesie und Kunst*, in which Schack describes the decoration of the Partal towers as among the best in the Alhambra (vol. 2, pp. 281–369).

205 Modesto Landa Lluch had been a well-known baritone in Madrid, singing *zarzuelas* throughout Spain, before he bought the Partal palace and retired to Granada. It was Landa who sold the building to Gwinner and Widmann, and Landa who stayed there as guardian and tenant until his death in 1909.

206 Sale documents from 1885 note the debt of Landa. The sale was agreed in front of a notary in Córdoba on 8 June 1885. Sale documents, MIK archives.

207 Gwinner describes in his memoirs how Widmann used Gwinner's money to acquire the building on his behalf (possibly because Widmann was in Granada living in the building at the time, while Gwinner was in Madrid). Gwinner, *Lebenserinnerungen*, pp. 42–43.

208 The sale document in the MIK archive reads, "*a excepción de un pequeño grupo adosado al muro de la izquierda y torre, que consiste en una cuadra, un patio pequeño y una habitación unida a la torre sobre el muro mismo de la Alhambra.*" Sale document, number 238, Córdoba 23 June 1885, MIK archives.

209 "*Existiendo en la parte de finca de que queda hecho propietario el Señor Landa un techo antiguo árabe, lo cede á el Don Anton Richard para que pueda quitarlo [mediante] al construir uno raso a la moderna, de su cuenta*" (in the part of the property that remains belonging to Señor Landa, there is an old Arab ceiling which he cedes to Anton Richard so he can remove it and build a modern ceiling, on his account). Sale document, number 238, Córdoba 23 June 1885, MIK archives.

210 Antonio Almagro Cárdenas, *Museo Granadino de Antigüedades Árabes*, Granada, J. Garcia Garrido, 1886, p. 45, note 1. Almagro Cárdenas attributed the discovery of the windows' dimensions and details to a "German architect who lived in the palace a few years ago": presumably Widmann.

211 The acquisition was finalized in a legal agreement in Frankfurt am Main on 26 May 1886 and transcribed and translated in the registration of property in Granada on 2 June 1886. MIK archives.

212 Gwinner paid 10,750 *pesetas* for the rest of the tower. This revised agreement was written into the sale deeds on 7 June 1886.

213 In a publication from 1886, Antonio Almagro Cárdenas described having seen the cupola in the mirador. Cardenas, *Museo Granadino*, p. 36. Carlos Sánchez Gómez, "El Taujel Viajero de la Torre de las Damas," in *21 Jardines del Partal*, Granada, University of Granada, 2007, p. 13.

214 They published a summary of their observations in the *Boletín del Centro Artístico*, 51 (1888), pp. 17–19.

215 Copies of the documents for the sale of the Partal from 1885 and the transfer of ownership in 1891 and 1921 are in the possession of the archives of the MIK, having accompanied the cupola sale from Klingler in 1978.

216 Torres Balbás, "Diario" (1965), p. 83.

217 The plaque has since been removed from the Partal and its current whereabouts unknown.

218 Avinoam Shalem, "The Poetics of Portability," in *Histories of Ornament: From Global to Local*, Princeton and Oxford, Princeton University Press, 2016, pp. 250–61.

219 Gwinner, *Lebenserinnerungen*, p. 45, my translation.

220 Klaus Brisch, former director of the MIK who oversaw the purchase of the cupola in 1978, wrote that Gwinner intended to dismantle the building and bring it back in its entirety to Berlin before the Granadan authorities intervened to stop him. I have not been able to confirm the veracity of this claim, but Brisch was in touch with the descendants of Gwinner, from whom he may have heard this version of events. See Klaus Brisch, "Kuppeldach aus dem Aussichtsturm des Torre de las Damas (Damenturm)," in pamphlets 808a and 808b at the MIK, Staatliche Museen Preussischer Kulturbesitz, Berlin-Dahlem, 1979, p. 169.

221 Gwinner signed the visitors' book of the Alhambra on 7 March 1866, on behalf of himself and *"meine bessere Hälfte"* (my better half). Album de visitants ilustres, Archivo del Patronato de la Alhambra y el Generalife.

222 Gwinner, *Lebenserinnerungen*, p. 45.

223 Gwinner identified him in his memoir as a well-known master builder called Ihne. This may have been the German architect Ernst Eberhard von Ihne (1848–1917), one

of whose buildings was the Kaiser-Friedrich-Museum in Berlin, now the Bode Museum.

224 John Sweetman, *The Oriental Obsession: Islamic Inspiration in British and American Art and Architecture, 1500–1920*, Cambridge, Cambridge University Press, 1998; Miles Danby, *Moorish Style*, London, Phaidon, 1995; Juan Calatrava Escobar *et al.*, *Owen Jones y la Alhambra*, Granada, Patronato de la Alhambra y Generalife, 2011.

225 Anna McSweeney, "Versions and Visions of the Alhambra in the Nineteenth-Century Ottoman World," *West 86th: A Journal of Decorative Arts, Design History, and Material Culture*, 22/1, 2015, p. 66, note 35.

226 Nieves Panadero Peropadre, "Recuerdos de la Alhambra: Rafael Contreras y el gabinete árabe del Palacio Real de Aranjuez," *Reales sitios: revista del patrimonio nacional*, 122 (1994), pp. 33–40.

227 Angelika Kaltenbach, "Das orientalische Kabinett der Villa Stauß. Ein noch unbekanntes Kunstwerk des Orientalismus in Berlin," in Julia Gonnella and Jens Kröger, eds., *Wie die Islamische Kunst nach Berlin kam. Der Sammler und Museumsdirektor Friedrich Sarre (1865–1945)*, Berlin, Reimer, 2015, pp. 79–87.

228 Vivian J. Rheinheimmer, *Herbert M. Gutmann: Bankier in Berlin. Bauherr in Potsdam*, Leipzig, Koehler & Amelang, 2007.

229 Mariam Rosser-Owen, *Islamic Arts from Spain*, London, V&A Publishing, 2010, p. 129.

230 Elke Pflugradt-Abdelaziz, "A Proposal by the Architect Carl von Diebitsch (1819–69): Mudéjar Architecture for a Global Civilization," in Nabila Oulebsir and Mercedes Volait, eds., *L'Orientalisme architectural entre imaginaires et savoirs*, Paris, INHA, 2009, pp. 69–88.

231 For more on orientalized interiors and the Alhambra style in European architecture, see in particular the chapter "Moorish Style" in Rosser-Owen, *Islamic Arts from Spain*. See also Juan Calatrava Escobar, ed., *Romanticismo y Arquitectura. La historiografía arquitectónica en la España de mediados del siglo XIX*, Madrid, Abada Editores, 2011; Sweetman, *Oriental Obsession*; Danby, *Moorish Style*; Calatrava Escobar, *Owen Jones*.

232 From a 1910 financial publication quoted in Manfred Pohl, "150th Anniversary of the

Birth of Arthur von Gwinner," *Bank and History: Historical Review*, 10 (2006), p. 1.

233 Suzanne Marchand, *German Orientalism in the Age of Empire*, Washington, DC, German Historical Institute and Cambridge University Press, 2009, pp. 333–426.

234 *The Washington Post*, 14 October 1917, p. 2. In 1908 Gwinner received his title of nobility from the Kaiser (allowing him to add "von" before his surname) and in 1910 was appointed by the Kaiser to the upper house of the Prussian parliament, the *Preussisches Herrenhaus*, where he spoke on national and international economic issues of the day.

235 See the obituary for Arthur von Gwinner, p. 6. The Berlin Club was also known as the Mittwochs-Gesellschaft.

236 Letter from Friedrich Sarre to Wilhelm von Bode, dated 16 December 1908, MIK archives. It is clear in his correspondence that Sarre did not select members only for their personal wealth, although this helped at a time when there was little public money available for acquisitions or excavations.

237 With grateful thanks to Reinhard Frost at the Deutsche Bank Archive for his help with the Gwinner papers held in Frankfurt am Main. Many of Gwinner's personal papers were lost, probably during WWII.

238 Letter from Friedrich Sarre to Wilhelm von Bode, dated 16 December 1908, MIK archives. Sarre explains that Gwinner's colleague at the Deutsche Bank, Rudolph von Koch, would not be so suitable as he apparently had "no artistic interests." Other members of the expert advisory commission included: Herbert M. Gutmann, banker (1879–1942); Eduard Simon (1864–1929), businessman; Otto von Falke, director of the Museum of Applied Arts (1862–1942); and Jakob Goldschmidt, banker (1882–1955). Gwinner was among Sarre's friends and colleagues who gave money for his sixtieth birthday celebrations, allowing him to acquire objects for the museum. Anna McSweeney, "Arthur von Gwinner und die Alhambra Kuppel," in Julia Gonnella and Jens Kroeger, eds., *Wie die Islamische Kunst nach Berlin kam. Der Sammler und Museumsdirektor Friedrich Sarre (1866–1945)*, Berlin, Staatliche Museen zu Berlin, 2015, p. 101.

CHAPTER SEVEN:
FROM PRIVATE COLLECTION TO THE MUSEUM

239 The first guidebook to the museum includes a description of the Maurische Kabinett and an admission of the few examples it had of Spanish objects. Staatliche Museen zu Berlin, *Führer durch die Islamische Kunstabteilung*, Berlin, Staatliche Museen zu Berlin, 1933, p. 7.

240 Among his 385 publications, many of which were devoted to individual works of art from al-Andalus and the Maghreb, Ernst Kühnel dedicated several important publications to the region. See: "Alhambraprobleme. Ergebnisse und Ziele der neuen Restaurierungsarbeiten," in *Monatsheft für Kunstwissenschaft*, 1/3, Munich and Berlin, Deutscher Kunstverlag, 1908, pp. 192–93, 438–39; *Granada*, vol. 12, Leipzig, Statten der Kultur, 1909; *Maurische Kunst*, Berlin, Bruno Cassirer Verlag, 1924. For a full bibliography of the writings of Kühnel see Kurt Erdmann, "Bibliography of the Writings of Ernst Kühnel," *Ars Orientalis*, 1 (1954), pp. 195–208.

241 "*In beispiellos barbarischer Weise waren die reizenden Wanddekorationen übertüncht, die zierlichen Fenster vermauert und statt ihrer neue in die Mauer gebrochen, um moderne Wohnungen zu schaffen, und der letzte Besitzer, ein Deutscher, besaß noch die Geschmacklosigkeit, sich die einzigartige Turmdecke mitzunehmen, als er den Palast dem Staate schenkte.*" Kühnel, "Alhambraprobleme," p. 192.

242 While it is likely that Gwinner read the 1908 article, his memoirs do not mention him taking offence at Kühnel's remarks. He may have simply preferred to keep the cupola in the family, having donated to many causes during his life, in particular his important fossil and mineral collection to museums including the Senckenburg Naturmuseum in Frankfurt am Main.

243 Note by Wolfgang Klingler relating to the cupola, dated 19 September 1975, MIK archives. It is typed in English and signed by Klingler, so was possibly the description sent to the Metropolitan Museum of Art in New York. The same history was related in a letter from Hans Gwinner (Gwinner's son), to Ernst Kühnel, dated 17 December 56, in which he describes the forty-four *azulejos* (Spanish-style tiles) in his possession, and

narrates the story of his father's cupola and the damage it sustained during WWII.

244 The letter from Hans Gwinner to Kühnel from 1956 states that the cupola was in crates in Bayern (see previous note). With thanks to Margret von Conta, granddaughter of Margarethe and Karl Klingler, for her help with this part of the cupola's journey and for her concern that the Jewish heritage of her family be remembered as part of this story.

245 Klingler note, 19 September 1975.

246 Carlos Sánchez Gómez, "Taujel Viajero," p. 14.

247 Letter from Klingler to Brisch, dated 26 January 77, MIK archives.

248 Antonio Fernández-Puertas, expert statement, Berlin, dated 19 April 1978, MIK archives.

249 Letter from Wolfgang Klingler to Klaus Brisch, Bremen, dated 26 January 1977, MIK archive.

250 Fernandez-Puertas expert report, dated 19 April 1978, MIK archives.

251 Richard Ettinghausen expert report, dated 9 March 1978, MIK archives.

252 Richard Ettinghausen, expert report, dated 9 March 1978, MIK archives.

253 Klaus Brisch, "Eine Kuppel aus der Alhambra in Granada," *Berichte aus den Berliner Museen Preussischer Kulturbesitz*, 3/14 (1978), pp. 6–10.

254 Ernst Kühnel, "Islamische Kunst in Dahlem," *Berlin Museen 4*, 3/4 (1954), pp. 38–42. See also Otto Kurz, "The Present State of the Berlin Museums," *Burlington Magazine*, 98/640 (1956), pp. 234–38.

255 Kühnel, "Islamische Kunst in Dahlem." See also Richard Ettinghausen's translation of Kühnel's report on the condition of the Berlin collections of Islamic art in Kühnel, "The Islamic Department of the Berlin Museum," *Ars Islamica*, 15/16 (1951), pp. 143–45.

256 Jens Kröger, "Early Islamic Art History in Germany and the Concepts of Object and Exhibition," in *Islamic Art and the Museum*, Berlin, Saqi Books, 2012, pp. 173–82.

257 Letter from Brisch to the President of the Stiftung Preussischer Kulturbesitz, dated 16 June 1977, MIK archives. "*Das einmalige Werk wäre eine ideale Ergänzung für die Schausammlungen, insbesondere weil zusammen mit dem bereits dort eingebauten Mihrab dann ein zweites wichtiges Denkmal islamis-cher Architektur, diesmal sogar islamischer Architektur aus Spanien, hinzu käme.*"

258 See Eva-Maria Troelenberg on the political narratives around the restoration of the Islamic collections in the 1950s, "Aus Ruinen auferstanden? Ernst Kühnel, Friedrich Bachor und der Wiederaufbau der Mschatta-Fassade nach 1945," *Jahrbuch der Berliner Museen*, 54 (2012), pp. 141–52.

259 Letter to the president of the Stiftung Preussischer Kulturbesitz, Herr Professor Dr. Werner Knopp, dated 19 April 1978, MIK archives.

260 Letter from Manuel Keene, research associate at the Islamic Department, Metropolitan Museum of New York, to Klaus Brisch, dated 20 July 1977, MIK archives.

261 "Kuppel der Alhambra," *Frankfurter Allgemeine*, 2 August 1978.

262 Untitled article in the Spanish national newspaper *ABC*, 10 August 1978, p. 23. "*Reclaman un artesonado de la Alhambra vendido a un museo aleman.*" The association for environmental and cultural protection was known as "Adelpha."

263 Note from Werner Knopp to Klaus Brisch, dated 18 August 1978, MIK archives: "*Obwohl unsere Position in diesem Falle ja juristisch wie moralisch einwandfrei ist, sollten wir die Entwicklung in Spanien doch mit Aufmerksamkeit verfolgen.*"

264 I have not been able to locate Brisch's reply to Knopp's note in the MIK archives.

265 Eleven pieces from the cupola were replaced following its purchase by the Museum in 1978. These were reportedly lost during WWII, when the cupola was in storage, according to notes in Klingler's letters (1977). The losses are not visible in the photograph from Sophienstraße, which suggests that the damage occurred between 1928 and 1978. Replaced sections are found in the *muqarnas* epigraphic frieze and in the lower sections in particular and are identifiable by their lack of colour paint traces and their lighter wood colour. The pieces of the cupola that were missing from its storage during the war were commissioned from the Berlin-based wood restorers Erhart Wagner in 1978.

266 Dodds, *Al-Andalus*, pp. 368–69. Catalogue number 116. The exhibition opened in Granada, but the cupola only joined the exhibition when it moved to New York in July 1992.

267 Letter from Montebello to Meinecke, dated 10 December 1991, MIK archives.

CHAPTER EIGHT:
THE PARTAL IN THE TWENTIETH CENTURY

268 The total number of tourists who visited the Alhambra in 2016 was 2,615,188. Data on visitor numbers is published annually by the Patronato de la Alhambra and is available at: http://www.alhambra-patronato.es/index.php/Balance-de-Visitantes-2016/1756/0/.

269 José Manuel Rodríguez Domingo, "La protección institucional de las 'antigüedades árabes' en Granada," *El patrimonio arqueológico en España en el siglo XIX. El impacto de las desamortizaciones*, Madrid, Ministerio de Educación, Cultura y Deporte, 2012, pp. 290–307.

270 In his description, Contreras recognized the antiquity and beauty of the Partal and its decoration, noting in particular the cupola. Rafael Contreras, *Estudio Descriptivo de los Monumentos Árabes de Granada, Sevilla y Córdoba, o sea, La Alhambra, El Alcázar y La Gran Mezquita de Occidente*, Madrid, Imprenta y Litografía de A. Rodero, 1878, pp. 186–87.

271 *Monumentos Arquitectónicos de España. Publicados a expensas del Estado y bajo la dirección de una comisión especial creada por el Ministerio de Fomento*, Madrid, Imprenta y Calcografía Nacional, 1856–82.

272 Anna McSweeney, "Mudéjar and the Alhambresque: Spanish Pavilions at the Universal Expositions and the Invention of a National Style," *Art in Translation*, 9/1 (2017), pp. 50–70.

273 See in particular Eric Calderwood, *Colonial al-Andalus: Spain and the Making of Modern Moroccan Culture*, Cambridge, MA, and London, Harvard University Press, 2018.

274 Eric Calderwood, "'In Andalucía, There Are No Foreigners': *Andalucismo* from Transperipheral Critique to Colonial Apology," *Journal of Spanish Cultural Studies*, 15/4 (2014), pp. 399–417.

275 Anna McSweeney and Claudia Hopkins, "'Editorial': Spain and Orientalism," *Art in Translation*, 9/1 (2017), pp. 1–6.

276 Ricardo Velázquez Bosco, *Plan General de Conservación de la Alhambra de Granada*, Granada, December 1917. In the plan (*Memoria*) the first point states: "*1. Desalojar todas las construcciones que forman parte integrante del Monumento que tengan interés en cualquier concepto, histórico-artístico, o arqueológico, que no deben estar convertidos en viviendas particulares. Los que las habitan pueden instalarse en las casas que son de propiedad del Estado y que no tienen interés alguno.*" APAG 002000/009. This document includes the *Informe, Memoria*, and *Presupuesto*, and is available at: http://www.alhambra-patronato.es/ria/handle/10514/14222.

277 Torres Balbás, "Diario" (1965), p. 83.

278 José Antonio González Alcantud *et al.*, *La Alhambra, mito y vida 1930–1990: tientos de memoria oral y antropología de un Patrimonio de la Humanidad*, Granada, Editorial Universidad de Granada, 2016.

279 Mulder, "Imagining Localities," pp. 229–54.

280 Recent efforts to preserve both the more recent history of the Alhambra and the stories of its inhabitants have gone some way to complicating our understanding of the site today. See in particular the work of José Antonio González Alcantud, including González *et al.*, *La Alhambra*.

281 Juan Manuel Barrios Rozúa, "La Alhambra romántica (1813–1849): gobernadores, maestros de obras y arquitectos," in José Antonio González Alcantud, ed., *La Alhambra: lugar de la memoria y el diálogo*, Granada, Comares, 2008, pp. 29–60. See also Asún González Pérez, "Reconstructing the Alhambra: Rafael Contreras and Architectural Models of the Alhambra in the Nineteenth Century," in McSweeney and Hopkins, eds., *Art in Translation*, pp. 29–49.

282 Lara Eggleton, "History in the Making: The Ornament of the Alhambra and the Past-Facing Present," *Journal of Art Historiography*, 6 (2012).

283 John Ruskin, *The Stones of Venice*, London, Smith, Elder & Co., 1851.

284 Torres Balbás, "Diario" (1966), pp. 89–111.

285 Carlos Vílchez Vílchez, *La Alhambra de Leopoldo Torres Balbás. Obras de Restauración y Conservación 1923–1936*, Granada, Editorial Comares, 1988, pp. 307–17.

286 Aroa Romero Gallardo, *Prieto-Moreno. Arquitecto Conservador de la Alhambra (1936–1978). Razón y sentimiento*, Granada, Editorial Universidad de Granada, 2014.

287 Jesús Bermúdez Pareja, "Techo cupular del Mirador de la Torre de las Damas," *Cuadernos de la Alhambra*, 2 (1966), pp. 129–30.

288 Bermúdez Pareja, "Techo cupular," p. 130, my translation.

CONCLUSION:
THE CUPOLA BETWEEN GRANADA AND BERLIN

289 Nicholas Thomas, *Return of Curiosity*, pp. 49–50.

290 Fax sent 4 August 2000 from the Germany embassy in Madrid to the MIK Berlin outlining the request and asking for advice on how to respond, MIK archives.

291 Isabel Soria and José Manuel Herraiz (directors) *Los Cielos Españoles*, TV documentary produced by Albella Audiovisual in collaboration with RTVE and Aragón TV (2019).

292 The project "virt:cult" was approved in January 2016. It deals with the contextualization of cultural heritage within virtual reality and game technology. It is managed by Prof. Thomas Bremer (Game Design), Prof. Susanne Brandhorst (Conceptional Design, Game Design), and Prof. Dr. Kay Kohlmeyer (Landscape Archaeology) of the Hochschule für Technik und Wirtschaft (HTW) of Berlin, in collaboration with the MIK and the Patronato de la Alhambra y Generalife in Granada.

293 Shaw, "In Situ," pp. 339–65: "Instead of reproducing the simulacral ideal of the authentic physical site, virtual and reproductive technologies of the twenty-first century can enable us to recreate the past while cherishing the present, and to magnify rather than hide the complicated and uneven stitches between the two."

294 Stefan Weber, "Pulling the Past into the Present: Curating Islamic Art in a Changing World, a Perspective from Berlin," *International Journal of Islamic Architecture*, 7/2 (2018), pp. 237–61, see esp. pp. 249–51.

Bibliography

Ali Bey el Abbassi, a.k.a. Domingo Badía y Leblich, *Viajes por Marruecos*, edited by Salvador Barberá Fraguas, Madrid, Editorial Nacional, 1984.

Almagro Cárdenas, Antonio, *Museo Granadino de Antigüedades* Árabes, Granada, J. Garcia Garrido, 1886.

Almagro Gorbea, Antonio, "El color en la arquitectura nazarí," in J. Gallego, ed., *Revestimiento y Color en la Arquitectura*, Granada, University of Granada, 1996, pp. 99–107.

Almagro Gorbea, Antonio, "An Approach to the Visual Analysis of the Gardens of al-Andalus," *Middle East Garden Traditions: Unity and Diversity*, Washington, DC, Dumbarton Oaks, 2007, pp. 55–73.

Almagro Gorbea, Antonio, ed., *El legado de al-*Ándalus. *Las antigüedades* árabes *en los dibujos de la Academia*, Madrid, Real Academia de Bellas Artes de San Fernando, Fundación Mapfre, 2015.

Alpers, Svetlana, "The Museum as a Way of Seeing," in Ivan Karp and Steven D. Lavine, eds., *Exhibiting Cultures: The Poetics and Politics of Museum Display*, Washington, DC, Smithsonian Institution Press, 1991, pp. 25–32.

Anderson, Glaire, *The Islamic Villa in Early Medieval Iberia: Architecture and Court Culture in Umayyad Córdoba*, Farnham, Routledge, 2013.

Appadurai, Arjun, *The Social Life of Things: Commodities in Cultural Perspective*, Cambridge, Cambridge University Press, 1986.

de Argote, Simón, *Nuevos Paseos Históricos, Artísticos, Económico-Políticos, por Granada y sus Contornos*, 3 vols., Granada, D. Francisco Gomez Espinosa de los Monteros, 1806.

Arnold, Felix, *Islamic Palace Architecture in the Western Mediterranean*, Oxford, Oxford University Press, 2017.

von Auffenberg, Joseph, *Humoristische Pilgerfahrt nach Granada un Kordova im Jahre 1832*, Leipzig and Stuttgart, J. Scheible, 1835.

Balbale, Abigail, "Jihad as a Means of Political Legitimation in Thirteenth-Century Sharq al-Andalus," in Amira K. Bennison, ed., *The Articulation of Power in Medieval Iberia and the Maghrib*, Proceedings of the British Academy 195, Oxford, Oxford University Press, 2014, pp. 87–105.

Balbale, Abigail, "Bridging Seas of Sand and Water: The Berber Dynasties of the Islamic Far West," in Finbarr B. Flood and Gülru Necipoğlu, eds., *A Companion to Islamic Art and Architecture*, vol. 1, Hoboken, NJ, Wiley Blackwell, 2017, pp. 382–403.

Ballantine, James, *The Life of David Roberts, R.A.: Compiled from His Journals and Other Sources*, Edinburgh, Adam and Charles Black, 1866.

Barrios Rozúa, Juan Manuel, "La Alhambra de Granada y los difíciles comienzos de la restauración arquitectónica (1814–1840)," *Boletín de la Real Academia de Bellas Artes de San Fernando*, 106/107 (2008), pp. 131–58.

Barrios Rozúa, Juan Manuel, "La Alhambra romántica (1813–1849): gobernadores, maestros de obras y arquitectos," in José Antonio González Alcantud, ed., *La Alhambra: lugar de la memoria y el diálogo*, Granada, Comares, 2008, pp. 29–60.

Barrios Rozúa, Juan Manuel, "La población de la Alhambra: de ciudadela a monumento (1814–1851)," *Boletín de la Real Academia de la Historia*, 205/3 (2008), pp. 461–92.

Barrios Rozúa, Juan Manuel, *Richard Ford, un aristócrata en la Alhambra romántica. Granada. Escritos con dibujos inéditos del autor Richard Ford*, Granada, University of Granada, 2012.

Barrios Rozúa, Juan Manuel, *Granada Napoleónica: ciudad, arquitectura y patrimonio*, Granada, University of Granada, 2013.

Barrios Rozúa, Juan Manuel, "El Generalife y las ruinas árabes de sus contornos. Un capítulo inédito de los *Nuevos Paseos* de Simón de Argote," *Al-Qantara*, 35/1 (2014), pp. 29–59.

Barrios Rozúa, Juan Manuel, *Alhambra Romántica. Los comienzos de la restauración arquitectónica en España*, Granada, University of Granada, 2016.

Basu, Paul, *The Inbetweenness of Things*, London, Bloomsbury, 2017.

Bermúdez López, Jesús, "The Alhambra and Generalife Official Guide," Madrid, TF Editores, 2010.

Bermúdez Pareja, Jesús, "Techo cupular del Mirador de la Torre de las Damas," Crónica de la Alhambra, *Cuadernos de la Alhambra*, 2 (1966), pp. 129–30.

Bermúdez Pareja, Jesús, *El Partal y la Alhambra Alta*, Granada, Obra Cultural de la Caja General de Ahorros y Monte de Piedad de Granada, 1977.

Bloom, Jonathan, *Art of the City Victorious: Islamic Art and Architecture in Fatimid North Africa and Egypt*, New Haven and London, Yale University Press and the Institute of Ismaili Studies, 2008.

Brisch, Klaus, "Eine Kuppel aus der Alhambra in Granada," *Berichte aus den Berliner Museen Preußischer Kulturbesitz*, 3rd series, 14 (1978), pp. 6–10.

Brisch, Klaus, "Eine Kuppel aus der Alhambra in Granada," *Jahrbuch Preußischer Kulturbesitz*, 16 (1979), pp. 169–76.

Bush, Olga, *Reframing the Alhambra: Architecture, Poetry, Textiles and Court Ceremonial*, Edinburgh, Edinburgh University Press, 2018.

Calatrava Escobar, Juan, "Un retrato de Granada a principios del siglo XIX: Los 'Nuevos Paseos' de Simón de Argote," *Demófilo. Revista de Cultura Tradicional de Andalucía*, 35 (2000), pp. 95–110.

Calatrava Escobar, Juan, ed., *Romanticismo y arquitectura. La historiografía arquitectónica en la España de mediados del siglo XIX*, Madrid, Abada Editores, 2011.

Calatrava Escobar, Juan, Mariam Rosser-Owen, Abraham Thomas, and Rémi Labrusse, *Owen Jones y la Alhambra*, Granada, Patronato de la Alhambra y Generalife, 2011.

Calderwood, Eric, "'In Andalucía, There Are No Foreigners': *Andalucismo* from Transperipheral Critique to Colonial Apology," *Journal of Spanish Cultural Studies*, 15/4 (2014), pp. 399–417.

Calderwood, Eric, *Colonial al-Andalus: Spain and the Making of Modern Moroccan Culture*, Cambridge, MA, and London, Harvard University Press, 2018.

Cardell, C., L. Rodríguez-Simón, I. Guerra, and A. Sánchez-Navas, "Analysis of Nasrid Polychrome Carpentry at the Hall of the Mexuar Palace, Alhambra Complex (Granada, Spain), Combining Microscopic, Chromatographic and Spectroscopic Methods," *Archaeometry*, 51/4 (2009), pp. 637–57.

Cardell-Fernández, Carolina, and Carmen Navarrete-Aguilera, "Pigment and Plasterwork Analyses of Nasrid Polychromed Lacework Stucco in the Alhambra (Granada, Spain)," *Studies in Conservation*, 51 (2006), pp. 161–76.

Casares López, Matilde, *Las Obras Reales de la Alhambra en el siglo XVI: un estudio de los libros de cuentas de los pagadores Ceprián y Gaspar de León (1528–1627)*, unpublished doctoral thesis, University of Granada, 2008.

Casares López, Matilde, "La ciudad palatina de la Alhambra y las obras realizadas en el siglo XVI a la luz de sus libros de cuentas," *De Computis: revista Española de Historia de Contabilidad*, 6/10 (2009), pp. 3–129.

Catlos, Brian A., *Muslims of Medieval Latin Christendom c.1050–1614*, Cambridge, Cambridge University Press, 2014.

Chmelnizkij, Sergei, "Methods of Constructing Geometric Ornamental Systems in the Cupola of the Alhambra," *Muqarnas: An Annual on the Visual Culture of the Islamic World*, VI (1989), pp. 43–49.

Christys, Ann, "Picnic at Madinat al-Zahra," in Simon Barton and Peter Linehan, eds., *Cross, Crescent and Conversion: Studies on Medieval Spain and Christendom in Memory of Richard Fletcher*, Leiden, Brill, 2008.

Constable, Olivia Remie, *Trade and Traders in Muslim Spain: The Commercial Realignment of the Iberian Peninsula, 900–1500*, Cambridge, Cambridge University Press, 1996.

Contreras, Rafael, *Estudio Descriptivo de los Monumentos Árabes de Granada, Sevilla y Córdoba, o sea, La Alhambra, El Alcázar y La Gran Mezquita de Occidente*, Madrid, Imprenta y Litografía de A. Rodero, 1878.

Cruces Blanco, Esther, and Pedro Galera Andreu, "Las Torres de la Alhambra. Población y Ocupación del Espacio. Informes de Juan de Orea (1572)," *Cuadernos de la Alhambra*, 37 (2001), pp. 41–58.

Danby, Miles, *Moorish Style*, London, Phaidon, 1995.

Daston, Lorraine, ed., *Things that Talk: Object Lessons from Art and Science*, New York, Zone Books, 2004.

Dickie, James, "The Palaces of the Alhambra," in Jerrilynn Dodds, *Al-Andalus: The Art of Islamic Spain*, New York, Metropolitan Museum of Art, 1992, pp. 135–51.

Dodds, Jerrilynn D., ed., *Al-Andalus: The Art of Islamic Spain*, New York, Metropolitan Museum of Art, 1992.

Eggleton, Lara, "History in the Making: The Ornament of the Alhambra and the Past-Facing Present," *Journal of Art Historiography*, 6 (2012), pp. 1–29.

Erdmann, Kurt, "Bibliography of the Writings of Ernst Kühnel," *Ars Orientalis*, 1 (1954), pp. 195–208.

Fábregas García, Adela, "Other Markets: Complementary Commercial Zones in the Naṣrid World of the Western Mediterranean (Seventh/Thirteenth to Ninth/Fifteenth Centuries)," *Al-Masāq*, 25/1 (2013), pp. 135–53.

Fábregas García, Adela, "El mercado interior nazarí: bases y redes de contactos con el comercio internacional," *Hispania*, 73/255 (2017), pp. 69–90.

Fairchild Ruggles, Dede, "The Mirador in Abbasid and Hispano-Umayyad Garden Typology," *Muqarnas: An Annual on the Visual Culture of the Islamic World*, VII (1990), pp. 73–82.

Fairchild Ruggles, Dede, "The Eye of Sovereignty: Poetry and Vision in the Alhambra's Lindaraja mirador," *Gesta*, 36/2, Chicago, University of Chicago Press, 1997, pp. 180–89.

Fairchild Ruggles, Dede, *Gardens, Landscape and Vision in the Palaces of Islamic Spain*, University Park, Pennsylvania State University Press, 2000.

Feliciano, Maria Judith, "Muslim Shrouds for Christian Kings? A Reassessment of Andalusi Textiles in Thirteenth-Century Castilian Life and Ritual," in Cynthia Robinson and Leyla Rouhi, eds., *Under the Influence: Questioning the Comparative in Medieval Castile*, Leiden and Boston, Brill, 2005, pp. 101–31.

Fernández-Puertas, Antonio, *The Alhambra*, London, Saqi Books, 1997.

Fernández-Puertas, Antonio, "Tipología de lámparas de bronce en al-Andalus y el Magrib," *Miscelánea de Estudios árabes y Hebraicos. Sección Arabe-Islam*, 48 (1999), pp. 379–92.

Fierro, Maribel, "Ways of Connecting with the Past: Genealogies in Nasrid Granada," in Sarah Savant and Helena de Felipe, eds., *Genealogy and Knowledge in Muslim Societies: Understanding the Past*, Edinburgh, Edinburgh University Press, 2014, pp. 71–88.

Ford, Brinsley, *Richard Ford in Spain*, exhibition catalogue, 5 June–12 July 1974, London: Wildenstein, 1974.

Ford, Richard, *A Handbook for Travellers in Spain and Readers at Home: Describing the Country and Cities, the Natives and Their Manners, the Antiquities, Religion, Legends, Fine Arts, Literature, Sports, and Gastronomy; With Notices on Spanish History*, vol. 1, London, J. Murray, 1845.

Ford, Richard, *Gatherings from Spain*, London, J. Murray, 1861.

Galera Mendoza, Esther, *Estructura urbana y organización productiva en la Alhambra durante el Antiguo Régimen*, Granada, University of Granada, 2013.

Gámiz Gordo, Antonio, "Los dibujos originales de los palacios de la Alhambra de J.F. Lewis (h.1832–33)," *EGA Expresión Gráfica Arquitectónica*, 20 (2012), pp. 76–87.

García Bueno, Ana, Maria Carmen López Pertiñéz, and Victor Medina Flórez, "La policromía en la carpintería nazarí," *Actas XV Congreso de Conservación y Restauración de Bienes Culturales*, Murcia, 2005, pp. 247–56.

Garcia Gomez, Emilio, *Cinco poetas musulmanes: Biografías y estudios*, 2nd ed., Madrid, Espasa-Calpe, 1959.

Garrido Atienza, Miguel, ed., *Las Capitulaciones para la entrega de Granada*, Granada, University of Granada, 1992.

Gell, Alfred, *Art and Agency: An Anthropological Theory*, Oxford, Clarendon Press, 1998.

Giménez Cruz, Antonio, *La España pintoresca de David Roberts*, Málaga, University of Málaga, 2002.

Girault de Prangey, Joseph-Philibert, *Essai sur l'architecture des Arabes et des Mores: en Espagne, en Sicile, et en Barbarie*, Paris, A. Hauser, 1841.

Girault de Prangey, Joseph-Philibert, *Choix d'ornements moresques de l'Alhambra, ouvrage-faisant suite á l'Atlas in folio, Monuments arabes et moresques de Courdoue, Séville et Grenade*, Paris, A. Hauser, 1842.

Gómez Moreno, Manuel, "Pinturas de Moros en el Partal (Alhambra)," *Cuadernos de la Alhambra*, 6 (1970), pp. 155–64. First published in 1916 by Ed. Sabatel, Granada.

González Alcantud, José Antonio, ed., *La Alhambra: lugar de la memoria y el diálogo*, Granada, Comares, 2008.

González Alcantud, José Antonio, *La Alhambra Mito y Vida 1930–1990*, Granada, University of Granada, 2016.

González Alcantud, José Antonio, José Muñoz Jiménez, and Sandra Rojo Flores, *La Alhambra, mito y vida 1930–1990: tientos de memoria oral y antropología de un Patrimonio de la Humanidad*, Granada, Editorial Universidad de Granada, 2016.

González Pérez, Asún, "Reconstructing the Alhambra: Rafael Contreras and Architectural Models of the Alhambra in the Nineteenth Century," in Anna McSweeney and Claudia Hopkins, eds., *Art in Translation*, 9/1 (2017), pp. 29–49.

Gosden, Chris, and Yvonne Marshall, "The Cultural Biography of Objects," *World Archaeology*, 31/2 (1999), pp. 169–78.

von Gwinner, Arthur, Obituary, *Monatsheft für die Beamten der Deutschen Bank und Disconto-Gesellschaft* (Jan–Feb 1932), pp. 1–10.

von Gwinner, Arthur, *Lebenserinnerungen*, edited by Manfred Pohl, Frankfurt am Main, Fritz Knapp, 1975.

Harvey, Leonard P., *Islamic Spain 1250–1500*, Chicago, University of Chicago Press, 1990.

Harvey, Leonard P., *Muslims in Spain 1500 to 1614*, Chicago, University of Chicago Press, 2008.

Hermosilla y Sandoval, José de, Juan de Villanueva, and Juan Pedro Arnal, *Antigüedades Árabes de España*, Madrid, Imprenta de la Real Academia de San Fernando, 1787 and 1804.

Hillgarth, J.N., *The Spanish Kingdoms, 1250–1516*, 2 vols., Oxford, Clarendon Press, 1976–78.

Hitchcock, Richard, *Muslim Spain Reconsidered from 711 to 1502*, Edinburgh, Edinburgh University Press, 2014.

Irving, Washington, *The Alhambra: A Series of Tales and Sketches of the Moors and Spaniards*, London, Henry Colburn and Richard Bentley, 1832. Revised by the author and republished in 1851 as *Tales of the Alhambra*.

Irwin, Robert, *The Alhambra*, Cambridge, MA, Harvard University Press, 2004.

Jenkins, Marilyn, "Al Andalus: Crucible of the Mediterranean," in *The Art of Medieval Spain A.D. 500–1200*, New York, Metropolitan Museum of Art, 1993, pp. 73–84.

Joy, Jody, "Reinvigorating Object Biography: Reproducing the Drama of Object Lives," *World Archaeology*, 41/4 (2009), pp. 540–56.

Jones, Owen and Jules Goury, *Plans, Elevations, Sections and Details of the Alhambra, from Drawings Taken on the Spot in 1834 by the Late M. Jules Goury, and in 1834 and 1837 by Owen Jones, Archt. With a Complete Translation of the Arabic Inscriptions, and an Historical Notice of the Kings of Granada, from the Conquest of that City by the Arabs to the Expulsion of the Moors, by Mr. Pasqual Gayangos*, 2 vols., London, Owen Jones, 1842–45.

Jones, Owen, *The Alhambra Court in the Crystal Palace*, London, Crystal Palace Library and Bradbury and Evans, 1854.

Jones, Owen, *The Grammar of Ornament*, London, Day and Son, 1856.

Kaltenbach, Angelika, "Das orientalische Kabinett der Villa Stauß. Ein noch unbekanntes Kunstwerk des Orientalismus in Berlin," in Julia Gonnella and Jens Kröger, eds., *Wie die Islamische Kunst nach Berlin kam. Der Sammler und Museumsdirektor Friedrich Sarre (1865–1945)*, Berlin, Reimer, 2015, pp. 79–87.

Kapitaikin, Lev, "Sicily and the Staging of Multiculturalism," in Finbarr B. Flood and Gülru Necipoğlu, *A Companion to Islamic Art and Architecture*, vol. 1, Hoboken, N.J, Wiley Blackwell, 2017, pp. 378–404.

Kennedy, Hugh, *Muslim Spain and Portugal: A Political History of al-Andalus*, New York, Addison Wesley Longman, 1996.

Kopytoff, Igor, "The Cultural Biography of Things: Commoditization as Process," in Arjun Appadurai, *The Social Life of Things: Commodities in Cultural Perspective*, Cambridge, Cambridge University Press, 1986, pp. 64–94.

Kröger, Jens, "Early Islamic Art History in Germany and the Concepts of Object and Exhibition," in *Islamic Art and the Museum*, Berlin, Saqi Books, 2012, pp. 173–82.

Kühnel, Ernst, "Alhambraprobleme. Ergebnisse und Ziele der neuen Restaurierungsarbeiten Monatshefte für Kunstwissenschaft," *Monatsheft für Kunstwissenschaft*, 1/3 (1908), pp. 192–93, 438–39.

Kühnel, Ernst, *Granada*, vol. 12, Leipzig, Statten der Kultur, 1909.

Kühnel, Ernst, *Maurische Kunst*, Berlin, Bruno Cassirer Verlag, 1924.

Kühnel, Ernst, "The Islamic Department of the Berlin Museum," *Ars Islamica*, 15/16 (1951), pp. 143–45.

Kühnel, Ernst, "Islamische Kunst in Dahlem," *Berlin Museen 4*, 3/4 (1954), pp. 38–42.

Kurz, Otto, "The Present State of the Berlin Museums," *Burlington Magazine*, 98/640 (1956), pp. 234–38.

Leo Africanus, Johannes, *Descripción general del* África *y de las cosas peregrinas que allí hay*, edited by Serafín Fanjul and Nadia Consolani, Granada, Fundación El Legado Andalusì, 1995.

Lévi-Provençal, Évariste, *Inscriptions Arabes d'Espagne*, Leiden, Brill, 1931.

Lewis, John Frederick, *Sketches and Drawings of the Alhambra, Made during a Residence in Granada, in the Years 1833–4*, London, Hodgson Boys & Graves, 1835.

Lewis, John Frederick, *Sketches of Spain and Spanish Character, Made during His Tour in that Country, in the Years 1833–4, Drawn on Stone from his Original Sketches Entirely by Himself*, London, F.G. Moon, 1836.

di Liberto, Rosa, "Norman Palermo: Architecture between the 11th and 12th Century," in Annliese Nef, ed., *A Companion to Medieval Palermo: The History of a Mediterranean City from 600 to 1500*, Leiden, Brill, 2013, pp. 139–94.

López Borges, Víctor Hugo, "Provenance, Collecting and Use of Five Nasrid Plasterwork Fragments in the Victoria and Albert Museum," *Actas del I Congreso Red Europea de Museos de Arte Islámico*, Granada, Patronato de la Alhambra y Generalife, 2012, pp. 15–35.

López Borges, Víctor Hugo, María José de la Torre López, and Lucia Burgio, "Characterization of Materials and Techniques of Nasrid Plasterwork Using the Victoria and Albert Museum Collection as an Exemplar," in *Actas del I Congreso Red Europea de Museos de Arte Islámico*, Granada, Patronato de la Alhambra y Generalife, 2012, pp. 345–70.

López Guzman, Rafael Jesús, *Colección de documentos para la historia del arte en Granada. Siglo XI*, Granada, University of Granada, 1993.

López-López, Angel C., and Antonio Orihuela Uzal, "Una nueva interpretación del texto de Ibn al-Jatíb sobre la Alhambra en 1362," *Cuadernos de la Alhambra*, 26 (1990), pp. 121–44.

López Pertíñez, Maria Carmen, *La Carpintería en la Arquitectura Nazarí*, Granada, Instituto Gómez-Moreno de la Fundácion Rodríguez-Acosta, 2006.

Ibn Luyūn, *Treatise on Agriculture*, edited and with Spanish translation by Joaquina Eguaras Ibáñez as *Ibn Luyun: Tratado de agricultura*, Granada, Patronato de la Alhambra y Generalife, 1975.

de Luz Carretera, Rodrigo, "El linaje de Luz durante el proceso de conquista y organización de la Granada moderna," in *Los linajes nobiliarios en el reino de Granada, siglos XV-XIX. El linaje Granada venegas, marqueses de Campotéjar*, Huéscar, Asociación Cultural Raigadas, 2010, pp. 173–206.

Malpica Cuello, Antonio, "La Alhambra que se construye. Arqueología y conservación de un monumento," in José Antonio González Alcantud and Antonio Malpica Cuello, eds., *Pensar la Alhambra*, Barcelona, Anthropos & Centro de Investigaciones Etnológicas "Angel Ganivet," 2001, pp. 33–66.

Malpica Cuello, Antonio, *La Alhambra de Granada, un Estudio Arqueológico*, Granada, Universidad de Granada, 2002.

Malpica Cuello, Antonio, "Las transformaciones de la Alhambra nazarí por la acción castellana," in José Antonio González Alcantud, ed., *La Alhambra: lugar de la memoria y el diálogo*, Granada, Editorial Comares, 2008 pp. 9–28.

Marchand, Suzanne, *German Orientalism in the Age of Empire*, Washington, DC, German Historical Institute and Cambridge University Press, 2009.

Marinetto Sánchez, Purificación, "Pila," in *Arte Islámico en Granada: Propuesta para un Museo de la Alhambra*, Granada, Editorial Comares, 1995, pp. 277–80, cat. no. 73.

McSweeney, Anna, "Arthur von Gwinner und die Alhambra Kuppel," in Julia Gonnella and Jens Kroeger, eds., *Wie die Islamische Kunst nach Berlin kam. Der Sammler und Museumsdirektor Friedrich Sarre (1866–1945)*, Berlin, Staatliche Museen zu Berlin, 2015, pp. 89–102.

McSweeney, Anna, "Versions and Visions of the Alhambra in the Nineteenth-Century Ottoman World," *West 86th: A Journal of Decorative Arts, Design History, and Material Culture*, 22/1 (2015), pp. 44–69.

McSweeney, Anna, "Mudéjar and the Alhambresque: Spanish Pavilions at the Universal Expositions and the Invention of a National Style," *Art in Translation*, 9/1 (2017), pp. 50–70.

McSweeney, Anna, and Claudia Hopkins, "'Editorial': Spain and Orientalism," *Art in Translation*, 9/1 (2017), pp. 1–6.

Monumentos Arquitectónicos de España. Publicados á expensas del Estado y bajo la dirección de una comisión especial creada por el Ministerio de Fomento, Madrid, Imprenta y Calcografía Nacional, 1856–1882.

Mulder, Stephennie, "Seeing the Light: Enacting the Divine at Three Medieval Syrian Shrines," in David J. Roxburgh, ed., *Envisioning Islamic Art and Architecture: Essays in Honor of Renata Holod*, Leiden and Boston, Brill, 2014, pp. 88–108.

Mulder, Stephennie, "Shrines and Saints for Sultans: On the Destruction of Local Heritage Sites by ISIS," *Aktüel Arkeoloji*, 51 (2016), pp. 93–99.

Mulder, Stephennie, "Imagining Localities of Antiquity in Islamic Societies," *International Journal of Islamic Architecture*, 6/2 (2017), pp. 229–54.

Münzer, Hieronymus, "Jerónimo Münzer. Viaje por España y Portugal en los años 1494 y 1495," translated by Julio Puyol, *Boletín de la Real Academia de la Historia*, 84 (1924), pp. 32–119.

Münzer, Hieronymus, *Viaje por España y Portugal 1494–1495*, Valladolid, Editorial Maxtor, 2019.

Navarro Palazón, Julio, F. Garrido Carretero, J.M. Torres Carbonell, and H. Triki, "Agua, arquitectura y poder en una capital del Islam: la finca real del Agdal de Marrakech (ss. XII–XX)," *Arqueología de la Arquitectura*, 10/7 (2013), pp. 1–43.

Nora, Pierre, ed., *Realms of Memory: Rethinking the French Past*, Chicago, University of Chicago Press, 1998.

O'Callaghan, Joseph F., *Reconquest and Crusade in Medieval Spain*, Philadelphia, University of Pennsylvania Press, 2004.

Orfila Pons, Margarita, "Granada en época romana: los restos arqueológicos, una visión global," in *Revista del CEHGR*, 25 (2013), pp. 15–28.

Orihuela Uzal, Antonio, *Casas y Palacios Nazaríes: siglos XIII–XV*, Granada, El Legado Andalusí, 1996.

Orihuela Uzal, Antonio, "Granada, between the Zirids and the Nasrids Art and Cultures of Al-Andalus," in *The Power of the Alhambra*, Granada, El Legado Andalusí, 2013, pp. 47–57.

Orihuela Uzal, Antonio "Evolución urbana de Granada desde los primeros asentamientos ibéricos hasta la época nazarí, in Jordi Segura, ed., *Ibèria, Roma, al-Àndalus. El fi com a principi*, Barcelona, Imprenta Barnola S.L., 2017, pp. 150–53.

Ortega Vidal, Javier, "Los dibujos de la 'arquitectural mahometana' en Monumentos Arquitectónicos," in Antonio Almagro, ed., *El Legado de al-Ándalus. Las Antigüedades Árabes en los Dibujos de la Academia*, Madrid, Real Academia de Bellas Artes de San Fernando, 2015, pp. 45–62.

Panadero Peropadre, Nieves, "Recuerdos de la Alhambra: Rafael Contreras y el gabinete árabe del Palacio Real de Aranjuez," *Reales sitios: revista del patrimonio nacional*, 122 (1994), pp. 33–40.

Pavón Maldonado, Basilio, *Tratado de arquitectura hispanomusulmana*, vol. 3, Madrid, CSIC, 2004.

Pflugradt-Abdelaziz, Elke, "A Proposal by the Architect Carl von Diebitsch (1819–69): Mudéjar Architecture for a Global Civilization," in Nabila Oulebsir and Mercedes Volait, eds., *L'Orientalisme architectural entre imaginaires et savoirs*, Paris, INHA, 2009, pp. 69–88.

Piggott, Jan R., *Palace of the People: The Crystal Palace at Sydenham 1854–1936*, London, C. Hurst & Co., 2004.

Pohl, Manfred, "150th Anniversary of the Birth of Arthur von Gwinner," *Bank and History: Historical Review*, 10 (2006). Newsletter published by Historische Gesellschaft der Deutschen Bank, e.V., Frankfurt am Main, 2006.

Puerta Vílchez, José Miguel, *Reading the Alhambra: A Visual Guide to the Alhambra through its Inscriptions*, Granada, Patronato de la Alhambra, 2011.

Puerta Vílchez, José Miguel, *Aesthetics in Arabic Thought: From Pre-Islamic Arabia through al-Andalus*, translated by Consuelo López-Morillas, Leiden, Brill, 2017.

Ramos Torres, Maria Cruz, "Preparativos en la Alhambra ante la venida de Felipe V," *Cuadernos de la Alhambra*, 8 (1972), pp. 91–98.

Rheinheimmer, Vivian J., *Herbert M. Gutmann: Bankier in Berlin. Bauherr in Potsdam*, Leipzig, Koehler & Amelang, 2007.

Rodríguez Domingo, José Manuel, "La protección institucional de las 'antigüedades árabes' en Granada," in *El patrimonio arqueológico en España en el siglo XIX. El impacto de las desamortizaciones*, Madrid, Ministerio de Educación, Cultura y Deporte, 2012, pp. 290–307.

Rodríguez Trobajo, Eduardo, "Procedencia y uso de madera de pino silvestre y pino laricio en edificios históricos de Castilla y Andalucía," *Arqueología de la Arquitectura*, 5 (2008), pp. 33–53.

Romero Gallardo, Aroa, *Prieto-Moreno. Arquitecto Conservador de la Alhambra (1936–1978). Razón y sentimiento*, Granada, Editorial Universidad de Granada, 2014.

Roscoe, Thomas, *The Tourist in Spain: Granada*, London, Maurice, Clark, and Co., 1835.

Rosser-Owen, Mariam, "Poems in Stone: The Iconography of "Amirid Poetry and its 'Petrification' on "Amirid Art," in Glaire D. Anderson and Mariam Rosser-Owen, eds., *Revisiting Al-Andalus: Perspectives on the Material Culture of Islamic Iberia and Beyond*, Leiden, Brill, 2007, pp. 83–98.

Rosser-Owen, Mariam, *Islamic Arts from Spain*, London, V&A Publishing, 2010.

Rosser-Owen, Mariam, "'From the Mounds of Old Cairo': Spanish Ceramics from Fustat in the Collections of the Victoria and Albert Museum," in *Actas del I Congreso Internacional Red Europea de Museos de Arte Islámico*, Granada, Patronato de la Alhambra y Generalife, 2013, pp. 163–86.

Rosser-Owen, Mariam, "Andalusi Spolia in Medieval Morocco," *Medieval Encounters*, 20 (2014), pp. 152–98.

Roxburgh, David J., ed., *Envisioning Islamic Art and Architecture: Essays in Honor of Renata Holod*, Boston, Brill, 2014

Rubiera Mata, María Jesús, *Ibn al-Yayyab: el otro poeta de la Alhambra*, Granada, Patronato de la Alhambra, 1994.

Ruiz Souza, Juan Carlos, "Castile and al-Andalus after 1212: Assimilation and Integration of Andalusi Architecture," *Journal of Medieval Iberian Studies*, 4/1 (2012), pp. 125–34.

Ruskin, John, *The Stones of Venice*, London, Smith, Elder & Co., 1851.

Sánchez Gómez, Carlos, "El Taujel Viajero de la Torre de las Damas," in *21 Jardines del Partal*, Granada, University of Granada, 2007.

Sánchez Martínez, Manuel, "Comercio Nazarí y Piratería Catalano-Aragones (1344-1345)," in *Relaciones de la Península Ibérica con el Magreb, siglos XIII–XVI*, Madrid, CSIC, 1988, pp. 41–86.

Sánchez-Montes González, Francisco, "La Alhambra del siglo XVII," in Rafael Jesús López Guzmán, ed., *Los Tendilla: señores de la Alhambra*, Granada, Patronato de la Alhambra y Generalife, 2016, pp. 99–103.

von Schack, Adolf Friedrich, *Poesie und Kunst der Araber in Spanien und Sicilien*, Berlin, W. Hertz, 1865.

Shalem, Avinoam, "The Poetics of Portability," in *Histories of Ornament: From Global to Local*, Princeton and Oxford, Princeton University Press, 2016, pp. 250–61.

Shaw, Wendy, "In Situ: The Contraindications of World Heritage," *International Journal of Islamic Architecture*, 6/2 (2017), pp. 339–66.

Soultanian, Jack, Antoine M. Wilmering, Mark D. Minor, and Andrew Zawacki, "The Conservation for the Minbar from the Kutubiyya Mosque," in Jonathan M. Bloom, Ahmed Toufiq, Stefano Carboni, Jack Soultanian, Antoine M. Wilmering, Mark D. Minor, Andrew Zawacki, and El Mostafa Hbibi, *The Minbar from the Kutubiyya Mosque*, New York, Metropolitan Museum of Art Publications, 1998, pp. 67–84.

Staatliche Museen zu Berlin, *Führer durch die Islamische Kunstabteilung*, Berlin, Staatliche Museen zu Berlin, 1933.

Sweetman, John, *The Oriental Obsession: Islamic Inspiration in British and American Art and Architecture, 1500–1920*, Cambridge, Cambridge University Press, 1998.

Tabbaa, Yasser, "Andalusian Roots and Abbasid Homage in the Qubbat al-Barudiyyin in Marrakech," *Muqarnas: An Annual on the Visual Culture of the Islamic World*, XXV (2008), pp. 133–46.

Tilley, Christopher, *Metaphor and Material Culture*, Oxford, Wiley, 1999.

Thomas, Nicholas, *The Return of Curiosity*, London, Reaktion Books, 2016.

Torres Balbás, Leopoldo, "La mezquita real de la Alhambra y el baño frontero," *Al-Andalus*, X (1945), pp. 196–214.

Torres Balbás, Leopoldo, "Las Casas del Partal de la Alhambra de Granada," *Al-Andalus*, XIV (1949), pp. 186–97.

Torres Balbás, Leopoldo, "Diario de obras en la Alhambra: 1923," *Cuadernos de la Alhambra*, 1 (1965), pp. 75–92.

Torres Balbás, Leopoldo, "Diario de obras en la Alhambra: 1924," *Cuadernos de la Alhambra*, 2 (1966), pp. 89–111.

Torres Balbás, Leopoldo, "Diario de obras en la Alhambra: 1925–26," *Cuadernos de la Alhambra*, 3 (1967), pp. 125–52.

Torres Balbás, Leopoldo, "Diario de obras en la Alhambra: 1927–29," *Cuadernos de la Alhambra*, 4 (1968), pp. 99–128.

Torres Balbás, Leopoldo, "Diario de obras en la Alhambra: 1930–36," *Cuadernos de la Alhambra*, 5 (1969), pp. 69–94.

Troelenberg, Eva-Maria, "Aus Ruinen auferstanden? Ernst Kühnel, Friedrich Bachor und der Wiederaufbau der Mschatta-Fassade nach 1945," *Jahrbuch der Berliner Museen*, 54 (2012), pp. 141–52.

Troelenberg, Eva-Maria, *Mshatta in Berlin: Keystones of Islamic Art*, Dortmund, Verlag Kettler, 2017. First published in German 2014.

Vílchez Vílchez, Carlos, *La Alhambra de Leopoldo Torres Balbás. Obras de Restauración y Conservación 1923–1936*, Granada, Comares, 1988.

Vílchez Vílchez, Carlos, *El Palacio del Partal Alto en la Alhambra*, Granada, Proyecto Sur de Ediciones, 2001.

Vílchez Vílchez, Carlos, "Los otros señores de la Alhambra. La tenencia de alcaldía del Generalife," in Rafael Jesús López Guzmán, ed., *Los Tendilla: señores de la Alhambra*, Granada, Patronato de la Alhambra y Generalife, 2016, pp. 93–97.

Vivian, George, *Spanish Scenery*, London, P. and D. Colnaghi, 1838.

Weber, Stefan, "Pulling the Past into the Present: Curating Islamic Art in a Changing World, a Perspective from Berlin," *International Journal of Islamic Architecture*, 7/2 (2018), pp. 237–61.

Imprint

Connecting Art Histories in the Museum
Volume 5
Anna McSweeney: From Granada to Berlin: the Alhambra Cupola
Dortmund: Verlag Kettler 2020.

Connecting Art Histories in the Museum is a collaboration between Staatliche Museen zu Berlin, Stiftung Preußischer Kulturbesitz and Kunsthistorisches Institut in Florenz, Max-Planck-Institut. The book series is edited by Michael Eissenhauer, Jörg Völlnagel, Hannah Baader, Gerhard Wolf.

Publication management and coordination at the museums: Sigrid Wollmeiner

Coordination at the publishers: Matthias Koddenberg
Proofreading and copyediting: Melinda Johnston
Layout and design: André Gösecke
Production: Druckerei Kettler, Bönen

Cover illustration: Detail of the Alhambra cupola, Spain 14th century, Inv. I.5/78.
© Museum für Islamische Kunst, SMB. Photo by Johannes Kramer.

Bibliographic information published by the Deutsche Nationalbibliothek
The Deutsche Nationalbibliothek lists this publication in the Deutsche Nationalbibliografie; detailed bibliographic data are available in the Internet at http://dnb.dnb.de

www.smb.museum
www.khi.fi.it

VERLAG **KETTLER**

Published by: Verlag Kettler, Dortmund
www.verlag-kettler.de
ISBN 978-3-86206-831-9

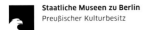